David Busch's Digital Infrared Pro Secrets

David D. Busch

THOMSON

COURSE TECHNOLOGY ™

Professional ■ Technical ■ Reference

Important: Thomson Course Technology PTR cannot provide software support. Please contact the appropriate software manufacturer's technical support line or Web site for assistance.

Thomson Course Technology PTR and the author have attempted throughout this book to distinguish proprietary trademarks from descriptive terms by following the capitalization style used by the manufacturer.

Information contained in this book has been obtained by Thomson Course Technology PTR from sources believed to be reliable. However, because of the possibility of human or mechanical error by our sources, Thomson Course Technology PTR, or others, the Publisher does not guarantee the accuracy, adequacy, or completeness of any information and is not responsible for any errors or omissions or the results obtained from use of such information. Readers should be particularly aware of the fact that the Internet is an ever-changing entity. Some facts may have changed since this book went to press.

Educational facilities, companies, and organizations interested in multiple copies or licensing of this book should contact the Publisher for quantity discount information. Training manuals, CD-ROMs, and portions of this book are also available individually or can be tailored for specific needs.

ISBN-10: 1-59863-355-4

ISBN-13: 978-1-59863-355-9

Library of Congress Catalog Card Number: 2006909689

Printed in the United States of America

07 08 09 10 11 BU 10 9 8 7 6 5 4 3 2 1

Publisher and General Manager, Thomson Course Technology PTR:
Stacy L. Hiquet

Associate Director of Marketing:
Sarah O'Donnell

Manager of Editorial Services:
Heather Talbot

Marketing Manager:
Heather Hurley

Executive Editor:
Kevin Harreld

Project Editor:
Jenny Davidson

Technical Reviewer:
Michael D. Sullivan

PTR Editorial Services Coordinator:
Erin Johnson

Interior Layout Tech:
Bill Hartman

Cover Designer:
Mike Tanamachi

Indexer:
Sharon Shock

Proofreader:
Sara Gullion

THOMSON

COURSE TECHNOLOGY ™

Professional ■ Technical ■ Reference

Thomson Course Technology PTR, a division of Thomson Course Technology
25 Thomson Place ■ Boston, MA 02210 ■ http://www.courseptr.com

Acknowledgments

Once again thanks to the folks at Course Technology, who have pioneered publishing digital imaging books in full color at a price anyone can afford. Special thanks to executive editor Kevin Harreld, who always gives me the freedom to let my imagination run free with a topic, as well as my veteran production team including project editor Jenny Davidson and technical editor Mike Sullivan. Also thanks to cover designer, Mike Tanamachi; layout tech, Bill Hartman; and my agent, Carole McClendon, who has the amazing ability to keep both publishers and authors happy.

About the Author

David D. Busch was a roving photojournalist for more than 20 years, illustrating his books, magazine articles, and newspaper reports with award-winning images before turning full time to writing and illustrating books. He's operated his own commercial studio, suffocated in formal dress while shooting weddings-for-hire, and shot sports for a daily newspaper and upstate New York college. His photos have been published in magazines as diverse as *Scientific American* and *Petersen's PhotoGraphic*, and his articles have appeared in *Popular Photography & Imaging, The Rangefinder, The Professional Photographer*, and hundreds of other publications. He has reviewed dozens of digital cameras for CNet Networks and *Computer Shopper*.

When About.com named its top five books on Beginning Digital Photography, occupying the first two slots were Busch's *Digital Photography All-In-One Desk Reference for Dummies* and *Mastering Digital Photography*. His 90-plus other books published since 1983 include bestsellers like *Digital SLR Cameras and Photography for Dummies* and *Digital Photography for Dummies Quick Reference*.

Busch earned top category honors in the Computer Press Awards the first two years they were given (for *Sorry About The Explosion* and *Secrets of MacWrite, MacPaint and MacDraw*), and he later served as Master of Ceremonies for the awards.

Contents

Chapter 3
Equipping Yourself 31

Chapter 4
Accessories After the Fact 57

Chapter 7
Flowers, Plants, and Close-Ups 135

Chapter 8
People, Places, and Things 151

Chapter 9
Architecture 167

Chapter 10
Experimental Action 181

PART III
EX POST (PROCESSING) FACTO. 201

Chapter 11
Fixing Up Your Images 203

Chapter 12
Color IR 217

Chapter 13
Hard Copies Made Easy 229

Appendix A
Glossary of Photographic, Digital, and
Infrared Terminology 237

Index 261

Preface

This is the book that blows the lid off digital infrared photography! If you thought that IR photography was too difficult, too specialized, too time-consuming, or too expensive, you're about to be astounded. Infrared imaging is an exciting creative tool that will enable you to capture some of the best and most interesting pictures you've ever taken.

Certainly, you can use infrared for some great landscape pictures. But I'm going to show you how you can apply this kind of photography to portraits, still lifes, close-up pictures, or even sports in ways that will amaze you, your friends, and colleagues. I'm going to lead you step-by-step through making your own IR filters and converting an existing camera to full-time infrared use. Other books may show you how to take good IR landscape photos; this one is your entrée into taking eye-popping infrared images… period.

Introduction

Digital infrared (IR) photography isn't just for weird landscapes anymore!

It's a blossoming new area that's a powerful creative outlet in its own right, giving the imaginative photographer whole new ways of seeing and picturing both familiar and unfamiliar subject matter. Yet, not much is written about infrared photography, and the articles and books that are available approach the topic, in my mind, from *entirely the wrong angle.* Most of the available information about IR imaging looks at this tool and technique from the landscape photographer's perspective, or for its scientific possibilities.

Indeed, entire books have been written that make IR photography appear to be a rather esoteric pursuit, usually fraught with cameras tied to rigid tripods using contemplative shooting techniques that would have bored Ansel Adams. If you were to believe most of the literature, you'd think IR photography was difficult, and perhaps best-suited for certain types of scenic photography in broad daylight.

That's *rubbish!*

IR photography can provide unique and flattering portraits, eye-catching close-ups of flowers, travel photographs unlike any you've ever seen before, and, if you know a few tricks, a new perspective on sports photography. Indeed, you may have seen infrared photos without even being aware that they *are* infrared images.

Serious amateur photographers who want to explore the full creative potential of their digital cameras are discovering what pro photographers have known for years: infrared photography produces enthralling black-and-white (and faux color) images that challenge the eye and mind. Many professional wedding photographers offer dreamy, high-key infrared coverage of nuptials. IR photography has made serious in-roads into fashion and architectural photography, too. Intermediate and advanced amateur photographers have picked up on this, and are investigating infrared photography, making it one of the hot topics in the photography user forums.

Infrared photography with film has been around for a long time and quickly outgrew its initial use in scientific and surveillance applications. The artistic and creative applications for IR developed more slowly when film cameras were the only outlet for photographers. Today, digital cameras make it relatively easy for any photo enthusiast to explore the mysterious and rewarding realm of infrared photography. *David Busch's Digital Infrared Pro Secrets* clears up the mysteries and puts serious digital photographers on a fast track to reaping the rewards of creative IR imaging.

Yes, you will find lots of information on shooting landscapes, scenics, and nature photos with digital infrared techniques. But there's a lot more you can do, too, if you have the kind of guidance you'll find in this book.

You don't need an expensive camera to explore infrared photography. A point-and-shoot camera will do just fine. (In fact, cameras with an optical viewfinder window actually have an advantage over digital SLRs when it comes to composing images.) All you need is this book, an infrared filter (I show you how to make your own), a digital camera, and an understanding of what you can do with digital IR photography. Those who jump into this arena whole-hog will be pleased to discover that many cameras, including dSLRs and consumer cameras like Canon PowerShot and Nikon Coolpix models, can be converted to shoot infrared photos full-time. I show you how to do that, too.

I covered IR photography in a limited way in two of my other books, *Mastering Digital Photography* and *Mastering Digital SLR Photography*. Even if you've read these books you can prepare to learn something new. If IR photography in general is new to you, prepare to be amazed.

Who Am I?

First, and foremost, I'm a photojournalist and made my living in the field until I began devoting most of my time to writing books. Although I love writing, I'm happiest when I'm out taking pictures, which is why I took 10 days off late in 2005 for a solo visit to Toledo, Spain, and am taking two weeks this year to visit Valencia, Spain—not as a tourist, but solely to take photographs of the people, landscapes, and monuments that I've grown to love in a dozen trips to the Iberian peninsula.

That means that, like you, I love photography for its own merits, and view technology as just another tool to help me get the images I see in my mind's eye. It also means that, like you, when I peer through the viewfinder, I sometimes forget everything I know and take a real clunker of a picture. Unlike most, however, when I see the result I can offer detailed technical reasons that explain exactly what I did

wrong, although I usually keep this information to myself. Some of the most interesting infrared techniques you'll find in this book resulted from accidents that turned out to be interesting once I sorted out what I'd done. It's this combination of experience—both good and bad—and expertise that lets me help you explore the wonderful new things you can do with infrared imaging.

Chapter Outline

Part I: Ready, Set, Go!

Chapter 1: Infrared Photography and You

This chapter explains some of the exciting new applications for infrared photography, and it outlines what you need to do to get yourself ready. You'll also find some basics on IR imaging, and what you can expect from photos you take by infrared illumination.

Chapter 2: Inside an Infrared-Capable Camera

Here you'll find a detailed explanation of how digital IR photography works—compared to conventional digital photography—a discussion of sensors, infrared filters, hot mirrors, and why some cameras do IR better than others.

Chapter 3: Equipping Yourself

You can shoot infrared with simple point-and-shoot cameras, or, if you're ambitious, adapt your digital SLR for infrared photography. In this chapter I explain the different options available for IR filters and how to make your own from inexpensive materials.

Chapter 4: Accessories After the Fact

A tripod is a good idea for infrared photography, but there are other gadgets that can help, such as an auxiliary viewfinder that will let you compose and frame your image even when you're shooting blind. I show you how to make your own viewfinder out of a $2.48 single-use film camera, and ways to make other useful IR gear.

Chapter 5: IR Camera Conversions

You can convert a simple point-and-shoot camera to full-time infrared use by removing the IR cutoff filter inside and replacing it with an IR pass filter. I show you how to do that in this chapter. If you don't want to tackle the job yourself, you'll learn where you can have your camera converted by experts. You'll also find step-by-step fully illustrated instructions for converting one of the most popular cameras.

Part II: Oh, Shoot! Infrared Photo Techniques

Chapter 6: First Steps with Infrared Landscape Photography

Learn how to set white balance for infrared, providing more vivid straight infrared and false-color infrared shots. I help you find IR-friendly subjects, and include a portfolio of the kind of photographs you can expect to take with your infrared-enabled camera.

Chapter 7: Flowers, Plants, and Close-Ups

In this chapter, you'll discover why flowers and plants are some of the best infrared subjects, especially when pictured up close. The text explains some of the tricks of getting good IR photos that will make flora look their best and most exotic, thanks to the other-worldly look of infrared imaging.

Chapter 8: People, Places, and Things

You can shoot infrared candid portraits, or set up lights in a home "studio" and take more formal portraits using IR illumination, which tends to be friendly to less-than-perfect skin while adding a subtle striking and sometimes glamorous look.

Chapter 9: Architecture

You're in for some surprises when you tackle architectural subjects in infrared! Ordinary buildings can be surrounded by outlandish, ghostly white foliage, set against a backdrop of a wine-dark sky and fluffy clouds. This chapter shows you how to make the most of angles and perspective distortion to create compelling architectural photos.

Chapter 10: Experimental Action

In this chapter, you'll learn to shed your tripod for action photography, apply fast shutter speeds, use flash, and other techniques to take infrared photography where no human has dared to go before.

Part III: Ex Post (Processing) Facto

Chapter 11: Fixing Up Your Images

Your great infrared shots can become even better if you know what manipulations to make in your image editor. This chapter shows you how to import RAW and JPEG IR files, adjust white balance after the fact, deal with IR noise, and change tonal values.

Chapter 12: Color IR

Infrared isn't just monochrome anymore! In this chapter you'll discover how to create exotic false-color looks through channel swapping, changing white balance, enhancing hue, and merging layers in new ways.

Chapter 13: Hard Copies Made Easy

There are a few special tricks for getting the most out of hard copies of your infrared photos, and this chapter explains them to you. Learn how to print IR in color and monochrome, and learn ways to enhance the look of prints of your infrared photos.

Appendix A: Glossary of Photographic, Digital, and Infrared Terminology

Part I

Ready, Set, Go!

This first part of the book will get you prepped and equipped for digital infrared photography. I'll show you how IR imaging works, take you on a tour of a digital infrared camera, and explain how to choose the best camera for IR photography. Then, you'll learn how to equip yourself with suitable accessories and, if you're brave enough, there are step-by-step instructions for converting your own camera to full-time infrared operation.

1

Infrared Photography and You

As I noted in the Introduction, digital infrared photography is an exciting new frontier. It's no longer just a type of photography you can use to get weird-looking landscape photographs. I may be biased, but I tend to think of IR imaging today as a stand-alone legitimate branch of photography in its own right, like black-and-white photography, low-light photography, or macro photography.

You won't find much written about digital infrared photography, which is a shame, because it's one of those photo arenas, like macro photography, that can be a powerful creative outlet, with whole new ways of seeing and picturing both familiar and unfamiliar subject matter. I'm going to resolve the dearth of information available about digital infrared photography with dSLRs by devoting a whole chapter to the subject.

If you purchased this book, you either love IR photography already or think it might be something you can pursue with a passion. As you'll see, when you want a certain creative or otherworldly look in your pictures, IR imaging can produce photographs that can be obtained in no other way. You're not limited to daytime landscapes, either: IR photography can be applied to people pictures, indoor shots, night photography, and other situations. All these are covered in this book.

This chapter will serve as your introduction to infrared photography, and explains why the technique is such a fascinating milieu to work within.

Infrared Photography Primer

It's probably a good idea to clear up one common misconception. All infrared photography of the digital variety captures images in what is called the *near infrared* (NIR) range; that is, the infrared light that's just beyond the range of human vision. Such photography does *not* capture far infrared or heat radiation. So if you have a hankering to mimic the commandos in the movies and photograph the heat signatures of, say, gullible friends wandering through the woods at dark in search of the elusive snipe, you're out of luck. Nor can you track jet airplanes like a heat-seeking missile. Almost all digital SLR IR photos rely on subjects that *reflect* healthy amounts of near infrared light, not those that *emit* far infrared or thermal infrared energy.

To really understand how infrared photography works with a digital SLR, it can be helpful to recall a little from high school science class lessons on how our eyes work, and compare that with how digital sensors operate. Digital image capture devices like film or the sensor in your dSLR don't perceive light the way our eyes do. It's not even close. Because of that, I'll explain each kind of "seeing" separately and in more detail in Chapter 2.

But, in brief, the ultraviolet, visible light, and infrared illumination are measured using their *wavelengths,* which is, quite literally, the distance between the peaks and troughs of the light wave oscillations that pass through the air (or other medium) before bouncing around (if it's reflected light) and reaching our eyes. The light we ordinarily see by ranges in wavelength from about 400 nanometers (violet) to 700 nanometers (deep red).

Of course, the incoming light also contains a significant amount of invisible, *near-infrared* (NIR) illumination, which is considered to be light in the 700–1200 nanometer range. Longer wavelengths, from 1200–3000 nanometers, and even longer (from 3000 nanometers to 1,000,000 nanometers) produce *far infrared* and the *thermal infrared* light that comes in so handy to spies, bank robbers, and commandos. A typical light source could also contain light from the short wavelength end of the spectrum, the ultraviolet range, but the glass used in camera lenses does a pretty good job of filtering out most UV light, and the popular UV filters that photographers like to use to protect their lenses remove much of the rest. Figure 1.1 shows a rough diagram of the electromagnetic spectrum that's not drawn to scale.

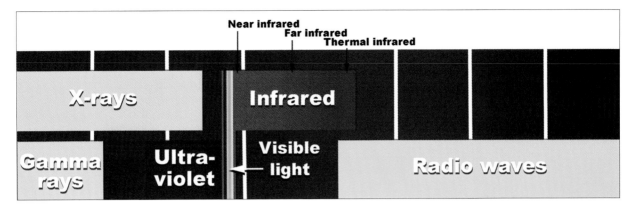

Figure 1.1 The electromagnetic spectrum, including visible light and infrared illumination, is arranged something like this.

All you really need to remember is that we see in the 400–700 nanometer wavelengths, and take infrared photos using illumination in the 700–1200 nanometer range. That information comes in useful when you choose an infrared filter (Chapter 3 will show you how to do that), because your IR photos will be affected by where the filter you use "cuts off" the light. As you'll learn, some IR filters let more visible light through to the sensor, and some allow less, producing slightly different results in either case.

Characteristics of Infrared Photography

For the purposes of this book, IR photography will be considered imaging that relies almost exclusively on near-infrared illumination, with perhaps a little tolerance for some visible light at the shorter end of the scale, primarily because filters that cut off visible light the most sharply and allow only infrared illumination to pass also tend to be the most expensive. Sometimes it's more practical to tolerate a bit of visible illumination to save some money.

Using a properly equipped camera, you can take pictures that are dramatically different from those you get using conventional visible light photography. The black-and-white results you get are nothing like the monochrome pictures derived from converting a color image to black and white, either. If you'll wade through some photo-technique-heavy explanation with me, I can give you a quick introduction to why this is true. We'll explore these ideas in more detail later in the book.

Figure 1.2 shows a view of a small river, taken from a bridge over that river, using a digital camera in color mode. The foliage and reflection of the greenery in the river is interesting enough, but, because the sunlight is coming towards the camera, the sky, although dotted with puffy clouds, appears as a plain blue-white expanse. Because the trees overlap the sky, I couldn't have fixed this using a split-density filter (which has a dark half that can be used to selectively reduce the brightness of the upper or lower portion of an image).

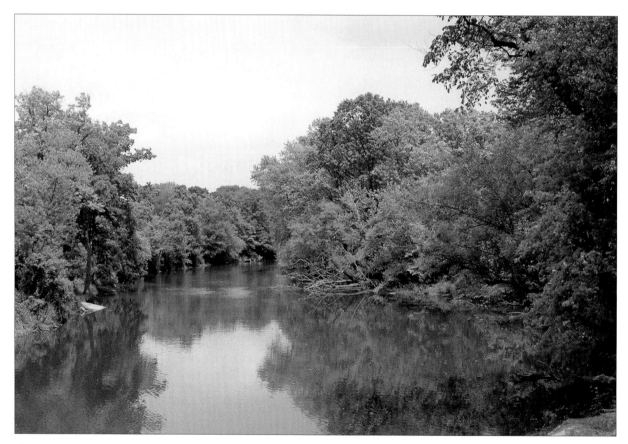

Figure 1.2 Under some lighting conditions, full-color images can lack a good balance between sky and foreground.

Figure 1.3 shows the same image converted to black and white, using Photoshop's Channel Mixer to provide the most suitable and accurate distribution of gray tones. (Converting ordinary color images to black and white can be problematic, and there are several different methods to choose from other than Photoshop's Desaturate command.) The monochrome version is even worse, because the sky now is an overcast dull white.

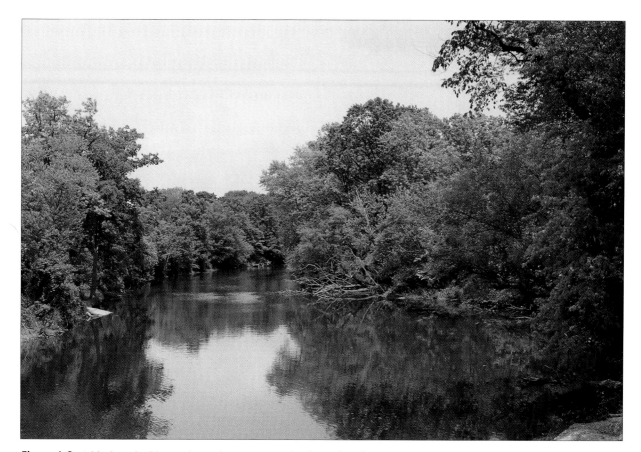

Figure 1.3 A black-and-white version only accentuates the featureless sky.

A picture of the same scene taken moments later using an infrared filter, shown in Figure 1.4, has the characteristic red cast of an exposure made without correcting the white balance (I'll show you how in Chapter 6). Even in this raw shot you can see how the lighter foliage and darker sky make the picture a bit more interesting. The final version, seen in Figure 1.5, is a much more dramatic photo, with the unearthly white tones of the plant life contrasting with the clearly differentiated clouds in the sky overhead. Even the water of the river looks a bit different, because the several-seconds exposure used for this shot allowed the flowing water to blur slightly into a smoother sheen.

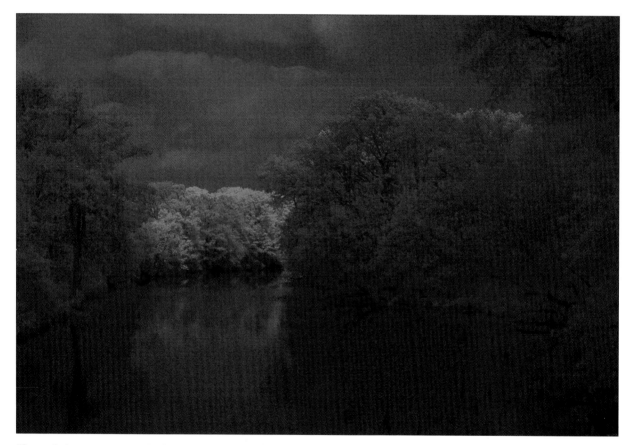

Figure 1.4 An uncorrected infrared shot has a look that's all its own.

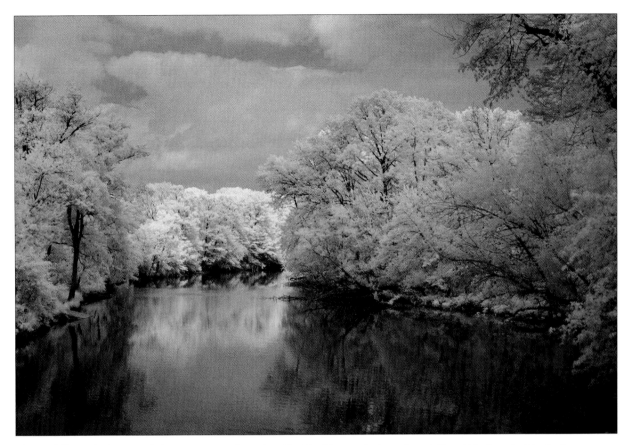

Figure 1.5 With the white balance set correctly as described in Chapter 6, the unique infrared black-and-white look appears.

And that's not all we could have done with this picture. I'll show you how to turn a black-and-white infrared photo into a faux color image, too, with eerie blue skies and other tones. (Figure 1.6, discussed next, provides a preview of that effect.)

Infrared imaging's allure to the creative photographer is based on these unique looks and properties it provides to the pictures captured using IR illumination. I'm going to describe them in the list that follows. Any one of these attributes might have been reason enough to prompt your investigation into infrared photography, but as a group of interesting properties, they are both challenging and compelling. Here are the main attributes of infrared shooting:

■ **Atmosphere piercing depth.** You might like the hazy quality that masks a distant mountain range, either for its romantic look or because a hazy view caused by light scattering as it bounces off particles in the atmosphere is what we have to put up with in real life. Or, you might *hate* the effect and seek to counter it with a so-called haze filter on your lens. Infrared photography is

the ultimate haze filter. Infrared light cuts right through haze, which is why aerial photographers, reconnaissance teams, and anyone using satellite imagery is so interested in shooting in the infrared portion of the spectrum. Figure 1.6 shows an infrared water scene in which the haze that normally appears at the horizon has been completely eliminated.

- **Back to monochrome.** There's always been something special about black-and-white photography, and infrared imaging almost forces you to look at your subjects in a monochromatic way. Even though "color" infrared photography is possible (I'll show you how in Chapter 12), most of the images will still be black, white, and shades of gray, magenta tones, or a color scheme described as "brick and cyan." Some of the best infrared photos don't even look as if they've been taken by infrared light. They are merely interesting grayscale photos, like the one shown in Figure 1.7.

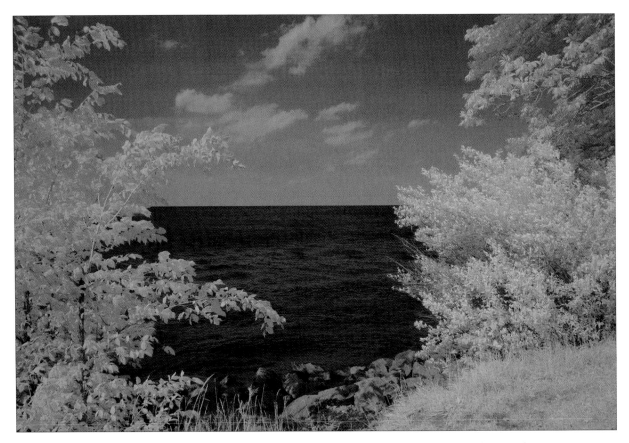

Figure 1.6 IR imaging can pierce through the haze that typically occurs at the horizon in scenic photographs.

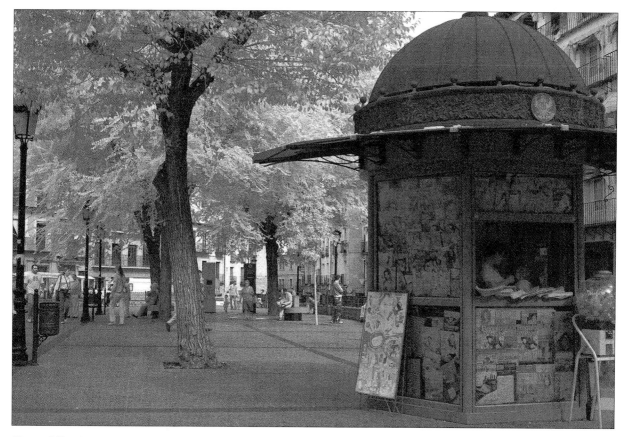

Figure 1.7 This image isn't obviously an infrared shot on first glance, but the IR look does give it an old-timey, European flavor.

- **False color.** When shooting infrared, you still need to use your camera's color photography mode. Experts in digital infrared photography recommend setting your camera's white balance manually, using grass as your sample. That white balance will provide the best overall grayscale images in your final picture.

- **Unexpected relationships.** Infrared photography produces tonal values and relationships that are unexpected and interesting. Subjects such as foliage reflect more infrared light than other objects, and skies may be darker than they seem when viewed by visible light. These unusual relationships are fodder for unusual and compelling photographs.

- **Light loss.** The IR filter blocks the visible illumination, leaving you with an unknown amount of infrared light to expose by. Unless you're using a camera that's been converted to full-time IR use (I'll explain how to do that in Chapter 5), you'll typically lose 5 to 7 f/stops worth of light. You'll need to

boost your exposure by that much to compensate. A tripod and long exposures, even outdoors, may be an obstacle for some kinds of photography (sports come to mind).

- **Long exposure quirks.** Because infrared exposures can be several seconds long or more, your photos will usually be taken with the camera mounted on a tripod, and moving objects will be rendered as blurs or ghosts. The effects of longer exposures can be very interesting, indeed. Those lengthy exposure times can actually be a benefit for other types of images (landscapes with waterfalls, say), which take on an interesting appearance with extra-long exposure times. Or, you can use the longer exposure times to create surreal effects, as in Figure 1.8.

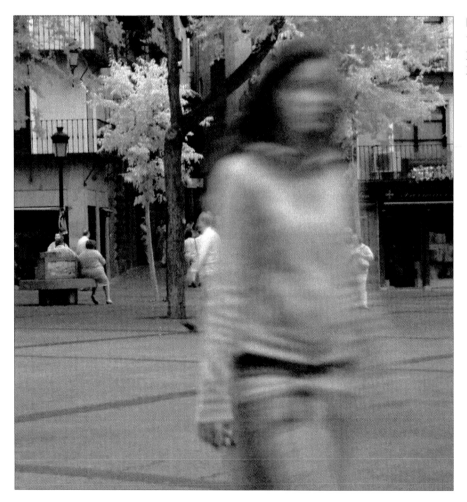

Figure 1.8 Long exposures that can result from infrared photography techniques can produce a surreal look.

■ **Shooting blind.** The visible light cutoff filter you'll be using with a non-converted camera means that, if you're using a dSLR, your viewfinder will appear to be completely black. The LCD review may be a little weird, too. You can't focus, you can't frame your image, and can't measure exposure accurately. From a creative standpoint, this means you must either shoot blind and take what you get, or carefully compose your image before mounting the IR filter. Both approaches lead to fascinating results, either resulting from pure chance, or from the need to work out your composition thoughtfully ahead of time.

■ **Focus problems.** Infrared light doesn't focus at the same point as visible light, so your autofocus system might or might not work properly. Lenses used to have an infrared marking on them that could be used in conjunction with the focus scale on the lens to correct the point of focus after you'd manually adjusted the image. Of course, we don't use manual focusing much these days, so you may have to experiment to determine how best to focus your camera for infrared photos. If you're shooting landscapes, setting the lens to the infinity setting probably will work (even though *infrared infinity* is at a different point than visible light infinity).

■ **Grainy look.** You'll find that infrared photographs often take on a grainy look. Part of that aspect comes from the different way in which your sensor captures and handles infrared illumination. But the look is also accentuated by the tendency to boost ISO settings to shorten those long exposures, and you must add the focus factor discussed above—-IR light doesn't focus at the same point as visible light. If you focus through your viewfinder, you may find that your image is still not sharply focused. I'll explain more about this effect later.

■ **Metering problems.** Exposure systems are set up to work with visible illumination. The amount of IR reflected by various subjects differs wildly, so two scenes that look similar visually can call for quite different exposures under IR.

■ **Lens coatings.** Some lenses include an anti-IR coating that produces central bright spots in IR images. A few Canon lenses fall into this category. Test your lens for this problem before blaming the artifacts on your filter or sensor.

What Can You Photograph?

Anything that reflects a lot of infrared makes a good subject, because it appears strangely light in tone compared to the way in which that object is ordinarily seen. Subjects that reflect very little infrared provide excellent contrast, because they look darker than we expect. Flower petals are bright under IR, but other parts of the plant, such as the seeds, may appear dark. Skies photograph fairly dark under IR conditions, but fluffy clouds may stand out in stark white contrast, because the water vapor they contain scatters the infrared wavelengths, as you can see in Figure 1.9.

Human skin is free from many defects under infrared illumination, offering some interesting, if weird, portrait possibilities. Indeed, the washed-out look that skin takes on, the lighter tone to lips and other features, coupled with the extra contrast and graininess you can get with IR imaging produces a unique look.

I'll show you lots of other suitable subjects for IR photography later in this book, but my best advice is to attempt the broadest possible variety of subjects to see what works for you.

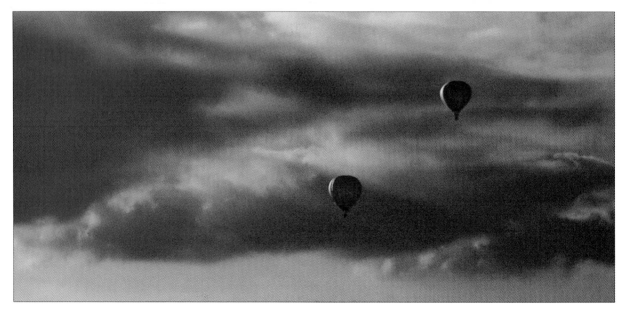

Figure 1.9 IR photography isn't confined to landscapes: you can photograph other outdoor subjects, such as this balloon ascension, for a unique appearance.

What Kind of Light Do You Need?

You need illumination that's rich in infrared wavelengths. Daylight is a good source, but incandescent lights are also rich in infrared. Fluorescent lights can be strongly deficient in IR, making them a poor choice. Hot coals, gas flames, fireplaces, and other burning light sources glow red in the visible spectrum, but also emit lots of infrared light. Even if you can't see a visible glow, most objects heated to 480 degrees F or higher will emit light strongly in the IR range. You might not be able to make photographs from the *heat* emitted by a fireplace, but the IR illumination the hearth produces is great.

I'll show you the effects of different kinds of light sources later in this book.

What Kind of Equipment Do You Need?

You don't need an expensive camera to shoot digital infrared photos. Many point-and-shoot models can do a great job, perhaps even better than more expensive digital SLRs in some cases. As you become more heavily involved in this type of photography, you might want to pick up an extra camera (new or used) especially outfitted for IR photography.

You'll need an infrared filter, which usually costs $100 or less, or else have your "dedicated" IR camera converted to full-time infrared use, for $100-$250 (depending on whether you do the conversion yourself, or have someone else do it for you). You might also want to buy a sturdy tripod, if you don't already own one. That's most of what you need. Infrared photography needn't be expensive or burdened with a heavy load of equipment. I'll show you how to make your own equipment in Chapters 3, 4, and 5.

Next Up

This chapter was a brief introduction to infrared photography. In the next chapter, you're going to learn more about how IR photography works, compared to conventional digital photography, and why some digital cameras do a better job with infrared than others.

2

Inside an Infrared-Capable Camera

When new acquaintances ask me what I do, I sometimes tell them that my job is to make horrid mistakes with my camera, compound them with astounding blunders in an image editor, and then write comprehensive instructions that will help others avoid making the same mistakes that have plagued me.

It's not that I am incredibly inept; I really, really enjoy pushing the limits of photography and related technologies to see what I can do, find out what I can't do, and then figure out ways to bypass the roadblocks. Along the way, I stumble over a disheartening number of obstacles, but manage to discover lots of cool techniques that result in books like this one. The foundation on which my turning bugs and blunders into features and techniques is built is understanding a little of the underlying technology.

In practice, you don't really need to understand how digital cameras capture infrared images to take good IR photos. You can follow the simple instructions in this book and go out and make your own infrared images. But if you're inclined to experiment a little, knowing how sensors grab IR, or even understanding the difference between how the eye, film, and digital capture works can pay off. This chapter isn't all that technical (if you took a few science classes in high school you probably already learned most of it), but it will provide you with the basic knowledge you need to put your experimentation on the right track, and, maybe help you overcome some especially challenging hurdles.

If you're *really* into experimentation and want to tinker with converting an existing camera to IR operation, or even building your own budget IR shooter (using a junk or toy camera, plus a $6 sheet of Rosco or Lee lighting filter material), I'll provide some tips in Chapter 5, but you'll want to absorb the information in this chapter first.

Retinas, Film, and Sensors

Our eyes, photographic film, and digital camera sensors capture images in very different ways, although all three perceive the various colors of light as a range of wavelengths measured in *nanometers*, or one billionth of a meter. In visible light, the distance between the peaks (or valleys) of the illumination ranges from about 400nm to 700nm. As I mentioned in Chapter 1, the near-infrared light used to take IR photos occupies the portion of the spectrum from 700 to 1200nm.

What scientists call short, mid, long, and far wavelength infrared and thermal infrared have much longer wavelengths than what you'll find in *near* infrared. *Much* longer, spanning what the technoids call three orders of magnitude, or what we normal folk might think of as 750 nanometers (.00000075 meter) to 1,000,000 nanometers (.001 meters, or 1 millimeter). That's quite a range!

INFRARED AND HEAT

While thermal infrared is often thought of as "heat radiation," that's not strictly true. Radiant illumination of *any* wavelength at all will heat the objects that absorb them (which is why microwave ovens work and green or ultraviolet lasers can char paper). Only about 50 percent of the heat absorbed from the sun by the Earth comes from infrared light. The rest comes from light at other wavelengths.

What the human eye, film, and sensors share is the ability to differentiate between longer, medium, and shorter *visible* wavelengths, and translate these into the red, green, and blue primary colors of light that can be used to assemble all the intermediate shades. Figure 2.1 shows how these RGB primaries overlap to produce magenta (red-blue), cyan (blue-green), and yellow (red-green). With a device like a digital camera or computer monitor, these colors combine to generate all the colors within that device's output range, or *gamut*. Some colors we can see cannot be reproduced by all mechanical or electronic devices, because of impurities in the colors or inks, or inability to produce certain wavelengths.

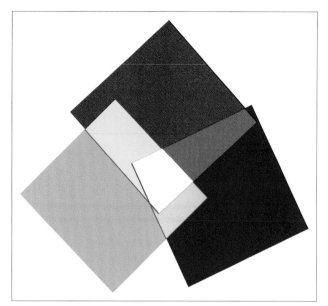

Figure 2.1 The primary colors of light—red, green, and blue—are used by digital cameras, computer monitors, and other devices to produce all the colors the device is capable of representing.

How the Eye Captures Images

Humans, of course, can't see by infrared illumination; that's why the portion of the spectrum we can see by is called *visible light*. What you do see as an image is actually a composite of two images, created by two different kinds of biological cells in the retinas of your eyes, called *rods* and *cones*. Each of these cells provides a different kind of vision.

When you're looking straight ahead in brightly lit environments, you're really, in a sense, experiencing a kind of tunnel vision, captured by the color-sensitive cones that provide a surprisingly narrow field of view directed frontward. These cones are less sensitive receptors, but provide a full-color image that your brain concentrates on, largely ignoring the information being received from the more sensitive (but colorblind) rods. These cells come into play when a fast-moving object approaches you from the side and catches your attention, or you must view images under lower light levels that can benefit from the rods' extra sensitivity.

You're not even aware of the difference between your straight-ahead and side fields of view, because your brain processes all the information for you, automatically, and combines the two into one "picture." But that's why, under low light levels, turning your head slightly to view an object off-center can provide a sharper view and also why, in darkness, everything seems to look grayer or, at a minimum, with much less color saturation.

There are three kinds of cones, each more sensitive to shorter, medium, or longer wavelengths (and thus called S-, M-, and L-cones for short). If you already know how film or sensors have layers or photosites that are heavily biased towards red (long), green (medium), and blue (short) wavelengths, you might be surprised to learn that the eye's cones aren't quite as discriminating among colors. Indeed, the S, M, and L cones don't correspond exactly to the blue, green, and red sensitivity of film or sensors at all. All three kinds of receptors respond to some extent to all colors of light, but happen to be *most* sensitive to particular colors. It's most accurate to label them as blue (S cones), blue-green (M cones), and yellow sensitive (L cones).

So, where do we get the RGB colors we believe are necessary to see a full range of hues? As it turns out, S cones respond to blue light strongly, but see green, yellow, and red light to a much lesser degree. The M cones most strongly react to green light, and detect blue, yellow, and red light much more weakly. The L cones, although they are most sensitive to yellow-green light, detect red light well, and see almost no blue at all.

Table 2.1 shows the approximate response of each kind of cone cell, displaying the range of colors perceived by each cell, as well as its peak (most sensitive) response point. You'll find this kind of information useful later on in choosing the kind of infrared filter you want to work with.

Table 2.1 Sensitivity Ranges of Cone Cells

Cone Type	Sensitivity Range	Peak Response	Color Sensitivity
S	400-500nm	420	Blue
M	450-630nm	534	Blue-Green
L	500-700nm	564	Yellowish-Green

You can see that the sensitivity ranges overlap slightly, particularly between the M and L cones, which are both sensitive to green and have similar peak response wavelengths. The same information is shown in Figure 2.2, which illustrates the degree of overlap visually. The "star" icon represents the peak sensitivity for each kind of cone. You'll notice that none of the three actually peak in the red portion of the spectrum. But, as it turns out, only the L cones actually do respond strongly to red illumination, so they are able to provide all the information about that color that our brains need to perceive it.

The figure also shows why we see greens most readily; two types of cones peak in the green portion of the spectrum. That's why monochrome computer monitors

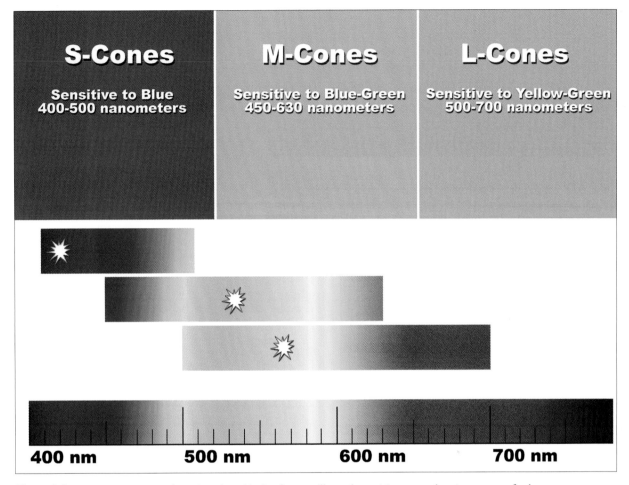

Figure 2.2 Our eyes perceive color using three kinds of cone cells, each sensitive to overlapping ranges of colors.

back in the dark ages of computerdom used green phosphors to display text (or, often, amber-yellow); both colors register with multiple visual cells in our eyes. You'll notice that infrared illumination is well outside our normal range of perception, so humans can't "see" infrared light.

How Film Captures Images

Color photographic film also captures the red, green, and blue colors of the visible spectrum to produce all the colors that film can record, using separate layers that are sensitive to each. The actual makeup of color film is much more complicated than that. While color films continue to be available in both transparency/slide (or positive film) format as well as color negative format, for simplicity's sake, I'm going to describe briefly only the makeup of the color negative variety.

Consider that photographic film is only 4 to 7 *thousandths* of an inch thick, and it's coated with up to several dozen emulsion layers that each may be only *half of one percent* as thick as the film base itself! Add metallic silver and some complex chemicals that must be frighteningly pure, and then require that the manufacturing process be carried out *in total darkness* under virtually clean-room conditions. Figure 2.3 shows a simplified cross section of a piece of film, with the film base and photosensitive emulsion layer pictured to scale.

Any film consists of several parts, including the emulsion containing the light-sensitive particles that capture the image, and the base material that the emulsion is coated on, either cellulose acetate or tougher polyester film. Film must be sensitized to be of any use in capturing images. That's accomplished by coating the film with layers of emulsion that contain light-sensitive ingredients. The first step is to dissolve pure silver bars in nitric acid, which is then dried to produce silver nitrate crystals. Next, gelatin is dissolved in pure distilled water, then mixed with potassium bromide and potassium iodide and heated. A silver nitrate solution is added to this mixture. The silver iodide/bromide crystals precipitate out of the solution, where they are suspended in the thickening gelatin, which is then coated onto one side of long rolls of film base or onto film sheets in layers that can be as thin as .00006 (6/100,000ths) of an inch. Films can have several light-sensitive emulsion layers (to capture red, green, and blue light in color film, for example) and include additional layers that perform other functions. Figure 2.4 shows a simplified cross section of a typical color negative film. Keep in mind that none of the layers in this figure are pictured to scale. The layers shown are as follows:

- **Anti-abrasion layer.** This layer protects the fragile layers underneath from scratches and abrasions.

- **Blue sensitive layer.** This layer absorbs blue light and (in a negative) produces yellow dye in the image areas of the film that contain blue subject matter.

- **Yellow filter layer.** This layer absorbs any remaining blue light, allowing only green and red to pass through to the layers underneath.

- **Green sensitive layer.** This layer absorbs green light and (in a negative) produces magenta dye in the image areas of the film that contain green subject matter.

- **Red sensitive layer.** This layer absorbs red light and (in a negative) produces cyan dye in the image areas of the film that contain red subject matter.

- **Film base.** This is the semi-transparent substrate onto which the emulsion layers are coated.

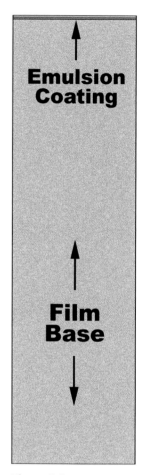

Figure 2.3 Film's photosensitive emulsion is unimaginably thin.

Anti-abrasion Layer
Blue Sensitive Yellow Dye Layer
Yellow Filter Layer
Green Sensitive Magenta Dye Layer
Red Sensitive Cyan Dye Layer
Film Base
Antihalation Backing
Noncurl Coating

Figure 2.4 This film cross section is not to scale, so you can see the individual layers more clearly.

- **Antihalation backing.** Light that passes through the film base would reflect back to the photosensitive layers, but is instead absorbed by the dye incorporated in the antihalation-backing layer, which is dissolved during processing.

- **Noncurl coating.** This layer is a hardened gelatin coating roughly the same thickness as the emulsion itself, and helps counter the natural curl of the film when it is dried.

The description of the color layers above doesn't take into account images that contain more than just pure red, green, or blue. Most images, of course, contain other hues, as well. In those cases, more than one light-sensitive layer is used to produce an image in a particular region of the film. For example, a subject with yellow tones will be registered by both the red and green sensitive layers, which will produce magenta and cyan dye, which combine to produce a blue color in the negative. Blue, in a negative, prints to yellow, its complementary color.

Because conventional silver-halide based film emulsions are not inherently sensitive to infrared illumination, infrared photography didn't become possible until 1910, when a special dye was discovered that could act as a color sensitizer for infrared light. Even so, very long exposures were required, so that most early infrared pictures (as today) were landscapes and other non-moving subjects.

During World War I, infrared-sensitive photographic plates were developed (in both senses of the word) to use the haze-piercing features of infrared illumination to improve aerial photography for applications like mapping and detecting camouflaged enemy installations. By the 1960s, false-color infrared photography with Kodak Ektachrome Infrared Aero Film, Type 8443 was used first in aerial photography (different colors were given to different degrees of IR reflectance, making the images easier to interpret, see Figure 2.5), and eventually onto psychedelic record album covers for the Grateful Dead, Jimi Hendrix, and others.

Because near-infrared illumination is only slightly longer than that of visible light, ordinary film cameras (and, later, digital cameras) could be used to take IR photographs. The chief concession made when this form of photography became popular was the addition of a red R or dot on the focusing scale of many lenses to indicate the infinity point for IR illumination (which was different from "normal"

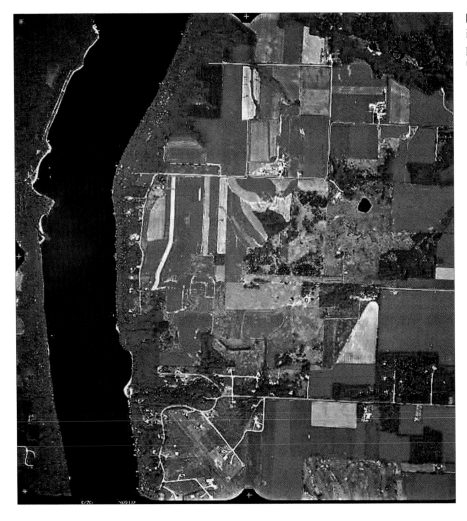

Figure 2.5 False-color infrared film images are particularly valuable for land use mapping.

infinity because the longer wavelengths come into focus at a different position). In addition, it turned out that many light-tight film cameras weren't totally opaque to infrared illumination and, further, some electronic 35mm cameras of the '90s had film-positioning mechanisms that used IR-sensitive sensors.

How Sensors Capture Images

With the exception of the Foveon sensor, which has separate red, green, and blue sensitive layers (much like photographic film), digital sensors for cameras start out sensitive to all colors of light, from a small amount of ultraviolet, through the visible spectrum, and on beyond to the near-infrared range that we can capture with photographs. Much of the technology that goes into creating a sensor is applied to countering this broad sensitivity to light so that certain pixels will respond, individually, to red, green, or blue light more or less exclusively.

The sensor itself is an array of rows and columns of pixels with, typically, 3872 columns and 2592 rows of pixels in a 10.2 megapixel sensor. Each of these photosites can be thought of as a kind of bucket that snares incoming photons. When enough photons have been captured (a *threshold* point), that pixel registers an image that's brighter than total black (a very dark gray, perhaps). As more photons pour in from a sufficiently long exposure, the bucket begins to fill and the pixel registers a brighter and lighter shade until the bucket completely fills, a white tone is registered, and no further captured photons are registered.

In practice, however, the additional light can "overflow" into adjacent photosites, producing an effect called *blooming*. That's why overexposure is bad: lost pixels aren't counted in the photosite where they belong, so detail is lost, and they may in fact register in nearby pixels where they don't belong.

Sensor Filter Layer

You can deduce from the description so far that naked photosites would register only brightness, without regard to color. Fortunately, overlaid on the surface of the sensor is a filter array of colors, with odd-numbered rows having red/green alternating pixel filters and even-numbered rows with blue/green pixel filters, as shown in Figure 2.6. With the filters in place (making up what's called a *Bayer array*, after the Kodak scientist who invented it), each individual photosite-pixel "sees" mostly red, green, or blue light.

As you might guess, a particular photosite might capture light that is not predominantly its "assigned" color; that is, a red-sensitive pixel might be struck by photons in the blue portion of the spectrum. To remedy that situation, your digital camera's software includes a *demosaicing* algorithm that examines adjacent pixels and assigns, after the fact, a color to the target pixel that's most appropriate for

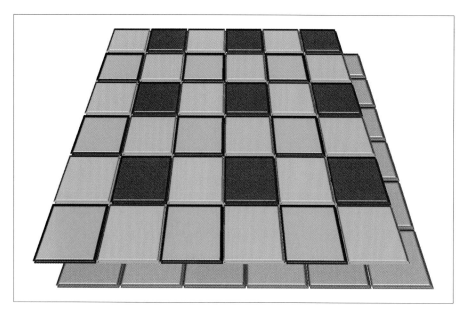

Figure 2.6 The sensor, which is sensitive to all visible light (and infrared) is overlaid with a Bayer filter array so individual photosites "see" only red, green, or blue.

the image captured. This interpolation allows sensors to capture color accurately, even though every color isn't represented at every pixel position.

Some sensors designed by Sony add a fourth color, emerald, to the filter array mix to improve the sensor's rendition of certain shades of red. Fuji has developed sensors with *two* octagon-shaped photosites at each pixel position. One is large and highlight-sensitive to light over a relatively narrow range, the other is a smaller photosite that has less sensitivity. That secondary photosite can absorb copious amounts of light to increase the brightness range of the sensor dramatically from very dark grays to very bright ones that would appear as black or white (respectively) in other sensors. Finally, as I mentioned earlier, Foveon-type sensors have three stacked photosites at each pixel position, each sensitive to red, green, or blue light, and so require no Bayer filter array at all.

Microlens Layer

Because of the nature of the optics used to focus images on digital camera sensors, some of the incoming photons approach the photosites at angles so sharp that they can strike the sides of the photon wells ("buckets") rather than hitting the light-sensitive portion of the sensor directly. The problem arises because the photosites themselves typically occupy only half the surface of a given sensor, with the rest of the sensor's surface given to other essential electronic components.

Imagine you had 10 rows of 10 buckets arrayed side by side so they touched. If you tossed ping-pong balls at the buckets from above or at an angle, you'd have a pretty good chance of each ball striking the bottom of the bucket directly rather than one of the sides. Now picture separating those buckets by a foot in each direction. Many of the ping-pong balls would miss the buckets entirely, while others would strike the sides because you'd now be standing at an increased angle from them as you tossed.

In such a situation, it wouldn't take long for some creative person to arrange to have a funnel, larger than the diameter of the bucket, above each container to focus the incoming balls toward the bottom of the bucket. In a real-world sensor, the "funnel" is a microlens, arranged in an array in yet another layer on top of the sensor. The tiny microlenses, each corresponding to one pixel (see Figure 2.7), refocus the light to a more suitable angle. These microlenses have little effect on infrared photography, so I won't dwell on them further.

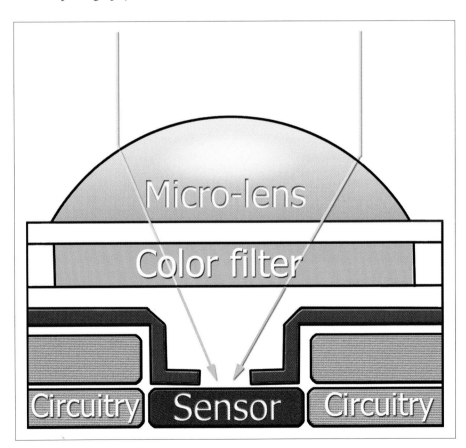

Figure 2.7 Tiny lenses redirect incoming light onto the sensor photosites.

Antialiasing Filter/IR Cutoff Filter Layer

The topmost layers of the typical sensor usually fulfill several purposes. First, there is an antialiasing filter (to remove moiré interference from the image), followed by an infrared cut-off filter to remove most (but not all) of the infrared light that reaches the sensor, and an outer scratch-resistant surface layer that protects the sensor from damage (see Figure 2.8). This outer surface is what you clean when you remove dust from your sensor.

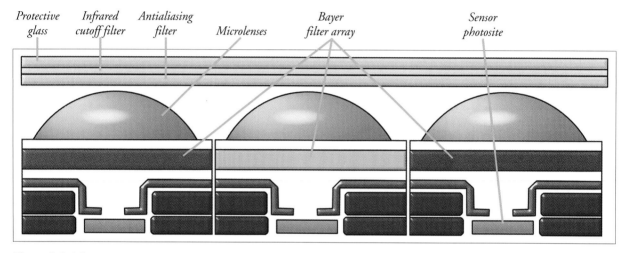

Figure 2.8 The sensor is topped with a Bayer filter array, microlenses to focus incoming light, and top layers that include an antialiasing filter, IR cutoff filter, and protective glass.

The antialiasing filter is necessary because detail in an image that's close to the resolution limits of the sensor can form unwanted patterns, the moiré effect you sometimes get from scanning halftoned photos or produced by unfortunately decorated neckties or shirts on television. When the pattern in the original subject and the pattern inherent in the image capture system (scanner, television camera, or digital sensor) interfere with each other, moiré is the result. The antialiasing filter blurs the image slightly to eliminate the interference, but at the same time eliminates some detail. Camera vendors decide on a compromise between the two image defects and choose an antialiasing filter that is stronger (for less moiré but impaired detail) or weaker (which can allow some moiré interference, with less masking of detail), depending on the design goals for the camera.

Similar decisions have to be made in terms of the strength or weakness of the IR cutoff filter used with a particular sensor. Eliminating too much infrared illumination reduces the effective sensitivity of the sensor, but allowing more IR through to the sensor robs an image of detail and color accuracy (through *infrared contamination*), because the infrared light doesn't form an image in exactly the same way as visible light.

The incoming light that passes through the lens contains a significant amount of invisible, *near-infrared* (NIR) illumination, in the 700–1200 nanometer range. It would also contain light from the other end of the spectrum, the ultraviolet, but the glass used in camera lenses does a pretty good job of filtering out most UV light, and the popular UV filters that photographers like to use to protect their lenses can remove much of the rest.

The IR cutoff filter (also often called an *IR blocking filter* or *hot mirror*) eliminates some or most of the IR illumination. Many kinds of subjects, particularly foliage, reflect a lot more infrared light in proportion to visible light, compared to other objects that nominally have the same visible reflectance. The dyes used in some clothing may reflect IR more heavily, so a blue jacket may actually photograph as purple, or a black fabric as blue if IR light isn't compensated for. Indeed, it's entirely possible for two subjects to *appear* to be the same color to our eyes, but reflect infrared so differently that they seem to be quite different when photographed by cameras with poor IR filtering. That's not an acceptable outcome with more expensive digital cameras, so IR-blocking filters are standard issue. You'll usually find that the more expensive the camera, the better it is at filtering out IR and, consequently, the less well it performs as an infrared camera. (Removing the camera's built-in IR cut-off filter can improve the situation, as you'll see in Chapter 5.)

Fortunately, for those of us with a curious or IR-oriented creative bent, it's not necessary to remove a camera's built-in IR cut-off filter to take infrared photos. These cut-off filters are far from perfect when it comes to removing infrared from the illumination that reaches your sensor. Enough IR remains that you can usually place the reverse kind of filter—one that removes most or all visible light, but *allows* the residual IR to penetrate, so you can take photos using that small amount of IR that manages to run the cutoff filter gauntlet. Of course, this little dribble of IR illumination is only enough for very long exposures (measured in seconds), but, for the intrepid, that can be sufficient.

Why Some Cameras Are Better for IR

Among the infrared community (egad! we've got a community!), some digital cameras are known as being better for IR photography than others. Certain Sony, Olympus, and Nikon point-and-shoot cameras, and some older Canon digital SLR models have been especially prized for their ability to capture infrared illumination. The Sigma SD10 digital SLR (with one of those Foveon sensors) actually has a hot mirror built into its unique removable "dust protector" filter in front of the camera. The filter can be easily taken out by the user and cleaned, or left out entirely if you want to use the camera for infrared photography.

The chief factor that governs how well a particular camera can serve as an IR tool generally is how efficient its IR cutoff filter is. As I noted, inexpensive cameras may have rather weak blocking filters, making them highly sensitive to IR illumination. As you go up the scale towards the pricier models, you'll usually find that the more expensive cameras have much more rigorous IR-blocking filtration. For example, I've found that the Nikon D2Xs camera requires exposures that are at least four times longer than the same vendor's Nikon D80 model, which has a price tag that's 75 percent lower.

I've also discovered that certain cameras and lenses suffer from flare or hot spots, producing uneven IR results. These artifacts may show up as dark or bright spots or areas on the image, or sometimes manifest as overall low contrast. I've had cameras that had dark or light streaks at one side or the other of the frame. Specific lenses can be good or bad for IR, too, depending on how well their anti-reflective coatings work, and whether they contain internal baffles that prevent light from bouncing around inside the lens barrel.

Flare characteristics may vary, with glare appearing in IR shots that wouldn't have been apparent in a straight full-color digital image. (Lens hoods can help alleviate flare problems, both for infrared as well as conventional digital photography.) Some IR photographers report that flare problems they had vanished when they converted their cameras to full-time infrared operation and removed the internal IR blocking filter.

You'll learn more about choosing a camera specifically for IR photography in Chapter 3.

Next Up

Now you understand why infrared photography is possible at all, and how IR is captured with both film and digital cameras. In the next chapter, you're going to start down the road to taking your own IR pictures by selecting a camera for the job, or equipping your current camera for infrared photography.

3

Equipping Yourself

There's a little prep work that you must do before you can begin shooting infrared photos. Some of it involves learning a few techniques, which you're already doing by reading this book. You also need to equip your camera for infrared photography, a process that can be as simple as buying an add-on filter, or a slightly more complicated procedure that involves minor surgery on your camera's innards. I'll explain both pathways to IR photography in the next three chapters.

Fortunately, infrared photography is within the reach of any digital photographer. All you need is a camera that's suitable for IR photography, and an infrared filter that cuts out most or all visible light and allows infrared illumination to pass. The filter can be fitted to the lens of your camera (which allows you to restore the camera to normal visible light operation simply by removing the filter) or placed *inside* the camera over the sensor, which then semi-permanently converts the camera to full-time infrared operation.

In theory, just about any digital camera can be used for infrared photography, because digital sensors are inherently highly sensitive to IR illumination. In practice, some cameras are *much* more suitable than others, primarily because of the effectiveness (or lack thereof) of the IR blocking filters the manufacturers include internally. There are other factors, as well. In this chapter, I'll show you the major considerations for choosing a digital camera for IR photography, and outline some tests you can do to see if the camera you already own is up to the job.

As I'll re-emphasize throughout this book, you don't need a super-sophisticated digital SLR to take good digital infrared photos. A great deal of the information in this chapter and elsewhere applies directly (and sometimes exclusively) to point-and-shoot cameras. In fact, as I'll explain, there are many reasons why a point-and-shoot camera is *better* for some kinds of IR photography than a dSLR. So, no matter what kind of camera you're using, read on.

What Makes a Good IR Camera?

Among IR photography fans, some cameras assumed legendary status because of their splendid performance in the infrared realm. Back around the turn of the millennium, a few cameras, such as the Olympus C2020Z, Epson 850Z, Canon PowerShot Pro70, the Nikon Coolpix 900 series (see Figure 3.1), and Minolta DiMage 7 were coveted for their ability to capture infrared pictures when equipped with a visible-light blocking filter. More recently, cameras like the Nikon D50 and D70s cameras and Fuji S2 have been good IR performers.

Some digital cameras are notable for their relatively poor performance as IR shooters, including the Nikon D200 and Nikon D2x, and Canon 1D Mark III. What is significant about the cameras with the least ability to photograph in the infrared spectrum (although IR photos are certainly possible with any of them) is that they are more expensive cameras. In improving the image quality of their upscale models, vendors are impinging on their cameras' ability to shoot IR photos. It's not

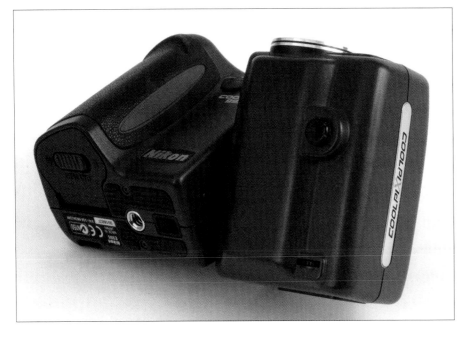

Figure 3.1 Several models of the swivel-hipped Nikon Coolpix 900-series cameras were known for their excellent infrared performance.

done out of spite; IR sensitivity does, in fact, reduce the quality of images taken by visible light.

Fortunately, even expensive digital cameras can take IR pictures; they'll just require exposures that are longer (*much* longer) than their more infrared-friendly counterparts. And, any of them can be converted to full-time IR shooting, if your interest-level is high enough to justify "sacrificing" an expensive camera to infrared photography. However, after reading the next sections, you might find that another, less expensive camera will do the job for you—or that you can pick one up second-hand and dedicate it to infrared use. The most important factors in selecting an IR camera follow:

IR Sensitivity

As I've noted, digital sensors, both CCD and CMOS, are sensitive to IR illumination to a certain degree. But, as you'll recall from Chapter 2, the IR-rich light reflected by suitable subject matter undergoes a lot of filtering before it reaches the sensor, including (with all cameras except those equipped with Foveon sensors) the red-green-blue light-sieves we call the Bayer array. But the major impediment to IR photography is the infrared cutoff filter in the supra-sensor filter sandwich, because it's designed specifically to remove as much IR illumination as the camera manufacturer deems desirable.

The cutoff filter reduces infrared contamination, as I explained in Chapter 2. IR light reduces the quality of images in several ways. Infrared converges at the focal plane at a different point than visible light, so, when your camera's autofocus system sets the focus for visible light, the infrared illumination reflected from the same subject is slightly out-of-focus. (The exact amount will vary depending on the f/stop used; a smaller aperture tends to bring more photons into focus.)

So, when a sensor is heavily sensitive to IR, a slight blurring can be introduced, reducing image quality. Moreover, some types of subjects reflect more infrared light than others of the same nominal color (at least as far as our eyes are concerned). So, high-IR-reflectance subjects may seem lighter in conventional visible light photos if the sensor registers too much infrared. Even worse, colors may change, as in the example of the blue jacket that photographs as purple, or the black shirt that appears blue because the dyes in the cloth reflect higher proportions of infrared light than our eyes can register.

Filtering out IR light reduces infrared contamination, but it also reduces the sensitivity of the digital sensor. There is always a certain amount of light in wavelengths that are right on the border between visible light and infrared; removing them might improve image quality, but also the reduction might not be noticeable. In designing digital cameras, vendors have to decide whether to err on the

side of safety (cutting the response of the sensor to light) or to go ahead and let some IR light pass through to the sensor, even if the image quality is not quite as good.

The best-performing cameras for infrared photography have been those introduced in the early days of digital photography, when vendors had less concern about IR contamination, or more recent less-expensive cameras which were deliberately designed with a higher IR cutoff point by their manufacturers.

There's no infallible way to see whether your camera is better or worse than average in terms of IR sensitivity. However, you can haunt user forums to see what models are favored by serious IR photographers; perform your own testing to compare the length of exposure required by different cameras under identical conditions (this isn't really practical unless you have access to a *lot* of cameras); or search the Internet for reports. One of the best, although it's not comprehensive, can be found at Gisle Hannemyr's site at http://heim.ifi.uio.no/~gisle/photo/ir.html#sensors.

Later in this chapter I'll show you how to test your own camera to see just how IR-sensitive it is.

Is Your Sensor Spotty?

In my own testing of various cameras for their infrared capabilities, I've come across some that, oddly enough, seem to have varying response to infrared *within a single sensor.* For example, one camera exhibits a dark streak down the right side of images that appears regardless of the lens used (see Figure 3.2). Another has glowing patches along the top of the image, similar to "amp noise" that some cameras can suffer from during very long exposures. In all cases, the cameras involved have been expensive models, so I've been chalking up these spotty sensors to vagaries of the IR cutoff filter with, perhaps, some amp noise mixed in (as these cameras also call for relatively long exposures). The phenomenon is different from the hot spots that can be produced by lenses, as discussed below. It also seems to become worse the longer the exposure is.

Here's a technique for determining whether a camera you've already set up for infrared photography suffers from this malady. You'll need to take a few test photos, and then manipulate them to exaggerate the effect (if present) and make it clearly visible.

1. Take a test photo of a typical infrared scene (a landscape works well) using an exposure that you determine to be appropriate for the illumination. The example shown in Figure 3.2 happened to be taken using the default white balance rather than a custom white balance for infrared (which accounts for the red cast). You might have to take several pictures to arrive at a "good" exposure.

2. Shoot several more photos, adjusting the ISO setting to the lowest available sensitivity, and using small f/stops to allow using longer exposures. For example, if your first picture was taken at 1 second at f/5.6, take additional photos at 2, 4, 8, and 16 seconds at f/8, f/11, f/16, and f/22, respectively. (This assumes that your camera is capable of using those settings; most point-and-shoot digital cameras don't have f/stops smaller than f/8.)

3. Load the test images into your image editor.

4. Use your image editor's levels and contrast controls to make each image as contrasty as possible. Photoshop's Auto Levels, Auto Contrast, and Auto Color controls work well, with some additional tweaking with the Brightness/Contrast adjustments.

5. Evaluate the images, looking for streaks, hot spots, and other anomalies that appear in *more or less the same position* in all your test frames. If you find streaks like those in Figure 3.2, you've identified a "spotty" sensor. My solution, when I discover a problem like this with a particular digital camera, is to crop out the affected portion mentally when I compose the image, and for real in the image editor after the picture is taken.

Figure 3.2 The sensor of this digital camera invariably produces discolored areas along the right edge of the frame, as well as other portions of the image

Sensor Size

All other things being equal, larger sensors tend to do a better job with infrared than smaller sensors. For that reason, point-and-shoot cameras with the smallest sensors are not as good as those with larger sensors, which in turn don't perform as well as the (relatively) huge sensors on digital SLRs. Of course, sensor size shouldn't be your primary criterion for selecting an infrared camera; other factors (particularly IR sensitivity) are more important. But you need to be aware of the effect the square millimeterage of your sensor has on your IR photography.

Larger sensors can snare more light during an exposure, including infrared illumination. That's why, as a *general rule*, the most basic point-and-shoot cameras will have ISO settings no higher than about ISO 400, while more advanced cameras have sensitivities up to ISO 800, ISO 1600, or ISO 3200. (You needn't have a dSLR to obtain such lofty sensitivity settings: one recent 7-megapixel Olympus non-dSLR boasts ISO options up to ISO 10,000!) So, larger sensors can equal higher sensitivity to both visible and IR light, assuming that the vendor doesn't filter out most of the IR spectrum with a restrictive cutoff filter.

In addition, larger sensors tend to produce less noise at a given ISO setting. A dSLR with a large APS-C sensor (one with a "crop factor" of 1.5X or 1.6X) might exhibit almost no noise at ISO 400, very little at ISO 800, and remain usable at ISO 1600 and beyond. On the other hand, point-and-shoot cameras with the smallest sensors may have unacceptable noise at ISO 400.

The ability to shoot at higher ISOs and/or with reduced noise levels is important for IR photography because the long exposures needed to overpower a camera's IR cutoff filter often call for use of elevated ISO settings to keep exposures within the realm of practicality. In addition, the nature of IR illumination produces pictures that exhibit some noise even at reduced settings.

Finally, because infrared photos tend to look a little grainy at most noise levels, a larger sensor size will reduce the amount of grain in your image, regardless of ISO setting. You'll find that images that contain lots of details, like the one shown in Figure 3.3, mask the inherent grain and noise of the image, whereas subjects with lots of areas containing a continuous tone (such as skies or walls) will provide opportunities for the grain and noise to be noticeable. In all cases, when it comes to sensor size for IR photography, bigger is better, faster, and more noise-free.

Lens Characteristics

The lens you use can have a significant impact in several ways. First, lens speed (the size of the maximum aperture) can be important, especially if you own a camera that doesn't have interchangeable lenses. In addition, particular lenses are less useful for infrared photography than others, because they may have "hot spots"

Figure 3.3 Detail-filled images tend to mask the appearance of grain and noise in your images.

that produce glare in IR images that is not detectable in pictures taken using visible light. Finally, the lens has to be physically capable of mounting a filter—and that's not always the case. I'm going to explain these one at a time.

Lens Speed

Lens speed is primarily important because of the long exposures most infrared photographs require. A faster lens allows opening up the aperture and effectively reducing the need for a slow shutter speed and lengthy exposure, or a higher ISO setting. A large maximum aperture works to your advantage in several ways.

There are times when you'll want to use the lens's largest f/stop in order to allow a faster shutter speed for creative reasons. Perhaps at smaller f/stops, you find yourself using a shutter speed of one second. Your camera is mounted on a tripod, so the one-second exposure isn't a problem from a camera steadiness standpoint. But assume you're taking photos of a subject with a small amount of movement that you'd like to freeze. It might be a landscape photo you're taking on a slightly windy day, and you discover that at one second the leaves on the trees blur noticeably.

Although this kind of blur (particularly of moving water in streams or waterfalls) can be an interesting effect, if you don't want it, a higher shutter speed is your best option. If your lens has a wider lens opening available, say f/2.8 or faster, you can use that, focus carefully (before you mount the IR filter), and work with a shutter speed of, say, 1/2 or 1/4 second to freeze—at least partially—subject motion. If you're looking to minimize noise, a faster lens can bypass the need to boost ISO settings into the noisy stratosphere. Open up a stop or two and keep your ISO setting at a lower level for higher image quality.

Lens speed is important from an overall quality standpoint, too. Most lenses are their sharpest when stopped down about two f/stops from their maximum aperture. So, an f/2.8 lens will produce its best image quality at f/5.6 or f/8. But a lens with an f/4.5 maximum aperture will require an extra stop and a half to yield its best image, forcing you to use f/9.5 or f/14 (assuming these half-stops are available with your camera) when you don't want to sacrifice sharpness. In infrared photography, that extra stop or two can be very important.

The maximum aperture available is most critical for those using non-SLR cameras with fixed lenses, because the zoom lenses on such cameras tend to be slower. Maximum apertures of f/3.5 to f/4.5 are typical when the lens is set to the wide-angle position, with even slower f/4.5 to f/6.3 maximum apertures when the lens is zoomed to its telephoto setting. Owners of dSLR cameras probably have zoom lenses with similar limitations, but they have the option of removing those lenses and replacing them with fixed focal length (*prime*) lenses that are much faster. Maximum apertures of f/2.8, f/1.8, or even f/1.4 are not uncommon. For some IR picture taking situations when you want faster shutter speeds, better image quality, and lower ISO settings, that extra speed can make a world of difference.

Hot Spots

Nearly all lenses are capable of producing hot spots in images, primarily from glare caused by light bouncing around inside the lens before it makes its way to the sensor. Infrared photography introduces a new wrinkle: the internal baffling designed to tame flare might not effectively absorb IR illumination, *plus* it's been shown that certain types of lens coatings (another characteristic that can help minimize flare) aren't fully transparent to infrared light, and can produce uneven results.

You can sometimes determine whether a lens used with your particular camera holds the potential for problems by doing a little research on the Internet (Gisle Hannemyr's site at http://heim.ifi.uio.no/~gisle/photo/ir.html has some good information). Better yet, you can make sure you're using a proper hood for your lens. A hood will minimize the amount of stray light striking the front of your lens, and, unless your optics are particularly notorious for the effect, help reduce hot spots, like those shown in Figure 3.4.

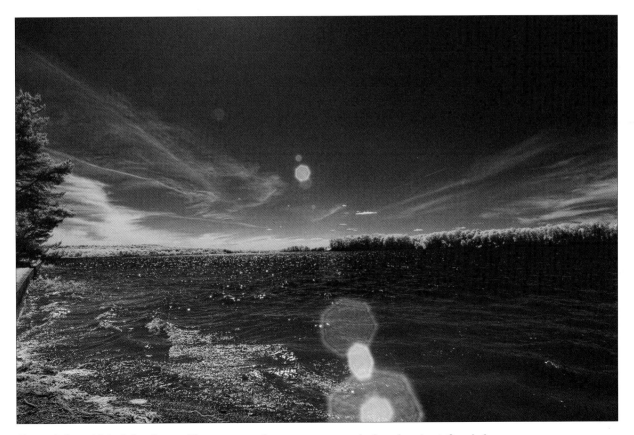

Figure 3.4 You'll find that flare and hot spots may be more pronounced when shooting infrared photos.

Physical Characteristics

Some of the physical characteristics of your lens can affect your infrared photography. First, if you're going to be using an infrared filter, your lens must be able to accept a filter in the first place. Most interchangeable lenses have built-in filter threads, so dSLR owners will have few problems in this area.

But it's not uncommon for the least expensive point-and-shoot digital cameras to lack a filter thread entirely. You may be able to purchase an adapter made specifically for your camera. There are also a variety of third-party filter adapters that can be fastened to the lenses of non-dSLR cameras. The challenge is tricky, because so many digital cameras have lenses that retract fully into the camera body when the camera is turned off or, frequently, when the camera goes into "sleep" mode or is used for lengthy picture review. Similarly, not all digital cameras have a mount that accepts a lens hood, which you might need to reduce flare or hot spots.

Exposure Options

Infrared photography is likely to have some effect on the functions of your camera's autoexposure system. In the best case, with a camera that has been converted to full-time infrared use (see Chapter 5 for instructions), the exposure system will function more or less just as it did before, but may require a small tweak, such as setting an exposure compensation adjustment (say plus or minus 1/2EV) so your exposures are spot on. In the worst case, with a camera using a visible light blocking filter over the lens, the autoexposure system may not function at all. When you block out visible light, you're also blocking the illumination used to measure exposure. In addition, some autoexposure systems require a certain amount of light—say, the equivalent of f/5.6—to function at all.

So, while autoexposure may still work for you, it's more likely you'll need to make at least some adjustments manually, or use manual exposure at any time that you're shooting IR pictures. That's not a problem for digital SLR owners, because all dSLRs have copious manual exposure adjustments. You can take a photo, review the image on your LCD, and add or subtract a little exposure to get the effect you want.

Those who are using non-dSLR cameras may not have the manual exposure adjustment settings needed. Advanced point-and-shoot cameras and those using electronic viewfinders (EVF models) usually have a full array of semi-automatic and manual exposure adjustments, including aperture-priority, shutter-priority, and full manual mode. More basic cameras may have those options, too, but many do not. If you plan to take infrared photographs with a blocking filter over your lens, you'll need a camera that allows you to set the shutter speed and aperture manually.

If you have an inexpensive camera *converted* to full-time IR shooting, however, you just might be able to get by without full exposure control. Once the IR blocking filter inside the camera is removed, the exposure system may work almost normally, and the ability to add or subtract EV might be all you need. That's good news for those who hope to take a cheap, used camera, and convert it to IR. However, if you're going to do the conversion yourself and a special "kit" isn't available for your particular camera, I urge you to check around on the Internet to see what others' experiences have been with that camera after conversion.

Infrared Rendition

This is a somewhat amorphous qualification, and it's difficult to lay down any hard-and-fast rules. Some cameras are known for the pleasing rendition produced when their firmware algorithms process an infrared picture. Most will do a good job of creating infrared black-and-white photos. Others just happen to process the IR pictures so that colors from visible light and infrared realms are combined to produce interesting false-color pictures. Some older Nikon, Olympus, and Minolta cameras are known for this quality. Again, you'll want to search the Internet to see what kind of results others are getting with the camera you contemplate using. You might be able to pick up a used camera for almost nothing that will provide a better IR rendition than the camera you already have. That's particularly true now that the Minolta/Konica Minolta camera organization is no longer with us, and vendors have become more rigorous in designing IR cutoff filters into newer cameras. Older cameras can be a bargain for infrared photography.

Your Camera Options

Given the basic requirements I just outlined, you can begin to assess your options for choosing a camera for infrared photography. Here's a quick rundown of the possibilities you should consider:

"Toy" Digital Cameras

Don't laugh. Photographers in general, and readers of my *Pro Secrets* books in particular, are often tinkerers. I was recently sent a link with instructions on building a digital camera from a flatbed scanner, believe it or not. It's a lot of fun experimenting with non-serious hardware just to see what you can come up with. You'll find lots of "toy" digital cameras available these days, including 3-megapixel $49 (and less) digital models with a little built-in memory and a USB cable for transferring the images to your computer.

Many photographers have "hacked" those $10 single-use digital cameras that you're supposed to take back to your retailer to have prints made. They are available under "house" brand names at many drug store chains. Ritz and Wolf camera stores sell the Dakota brand for about $11 for the basic model, or $19 for a version with an LCD for picture preview. These are the equivalent of a digital pin-hole camera. While I don't explicitly cover converting toy cameras to IR photography, you can get a lot of ideas on what needs to be done in Chapter 5.

Point-and-Shoot Cameras with Filters

Basic point-and-shoot cameras outfitted with an external filter have an advantage over most other cameras *if they include an optical viewfinder.* Such cameras allow you to compose and preview your IR photograph through the optical viewfinder, so you won't be shooting blind. That's not true of point-and-shoot cameras that have no optical viewfinder, and which rely on the back panel LCD for picture preview. Nor is it possible to preview IR images on more advanced non-dSLR cameras that use an electronic viewfinder (EVF) inside the camera. And, of course, you must shoot blind when using advanced digital SLR cameras.

The most difficult thing about using these cameras for infrared photography is figuring out a way to attach an infrared filter when using a camera that doesn't have a filter thread, like those shown in Figure 3.5. You can often purchase add-on adapters or, if you were desperate enough, tape a suitable piece of filter material to the front of the camera, or hold it in front of the lens.

Figure 3.5 The chief challenge in using these point-and-shoot cameras for infrared photography is finding a way to attach a filter.

Advanced Non-dSLRs with Filters

The advantage of more advanced cameras, both point-and-shoot and EVF cameras, is that they are more likely to have the kind of controls needed to fine-tune the exposure of IR pictures. These cameras also have higher ISO settings, better noise reduction, and a longer zoom range with their fixed, non-interchangeable lenses. If you need an 18X zoom (the equivalent of 28mm to 504mm!) you can get it with an advanced non-dSLR camera.

Many of these will include either a filter thread right on the lens or an attachment that accepts filters. Many Canon point-and-shoot cameras, for example, have a removable collar around the lens that can be replaced with an adapter for attaching filters, close-up lenses, telephoto converters, and wide-angle lenses. EVF cameras, like the one shown in Figure 3.6, almost always are compatible with add-on filters.

Figure 3.6 EVF cameras actually have a pair of LCDs; the one on the back panel and a smaller one inside the camera for viewing.

Digital SLR Cameras with Filters

The dSLR is the most flexible and capable of all digital cameras, featuring inter-changeable lenses, high ISO settings with the least amount of electronic noise, fast shutter speeds, as well as the ability to use slow shutter speeds and make very long exposures of up to 30 seconds or more (which is especially useful for digital IR photography). However, the digital SLR's most-liked features: automatic focus, automatic exposure, and precise previewing of the final image, all involve through-the-lens perception that is rendered useless by the visible-light blocking filter needed for infrared photography.

Because exposures will be long, the camera needs to be mounted on a tripod, any-way, so it's possible to compose the image and *then* attach the filter. When using wide-angle lenses, it's also feasible to just point the camera in the general direc-tion you want to shoot, even with the filter already attached, and then fine-tune the composition in your image editor. My guess is that most of the readers of this book will be using a digital SLR with an attached filter, so the techniques I describe in later chapters will offer suggestions for leveraging the dSLR's strengths and min-imizing its weaknesses in IR photography.

Point-and-Shoot and dSLR Cameras You Convert Yourself

As you'll see in Chapter 5, it's quite possible to convert your own camera to full-time IR photography by removing the internal IR blocking filter and replacing it with a visible-light cutoff filter instead. The advantages of going this route are tremendous.

With no filter mounted on the front of the lens, you can preview and compose your image as you normally would, through your camera's optical viewfinder, back panel color LCD, or internal electronic viewfinder. The spontaneity gained is worth the cost and effort of conversion alone. But even more significantly, once the IR blocking filter has been removed, your camera's sensor responds to IR illu-mination almost as robustly as it did to visible light.

You can take photos using exposures that are close to what you would have used for ordinary visible light photography, without the need for a tripod and long, long exposure times. A successfully converted camera can be used normally, and you can take the same kind of pictures you took with its non-converted version, including portraits, sports, and close-up pictures, but in infrared mode only.

Of course, you must expend the time and effort to make the conversion, and your camera will no longer be able to shoot conventional visible light photos. And it is possible to err when making the conversion, which is why doing it yourself often makes the most sense when converting lower-cost cameras, or when the job will

be done by an experienced tinkerer who is used to disassembling and reassembling mechanical and electronic devices. But when it comes to IR photography, conversion will set you free.

Point-and-Shoot and dSLR Cameras Professionally Converted

There are several different companies that will convert selected models to IR photography for $200-$250, with a few charging a bit more for the service. Although the price is higher than the estimated $100 it will cost you to convert a camera yourself, there are several advantages. The conversion services have already determined which cameras are most suitable for IR modification (I list those in Chapter 5), and have accumulated a wealth of experience in doing the work.

I've converted digital cameras myself, and my assessment is that the process is really quite easy *the second time you do it to any particular model.* Experienced hands have learned the shortcuts, learned just how to disconnect and reconnect the little ribbon cables you'll find inside the typical digital camera, like the one shown in Figure 3.7, and know the best ways to do the conversion quickly and cleanly. In addition, these services recalibrate the autofocus system for you, so that focusing is more precise and accurate than you'd be able to achieve yourself. While do-it-yourself IR conversion is practical and not difficult, letting someone else do it for you is a good idea, particularly if you're converting an expensive camera.

Figure 3.7 You can convert a dSLR to infrared shooting, and will need no external IR filter.

Is Your Camera IR Capable?

While the discussion in the previous section can be used to select a camera to be used for digital infrared photography, it's more likely that you'll be shooting IR photos with a camera you already own. In which case, the big question will be: is my camera IR capable? I haven't been able to test every digital camera to see how well it renders IR, of course, but I have found significant differences, even within a particular vendor's product line. So the question is not one to be taken lightly.

For example, Nikon's entry-level digital SLR cameras, such as the Nikon D40, D50, D70s, and D80 filter out much of the infrared illumination, but still let enough through to allow wonderful IR images. I've found that the same vendor's Nikon D2x model, on the other hand, is at least three stops *less* sensitive to infrared than the D70s. Used side-by-side in identical situations and at the same ISO setting with the same IR filter, the D70s can expose IR photos properly under bright daylight at 1/15 second and f/4, while the D2x requires as long as a full second. You might think that with the camera mounted on a tripod in both cases, the difference isn't important. However, when you're photographing subject matter that moves even slightly (with landscape photographs this movement can come from the leaves and branches on trees), the slower shutter speed mandated by a less-sensitive camera can lead to unwanted blur. (If you *want* blur, the limitation becomes an advantage.)

You'll find the same situation with other vendors' models. Canon's high-end cameras, like the Canon EOS D1s Mark II seem almost immune to IR light, while the Digital Rebel XTi does a much better job. Canon's point-and-shoot cameras are even more friendly to infrared illumination. The same is true for cameras from Sony, Pentax, Samsung, Casio, Fuji, Olympus, Panasonic, and Leica; some do a good job, others less so.

This difference in sensitivity can produce some differences in how you take your photos. For example, you might be able to take IR photos with a camera that is highly sensitive to infrared using a monopod at 1/15th second, whereas that full second exposure with a less-sensitive camera would call for a solid tripod. Indeed, I've found more sensitive cameras to be a better choice for IR photography much of the time, because of this sensitivity advantage, compounded by the lower levels of noise it produces at ISO 1600.

Testing for IR Sensitivity

You can easily test to see if your camera is sensitive to IR illumination. All you need to do is photograph a source of infrared light. If you own a television, VCR, DVD player, or sound system, you undoubtedly have an IR source handy: your remote control. Media Center PCs and other computers, MP3 players, microwave ovens, camcorders, or digital SLRs, and dozens of other gadgets can also be operated with an infrared remote control.

The old trick of pointing the remote at your camera and pressing the button works, but isn't ideal. I've developed a slightly more sophisticated technique that makes it even easier to tell whether your camera is adept at capturing IR. Just follow these steps:

1. Mount your camera on a tripod at night or in a room that can be darkened.
2. Using the Manual exposure mode, select an exposure of about 15 seconds with your lens wide open.
3. Darken the room.
4. Start the exposure (use your self-timer if you want).
5. Stand in front of the camera, point the remote control at the lens, and press down and hold a button.
6. Wave the remote control as you point it at the lens.
7. When the exposure is finished, choose a smaller f/stop and repeat Steps 4 to 6. Continue until you've run through five or six ever-smaller stops.

When you evaluate the photos you've taken, if your camera is sensitive to IR illumination you'll see that, because you waved the remote control, the IR source will be shown as a dotted line, as you can see in Figure 3.8. That's because IR remotes don't issue a continuous beam of infrared light but, rather, spurt out data packets in a code that tells the receiving device what command is being delivered. This method works better than simply pointing the remote at the camera and taking a picture because the dotted lines are more distinct than the "glow" that might be spotted on a non-moving remote. That glow is probably overexposed, too, so you really can't tell how sensitive your camera is to IR. Compare the dotted lines from several different exposures and you'll get a good idea whether your sensor easily images IR information or is relatively insensitive.

Figure 3.8 If your camera is sensitive to infrared, the remote's IR will be visible in your photos.

What Now?

If your digital SLR turns out to be not so good for IR photography, you might be tempted to turn to some other measures—some reasonable, some desperate—which are used with mixed success by a few dedicated IR shooters.

One of these steps is to purchase a camera especially for digital infrared photography. One mondo-expensive (think $12,000 plus), 22-megapixel medium format digital SLR features a removable IR filter (the separate filter can be taken out and cleaned, too, reducing the problem of sensor dust). You'd have to be doing a lot of IR photography to experiment with a camera like this (or else need it for super-high-resolution photography work, also).

There was a lot of excitement when Canon introduced the Canon EOS 20Da, which has extended deep-red sensitivity, plus the ability to lock up the mirror, open the shutter, and see a "live" black-and-white preview. Alas, it turns out that this camera, intended for astrophotography, is optimized for hydrogen-alpha light and its IR sensitivity isn't significantly better for terrestrial photography. Unless you're photographing a lot of nebulae, you'll want to pass on this camera, too.

Another alternative is to operate on the camera, removing the built-in IR blocking filter entirely, and replacing it with a filter that passes only infrared light. The ease of this surgery varies from camera to camera and, of course, renders the camera less suitable for ordinary photography. If you own an older dSLR, have the necessary skills, and don't want to use it for non-IR imaging any more, building your own IR-capable camera is a serious option that I cover in detail in Chapter 5.

The final option is to eschew digital SLR shooting altogether, and resort to a non-dSLR camera that happens to have a high sensitivity to IR. Some older Nikon Coolpix 900-series models and a few Canon point-and-shoots are prized for their ability to capture infrared. As a bonus, you won't be shooting blind, as you use the optical viewfinder window of these cameras to compose your photo, or even see a dim preview on the rear-panel LCD.

Obtaining an IR Filter

References to infrared filters can be confusing. You'll see mentions of the IR filter or hot mirror in your camera, which *blocks* IR illumination, as well as to the IR filter placed on your lens, which *passes* infrared, but blocks everything else. It's easy to get the two types of "IR filter" confused. This section deals with the kind of IR filter that lets infrared light pass through to the sensor. This is the type that you'll place in front of your lens or, if you are converting your camera using the instructions in Chapter 5, install in front of the sensor.

MIRRORS HOT AND COLD

As you read more about infrared, you'll find the terms *hot mirror* and *cold mirror* both used. In practice, they have the opposite effects. A hot mirror reflects infrared, but allows the rest of the visible spectrum to pass through. A cold mirror passes infrared, but reflects visible light. The origin of the two terms becomes clearer when you trace them back to their original applications. Hot mirrors have been used to protect systems by reflecting heat away at an angle. They're used for specialized applications such as microscopy. Cold mirrors operate within a wide range of temperatures in systems such as lasers to reflect visible light while transmitting infrared illumination.

The filter you want should block as much as possible of the light below 700 nanometers, while transmitting light in the 700–1200 nanometer range, where infrared illumination resides. Of course, filters that we humans can actually afford to purchase don't block *all* the visible light. In practice, a filter is considered to be effective if it removes at least 50 percent of the illumination at a particular wavelength. The 50 percent point is the commonly used benchmark for cutoff filters of this type. Table 3.1 shows a table of common filters (using the Wratten numbering system developed by Eastman Kodak Company).

You'll find other nomenclatures applied by different filter manufacturers. Hoya and Heliopan, for example, incorporate the cutoff point into the filter name; the Hoya IR83 and Heliopan RG830 have cutoff points at 830 nanometers.

Table 3.1 Light Blocked by Red/Infrared Filters

Filter Number	50% blockage
Wratten #25	600nm
Wratten #29	620nm
Wratten #70	680nm
Wratten #89B	720nm
Wratten #88A	750nm
Wratten #87	800nm
Wratten #87C	850nm
Wratten #87B	940nm
Wratten #87A	1050nm

Unfortunately B+W calls the same filter a B+W093, and there is no exact Wratten equivalent. For the sake of simplicity, I'll use the most popular Wratten filter numbers in the table. You can find the equivalent filters from the leading vendors in charts provided by those vendors; for instance, a Wratten #89B filter is the same as an R72 filter sold by Hoya, or the Cokin A/P007.

The filters with cutoff points below 700 nanometers (the #25, #29, and #70) are really just deep red filters, not particularly useful for digital infrared photography, even though they had some uses with a few types of infrared *film* imaging. The true IR filters start with the very popular #89B/Hoya R72. As the cutoff point moves higher in the spectrum, these filters typically become more expensive, which is why the #89B/Hoya R72 is such a popular filter. At the high end you'll find filters like the #87A, which, at 1050 nanometers, actually cuts off some of the true infrared illumination.

In practice, you'll find that many newer cameras with more rigorous built-in IR cutoff filters, simply won't handle any of the #87-series filters. These are closer to true infrared filters and may not pass enough light for many newer sensors to form an image, even with very long exposures. Unless you know your sensor is highly sensitive to IR (say, it's an older camera like a Canon EOS D30), you're better off sticking to the #89B (Hoya R72) or #88A filters. The #87-series filters are much more expensive, anyway.

To be technically precise, the cutoff point for a given filter does not reside exactly at the wavelength listed. Some filters have a relatively sharp cutoff (although it is actually a narrow gradient), while others have a more gradual transition. This attribute is rarely important for conventional infrared photography, but if you need to know more about a particular filter's transmittance, the manufacturer can supply you with a chart showing the filter's *spectral curve*. Unless you already know what a spectral curve is, you probably don't need to study one.

Your choices for the physical form of the filter are varied, with several options to consider. Here are your main alternatives:

Standard Filter Size

You can purchase many IR filters as glass disks mounted in circular metal frames with threads sized to fit your particular lens. If you need, say, a 67mm IR filter, you simply choose the type of filter you want, and order one in that size and screw it into the threads on the front of your lens when you're ready to shoot. Standard filter sizes are the most popular, but also potentially the most expensive route. There are specific advantages and disadvantages to this approach:

- **Simplicity.** Buying and using a single IR filter is a no-brainer. The size of the filter thread is probably printed or etched on the front of your lens barrel.

- **Cost.** Standard filter sizes are not excessively expensive in moderate diameters. While infrared filters are never cheap, you can frequently get one for considerably less than $100. However, if you need a 77mm filter to fit your fast wide-angle or telephoto lens, expect to pay $150 or more for one of these huge pieces of glass.

- **Non-interchangeability.** Unfortunately, a given filter fits only lenses with the same size thread, so your IR filter may not fit all the lenses you'd like to use it with. My favorite optics are a 105mm macro lens, a 28mm-200mm zoom, and an 18-70mm all-purpose zoom that take 52mm, 62mm, and 67mm filters, respectively. So, I purchase 67mm-threaded filters and mount them on all three lenses using 52mm-67mm and 62mm-67mm adapter rings. Figure 3.9 shows a 67mm filter mounted on a lens with a 49mm filter thread, thanks to nested 49mm-52mm and 52mm-67mm adapters.

Figure 3.9 Step-down rings allow using a 67mm infrared filter on an EVF camera with a 49mm lens filter thread.

Gelatin Filters and Custom Filter Holders

You can purchase many filters, including infrared filters, as 3 × 3-inch gelatin or polyester squares, sometimes mounted between pieces of glass. Just buy the filter you want to use and drop it into a filter holder designed for that purpose on the front of your lens. The factors to consider with this approach are:

- **Simplicity.** Filters of this sort are even easier to use than the screw-in kind. Drop them in and you're ready to go. You can even slide the filter out to restore your view through the finder when you want to compose a new image.

- **Cost.** If you already own a filter holder, such as those provided for the Cokin system, a drop-in infrared filter can be very inexpensive. Of course, if you need to purchase the mounting system, you'll have an initial outlay of $30 or so for the holder. Real tightwads can tape filters to the front of their lenses, too.

- **Interchangeability.** You can buy adapters for filter mounting systems for many different thread sizes, so you might be able to use the same IR filter on several different lenses in your collection.

- **Extra stuff hanging on your lens.** One reason I prefer the standard-filter-size option over filter holders is that the latter are a little klutzy and require fastening a bunch of extra stuff to the front of your lens. Of course, infrared photography is often slow-moving contemplative work involving non-mobile subjects such as landscapes, so all this paraphernalia may not be a concern for you.

Make Your Own Filter

It's entirely possible to make your own IR filter using the technique I'll describe next. Rolling your own will cost you a little time, but can be more satisfying for those who like to work with their hands, and far less expensive than either of the two filter purchase options outlined above.

Make Your Own IR Filter

You can build your own infrared filter. All you need is filter material, which can be purchased at low cost or even obtained for free, and some sort of a convenient holder. This section will show you how to put together your own IR filter inexpensively. I'll show you what you need to get started.

Filter Material

You have two rather unconventional choices for materials that can be used to make cheap infrared filters. One of them is a special kind of lighting gel used to color stage lighting, and the second is nothing more than good-old-fashioned photographic film.

To use a lighting gel as an infrared filter, you'll need to get a sheet of Rosco Roscolux Congo Blue #382 filter material (the Lee equivalent is #181). It's available in 20 × 24-inch sheets for about $6 from B&H Photo Video in New York (http://www.bhphotovideo.com). You'll need to stack about six layers of this material to filter out most of the visible light, leaving only the infrared wavelengths above 720nm. You should be aware that this material is flimsy and easily scratched, and isn't of optical quality, so your image will be degraded somewhat. But it's really cheap, and perfect for experimentation. You may find after using this do-it-yourself IR filter that you are willing to invest in a good glass filter that will yield better results.

Another cheap filter alternative, assuming you know someone who is shooting Ektachrome photographic film, is to use ordinary *unexposed,* processed Kodak Ektachrome E-6 transparency film. It makes a fine infrared filter. If you're a veteran of the days when film was used for photography, you might have used Ektachrome film in your 35mm SLR.

But 35mm film isn't large enough to cover the front of your lens. What you really need are 4 × 5-inch sheets of this film, as used by professional photographers. If you have a pro friend, you might be able to wangle a couple of unexposed sheets that have been processed (unprocessed film won't work). Studies by photo tech wizard Andrew Davidhazy, the famed professor of imaging and photographic technology at the Rochester Institute of Technology, report that one thickness of E6 film is roughly equivalent to a #87 filter, while two thicknesses become visually opaque and provide approximately the equivalent of a #88 filter in terms of light transmission. Your E6 film "filter" can be cut down (see Figure 3.10) and placed in front of your lens using a filter holder like the one described next. You'll lose some sharpness, of course, but these cheap filters can be interesting for experimentation.

If you want to experiment with IR photos taken in dim light by electronic flash, there's another alternative. You can use the Ektachrome film as a visible light blocking filter placed over your electronic flash unit. If the light is dim enough, the IR-filtered flash unit will provide the predominant illumination. You can also use multiple flash units to provide higher levels of artificial IR illumination. Plus, as Professor Davidhazy points out, E6 filters on flash don't melt or buckle as easily as gelatin filters like the Roscolux Congo Blue in the same application.

If you don't want to work with E6 film filters, you can purchase Wratten gelatin filters in sizes such as 3 × 3 or 4 × 4 inches from your retailer. It's unlikely that a local store will have these specialized items in stock, so you may have to special-order them, or purchase from a mail order firm. They're not as cheap as you might expect for a little square of filter material; a #89A filter costs about $55 in the 3 × 3-inch size, and $85 as a 4 × 4-inch square. On the other hand, the equivalent filter in a standard screw-in 77mm size can cost as much as $175. A 4 × 4-inch gelatin filter is 100mm on a side, so you might be able to create more than one filter from one of them.

Figure 3.10 Cut disks of IR filter material out of unexposed, processed Ektachrome sheet film.

Filter Mount

Once you've got your filter material, you'll need to attach it to your lens. If your lens has a filter thread, the most convenient way to attach a homemade filter to a lens is with a screw-on mount. In building your own IR filter, you can call on photographic history as an aid and use Series-type screw-in filter holders. This kind of filter holder dates back from before filters in standard screw-in sizes were available and can come in very handy.

You see, in ancient times, lenses didn't have common systems for mounting filters up front. Some lenses had threads, others used bayonet mounts. Some required push-on mounts to hold accessories. The solution was the Series system, which used standard filter *sizes* and holders tailored to each type of lens. You can still buy Series adapters and filters today, and they're easily found in the used/junk bins of most camera stores because they have been largely supplanted by standard filter sizes.

The Series system works like this: The filter mount comes in two pieces, shown in Figure 3.11. One piece attaches to your lens, using either a screw-in thread that matches your lens' filter thread size or by a bayonet or push-on mount suitable for your particular lens. Several different size ranges are available, called Series VI, VII, VIII, or IX (or, today, 6, 7, 8, or 9), with each Series size suitable for a range of lens diameters. There can be a little overlap; for example, a Series VII ring might fit lenses in the 46mm-67mm range, with Series VIII fitting lenses with 62mm to 77mm diameters. A standard size (for that Series) retaining ring screws into the inner ring, with enough space between the two for a Series-sized filter.

The Series system is remarkably flexible. You'd buy an inner ring, say a Series VII size, for each of your lens sizes. You might have inner rings in 52mm, 62mm, and 67mm sizes to fit three or more different lenses. Then, you'd buy (or make) filters in Series VII size. You could drop any Series VII size filter into any of the

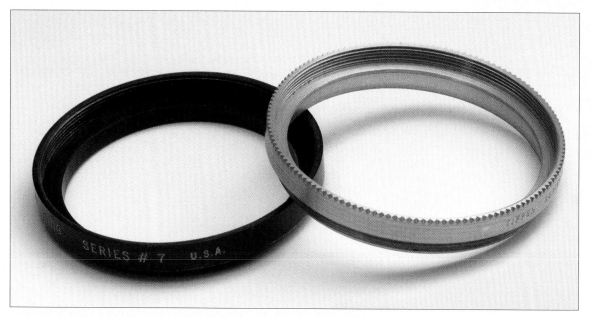

Figure 3.11 A Series adapter consists of two parts, and the filter fits between them.

three inner rings (including your homemade IR filter), then seal the sandwich with an outer Series VII retaining ring (the silver-colored ring in the figure). Thus, one set of filters could be used with multiple lenses. Other accessories, such as lens adapters, can also be screwed into Series adapters.

What you want to find is a set of Series rings that fit one or more of your lenses (your camera store may have them for a couple dollars in their "junk" box) and an old, scratched Series filter of the same size.

Once you've got all the pieces together, it's time to make your IR filter. Just follow these steps:

1. The junk filter will have a rim made of aluminum or some other metal surrounding the glass filter. Take a jeweler's saw, Dremel tool, or other utensil and score the rim vertically in two places on opposite sides so you can carefully split the rim into two pieces.

2. Remove the original glass from the filter and set the rim pieces aside.

3. Use the original glass as a template to cut a circular piece of your gelatin IR filter of the exact same size.

4. Carefully reassemble the two rim pieces with your round gelatin filter in the slot that formerly held the glass filter.

5. Use cyanoacrylic ("super") glue or Epoxy to bond the two rim pieces together. Hold tightly until the bond forms. You might want to wait 24 hours before handling the new filter, depending on the instructions provided with your glue.

6. Fasten the inner ring of your Series adapter to your lens.

7. Drop in the IR filter you just made.

8. Attach the retaining ring. That's all there is to it.

Next Up

There's more to taking infrared photos than choosing a camera and equipping it with an infrared filter. You'll find other gear and accessories useful for making your IR photography fun and effective. In Chapter 4, I'm going to show you exactly what you need to improve the quality of your infrared experience.

4

Accessories After the Fact

Photographic gadgets are part and parcel of taking serious photos, and infrared photography is no exception. The first photographers were a mixture of artisan, artist, and inventor, and frequently had to make their own equipment or even coat their own photographic materials with photosensitive substances of their own devising (one of the earliest photographs was captured using a kind of asphalt coated on pewter).

Today, there are thousands of different accessories available for cameras, ranging from lens hoods and filters to remote control devices, satellite positioning add-ons that embed the exact location of the camera when the picture was taken into the image file, and wireless thingamabobs that transmit each photo as it is snapped over the ether to an external laptop. And, even if a particular gadget isn't available for your camera, you might be able to make it yourself, which is how many commercial products got their start—from do-it-yourselfers.

This chapter explains some accessories available that can be particularly useful for infrared photography. Few of them are items that can be used *only* for IR photography, and it's likely that you probably own many of them. If not, then perhaps this chapter will prompt you to go out and buy (or make) a particularly helpful gadget.

The gadgets you see here by no means exhaust all the possibilities. If you use your imagination, you'll come up with ideas that I haven't even tried yet. For example, if you drill a hole in the center of a dSLR body cap, cover it with a piece of metal that's been pierced with a pinhole and layered with infrared filter material (as

described in Chapter 3), you've got a pinhole infrared camera. Or do you? (This might actually work a lot better with a camera that's been converted to IR, as you wouldn't need the filter over the pinhole.) I've never tried this, but plan to, some-day. I know the exposures would be horrendously long (many minutes with an unconverted camera and several seconds with an IR converted camera, minimum) but the results could be interesting.

If you approach infrared photography with the same can-do spirit, you'll find your creative options are wider than you thought possible.

An Auxiliary Viewfinder

Holding the camera steady for long exposures when taking infrared photographs with a visible-light blocking filter on your lens won't be your biggest problem. As I've mentioned several times before, with several types of cameras you'll be shoot-ing blind. In this section, I'm going to offer some tips for remedying that situa-tion, including the use of an auxiliary viewfinder.

Because the filter is basically opaque to visible light, you won't be able to see any-thing prior to taking the exposure if you're shooting with one of these types of cameras (the image shows up fine on the LCD after the picture is taken):

- **Point-and-shoot cameras with no optical viewfinder.** There is an alarming (to me) trend among manufacturers of point-and-shoot digital cameras to eschew an optical viewfinder entirely, relying on the back-panel color LCDs that have grown to 2.5 to 3.0 inches in size (and larger). Consumers seem to prefer holding their cameras out at arms' length to compose and view pho-tos, and the larger the LCD screen, the less room there is for a conventional optical viewfinder. Unfortunately, there are no LCDs that are easy to view in either direct sunlight or when inspecting dim images. When shooting IR pho-tos, you can encounter both situations simultaneously. But even if you're shooting in subdued lighting, you'll still find it difficult to compose an image on an LCD.

- **Electronic viewfinder (EVF) cameras.** This type of camera has *two* LCDs, one on the back and one mounted internally that's seen through a viewfinder window (see Figure 4.1). The internal LCD solves the problem of viewing conventional scenes in bright sunlight, and electronic amplification ("gain") boosts dim images so they are more easily seen as well. However, it's rarely possible to see an image that's been IR filtered either through the viewfinder or on the back-panel LCD, unless the camera is specifically designed for it, such as Fujifilm's FinePix IS-1 infrared-friendly model (see Chapter 5 for more information on this innovative camera).

■ **Unconverted digital SLR cameras.** In terms of seeing what you're doing, a digital SLR with an IR filter mounted is undoubtedly the worst type of camera for attempting to preview an image before snapping the shutter. You'll usually see nothing at all when peering through the viewfinder (except for your camera's status display). It's usually possible to make out an image on the back LCD after the picture is taken (particularly if you've adjusted the white balance correctly for IR, as discussed in Chapter 6), but, by then it's too late. If your dSLR has been converted for IR use, your viewfinder looks exactly the same as it did before, which is one of the reasons why IR conversion has become more popular.

There are several things you can do to improve your ability to preview and compose your IR images with one of these cameras. For example, if you're shooting from a sturdy tripod, you can focus and compose your images without the IR filter, then attach the filter just before you're ready to shoot. (This is easier to do if you're working with Cokin-style filter mounting systems and slide-in filters.)

Obtaining a Ready-Made Viewfinder

Another solution is to use an auxiliary viewfinder. These are small optical devices that slip into the accessory shoe (or flash shoe) on top of the camera (see Figure 4.2) and provide a miniature

Figure 4.1 You'll find it difficult to preview or review an IR image on a back-panel LCD.

Figure 4.2 An accessory shoe on top of the camera can be used to mount an add-on viewfinder.

viewing system with an optical image and a set of lines (called *framelines*) around the actual image area, as shown in Figure 4.3. The view is similar to what you get with an optical viewfinder in many digital cameras today.

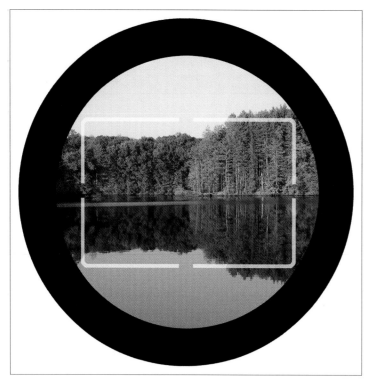

Figure 4.3 Some accessory viewfinders have brightline frames that show the image area.

If your interest in photography predates digital photography, you might know that accessory viewfinders are useful items for *rangefinder* cameras. The RF camera is a non-SLR camera (think Leica!) that uses an optical viewfinder as its only means of composing an image. Rangefinder cameras might have only a single set of brightlines showing the field of view for a single lens, but it was more common for such cameras to include several different framelines that became visible or invisible, depending on which lens you were using. For example, my old Leica M4 had brightline frames for 35mm, 50mm, 90mm, and 135mm lenses built right into the camera.

Auxiliary viewfinders were used for lenses that didn't have appropriate frames in the camera's own optical viewing system and/or for lenses which were impractical to accommodate. For example, a telephoto lens longer than 135mm would require a very tiny frame in the viewfinder, while a 28mm lens needed a view that was wider than could be shown. These add-on viewfinders were available for single lens focal lengths, such as 28mm or 21mm, as well as in more sophisticated

versions with switchable brightline frames similar to those found in the cameras themselves. Viewfinders of this type are still readily available, and you might want to consider one for your IR shooting. Later in this chapter, I'll show you how to make one for a few dollars.

When considering a ready-made accessory finder, there are several things to keep in mind:

- **Accessory shoe required.** If you want to mount an add-on viewfinder on top of your camera, your camera must have an accessory shoe. That won't be a problem with digital SLRs, nor with most advanced cameras (such as EVF models). Accessory shoes are standard, although some models use a non-standard mount. Minolta/Konica Minolta EVF and dSLR cameras and Sony dSLRs are particularly guilty of this; adapters to convert to standard shoe mount are available. The accessory shoe of digital cameras is of the "hot shoe" variety with electrical contacts. If your accessory finder has an all-metal foot, you may have to cover it with tape to avoid shorting out the electrical contacts. You probably won't find an accessory shoe on most point-and-shoot cameras that lack an optical viewfinder, but Velcro mounting is still a possibility.

- **Expense.** Many older viewfinders are collector's items, and command high prices. You can pay $150 or more for one in mint condition. You also may be able to find one in your camera store's junk drawer for a few dollars.

- **No Zoom.** These viewfinders are for fixed focal lengths only, even if they offer framelines for several different focal lengths. So, if the VF is set for 28mm, you can *only* use it to preview images you plan to capture at 28mm (or the equivalent; see below). These viewfinders won't show you the field of view for in-between zoom settings; however, I find they still can be used for centering and roughly composing an image. If I have a viewfinder that provides the approximate view of a 28mm lens (equivalent), the image is still centered properly if I decide to zoom in to 30mm or 35mm, or out to 24mm or 20mm.

- **Field of view translation.** If you're using a digital SLR, you'll need to take your camera's crop factor into account. That is, if your camera has a 1.5X crop factor (because its sensor size is smaller than the full 24×36mm frame that dSLR lenses were originally designed for), and you want to use a viewfinder with the equivalent of a 28mm field of view, you'll need to set your zoom lens to roughly 18mm. This calculation is generally *not* required for viewfinders used with point-and-shoot cameras; vendors usually convert the focal lengths of their lenses into equivalent focal lengths for you. So, if you're using a point-and-shoot camera at a marked 28mm, that's the FOV you actually get, regardless of the actual focal length of the lens.

- **Field of view accuracy.** Because you're using the add-on viewfinder to frame your IR shots more precisely, you'll need to make sure the view shown through the auxiliary finder does reflect the boundaries of your image. That's usually easy to do: take a few shots, lining up the framelines in the viewfinder with lines in your subject and compare your compositions to what you actually get. Take photos of a grid-like object at a distance, if necessary.

- **Beware of parallax.** If you do the test recommended above using a subject that's closer to the camera than two or three feet, you'll notice that the image you get will *not* be closely aligned with what you saw through the viewfinder. That's called parallax error, and while sophisticated rangefinder cameras are coupled with the focusing mechanism so they can automatically adjust for the difference in views between the lens and the viewfinder at close distances, you won't get that benefit from an add-on viewfinder. Learn to compensate when shooting at closer distances. For example, if the viewfinder is right above the lens, then understand that some of the top of the frame that you see will not appear in the finished image.

If you're serious about IR photography with a camera requiring an auxiliary viewfinder, you can shop online for one at CameraQuest, which is the absolute authority on camera viewfinders. You can find what you need at http://cameraquest.com/voigtacc.htm. If you want to create your own viewfinder on a budget, read on.

Making Your Own Viewfinder

You can easily make your own accessory viewfinder. It won't be as good as one of those jewel-like auxiliary units created for rangefinder cameras, but it will allow you to view and to find, which, after all, is what a viewfinder is all about.

Of course, you could make a simple target frame out of a piece of cardboard and attach it to the top of your camera, but that's not a lot of fun. I think my solution is better. Keep in mind that several of the provisos I listed previously for manufactured viewfinders also apply to the do-it-yourself variety: you'll need an accessory shoe on your camera, your homemade viewer won't zoom, and you'll have to take into account field of view and parallax effects when lining up your shots.

However, this project is easy. All you need is a scrap accessory shoe foot (you can probably find one in your camera dealer's junk drawer for a couple dollars) and an optical viewfinder scavenged from a single-use camera (what we used to call disposable cameras back when "disposal" wasn't an environmental no-no). Today, these cameras, such as the Kodak and Fujifilm models shown in Figure 4.4, are almost completely recycled after the film inside them is exposed, processed, and printed. We're going to recycle the cameras in a slightly different way. (You're free to drop off the remaining pieces at your photofinisher so the rest of the camera can be recycled, too, if you like.)

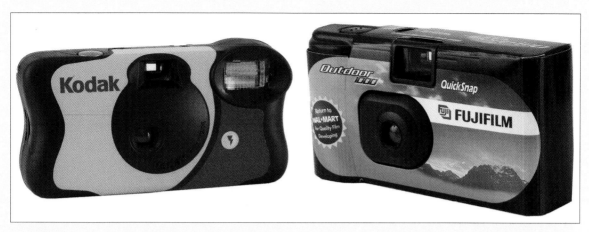

Figure 4.4 Kodak and Fujifilm both make inexpensive single-use cameras with viewfinders that can be recycled.

Either camera will cost you just a few dollars; I paid $2.48 for the Fujifilm camera, and about $1.50 more for the Kodak model, which contained a built-in electronic flash. (I must admit I was a little amazed to open up the Kodak camera and find a well-designed circuit board with electronic flash attached, and a AA alkaline battery, along with an ordinary 35mm film canister for less than what I used to pay for a roll of film alone!)

If you're looking for a quick-and-dirty solution, I recommend using a Kodak camera, because the viewfinder is all in one piece. The Fujifilm camera's viewfinder comes in two pieces, and lends itself to a more finished and customized viewfinder if you're so inclined, and handy with tools. Just follow these directions.

1. **Remove the labels or outer covering of the camera.** You can peel or tear off the paper containing the logo, instructions, and other printed material.

2. **Open the camera.** On the top, bottom, and sides of the Kodak camera you'll find a quartet of interlocking plastic fingers that can be pried apart to separate the two halves of the camera. You'll find similarly obvious places to insert a small screwdriver to snap open the Fujifilm camera, too.

3. **Remove the viewfinder optics.** The front window of the Fujifilm viewfinder slides right out. You'll need to do a little work to extricate the rear window. Both are shown in Figure 4.5. The Kodak viewfinder snaps out as a single plastic piece, as you can see in Figure 4.6.

4. **If you're using the Kodak camera.** All you need to do to create a workable viewfinder is to trim some of the excess plastic and glue the viewfinder assembly to the top of a slide-in accessory shoe foot.

5. **If you're working with the Fujifilm camera.** You can mount the front and rear optical elements at the correct distance apart on a support of your own making, and even place the whole contraption inside an enclosure you design for a more finished look and increased ruggedness.

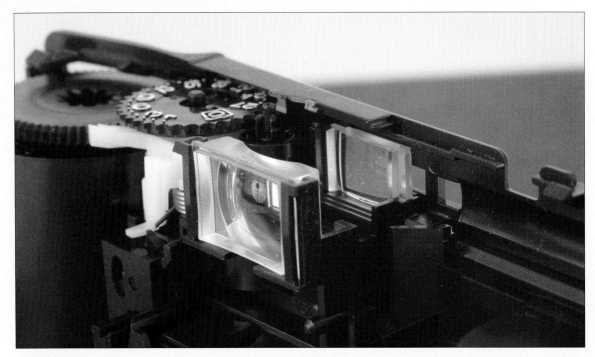

Figure 4.5 The Fujifilm viewfinder comes in two pieces, which can be removed and mounted separately.

Figure 4.6 The Kodak viewfinder can be extracted as a single piece.

6. **Mount on accessory shoe foot.** You can use a tiltable accessory shoe, as shown in Figure 4.7, which allows aiming the viewfinder before mounting the IR filter. If you're shooting close-ups, you can even match the add-on viewfinder's perspective with your camera's view. Or, you can find a simple foot that holds in place through friction (some have a leaf spring that provides some extra pressure, as opposed to one that uses a tightening thumb wheel to lock the shoe in place, as shown in Figure 4.8). If you have a point-and-shoot camera that lacks an accessory shoe, you could also use Velcro attached to the Kodak viewfinder with a matching piece on the top panel of the camera itself.

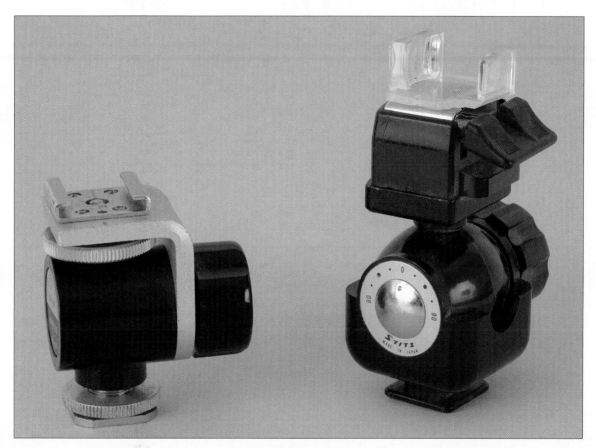

Figure 4.7 An accessory shoe that tilts makes it easier to aim your add-on viewfinder.

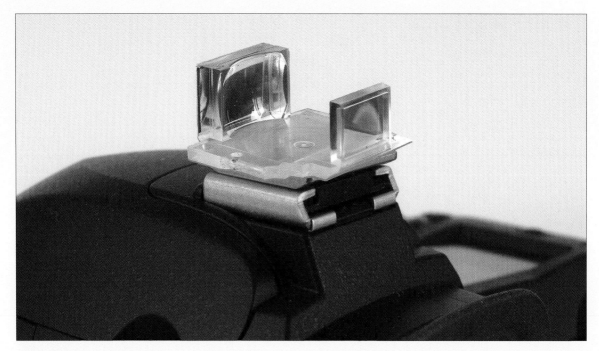

Figure 4.8 Fasten the viewfinder to an accessory shoe foot and slide into the mount on your camera.

Filters

Filters—the kind you mount onto the front of your camera's lens, not the special effects you apply in an image editor—give you a host of different capabilities that you can't manage with your unadorned camera. And, even though some image editor filters were designed specifically to mimic the looks possible with lens filters, there are many effects that you can't achieve without the real thing. Polarizing, neutral density, starburst, and split density filters all can produce images in the camera that you can't easily duplicate in Photoshop.

However, even if you're familiar with the use of filters on your lens, you'll still want to read this section. When you're working with infrared, certain filters have some special requirements and effects that you should be aware of. There is a lot more to filters and infrared than infrared filters.

As you learned in Chapter 3, filters can be glass discs, colored gels, or polyester/gel sandwiches that can be screwed onto the front of your lens, mounted in a holder in front of your lens, or simply taped or held in place for temporary duty. Certain kinds of lenses, such as very long telephoto optics with huge front elements, or very wide-angle lenses with large curved front surfaces, use built-in or drop-in filters at the rear of the lens.

I happen to own a fish-eye lens with red, orange, and yellow filters that can be dialed in as required—but none of them would have any effect on an infrared photo. That's because of an important difference between infrared and conventional photography: because *visible light is largely removed* by the infrared filter, other wavelengths of light affected by add-on filters may not even be present. So, if you're using an IR filter on your lens or have an IR-converted camera, the yellow, green, orange, or red filters sometimes used to produce special effects in black-and-white photography behave as if they weren't there at all. There's no yellow, green, or orange colors to remove at all, and, usually, precious little red. You'll find that most haze or UV filters, warming filters, cooling filters, and gradated color filters (say, amber on one half and blue on the other half) are rendered invisible for IR photography. Forget about them; they'll do nothing for your pictures except increase your chances of flare and, maybe, a slight reduction in image quality.

A little common sense should tell you that certain filters shouldn't be particularly helpful. For example, given the very long exposures that are needed with an unconverted camera, you'd probably think that a neutral density filter would be a foolish addition. Or that, because IR photography already darkens the sky and increases contrast, you probably wouldn't ever need a polarizing filter. However, you may be surprised to learn that these and other filters can still be quite useful. I'm going to describe some filter options in this section and, a little later, show you how you can make your own.

Polarized IR

Scientists have a very accurate, but fairly incomprehensible way of describing the way light moves: light waves oscillate in multiple directions, perpendicular to the axis of propagation. That's a mind-numbing way of saying that light headed towards your camera lens is vibrating in waves that go up and down, side to side, and all the angles in between. That is, unless it is altered on the way to the lens.

For example, light reflected by transparent, shiny objects can be fully or partially polarized; instead of vibrating in all planes perpendicular to the incoming light wave, the light vibrates in only one or a few directions. The same thing can happen to light in the skies: it's scattered and partially polarized. A special kind of filter can take advantage of this polarization by removing all the light waves except for those along one axis, using what you can think of as "slats" running in one direction (like window blinds) so that the light received by the lens vibrates only in one direction, rather than haphazardly. Figure 4.9 provides a rough representation of how a polarizing filter works. In this simplified example, think of the purple light waves as vibrating vertically, and the red-colored light waves as vibrating in a horizontal plane. The slats in the polarizing filter block the up-and-down waves, and allow those vibrating horizontally to pass.

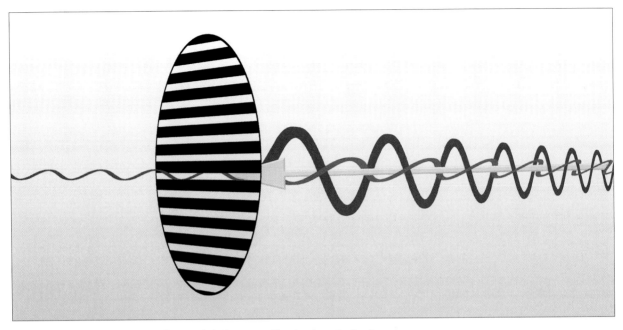

Figure 4.9 A polarizing filter allows only light waves vibrating in a single plane to pass.

A polarizing filter, like the one shown in Figure 4.10, lets you take advantage of this effect to block unpolarized light, reducing glare from reflections, and, potentially, darkening the sky. As it turns out, polarizing filters work just fine with infrared light, and can be used to create some interesting effects. Of course, the sky-darkening effect, while present, may not be as important as with conventional photography, because IR pictures tend to show dramatic dark sky effects already. But the reflection-reducing capabilities can come in handy.

Figure 4.10 A polarizing filter must be rotated to achieve the proper alignment.

Figure 4.11 shows two different views of the same scene taken from slightly different vantage points on the same afternoon. At top is a straight infrared photo with no polarization, and reflections are clearly visible in the water of the inlet. At the bottom is an image taken from a little farther away, using a polarizing filter, which removed the reflections in the water and provided a starker, more foreboding look. You might prefer a straight shot, or like the look of the polarized image.

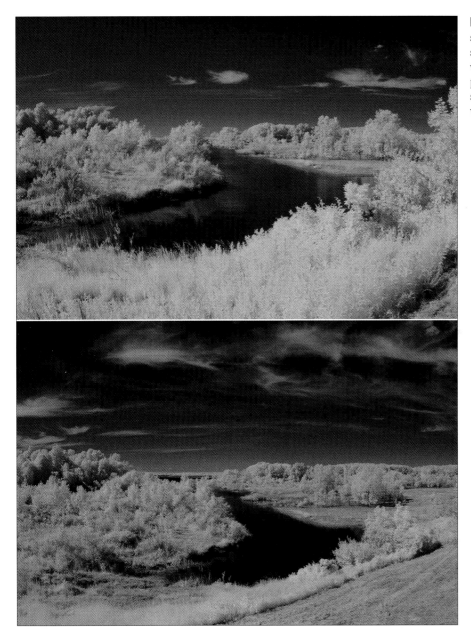

Figure 4.11 The straight IR shot without polarization has skies that are slightly less dark, while the version using the polarizing filter has darker skies and less reflections in the water.

Polarizing filters are best used with converted IR cameras, because the filter must be rotated and the effect evaluated through the viewfinder to achieve the full benefit of polarization. If you're using a camera with both IR filters and polarizing filters mounted up front, you'll need to mount the camera on a tripod, adjust the amount of polarization first, note the degree of rotation (mark it on the filter with a grease pencil if you must), and then add the infrared filter. If the polarizer rotates when the IR filter is added, readjust to the mark you made. Note that not all polarizers have filter threads on their front edges, so it may not be possible to add an IR filter. Indeed, it might be easier to use a lens-mounted polarizing filter in conjunction with a Cokin-style filter adapter in front of that for the IR filter. I personally reserve the polarizer technique for cameras that have been converted to full-time IR use; it's a lot less of a hassle.

When using polarizers, remember that the effect is strongest when the camera is pointed 90 degrees away from the light source (the light is to your immediate right or left), and provides the least effect when the camera is directed 180 degrees from the light source (behind you). Also keep in mind that very wide-angle lenses may produce uneven polarizing effects. For example, an 18mm lens (equivalent to that focal length on a full-frame camera) has a field of view of about 90 degrees, so it's entirely possible for subjects at one side of the frame to be oriented exactly perpendicular to the light source, while subjects at the opposite side of the frame will face the light source at a 0-degree angle. You'd end up with maximum polarization at one side of your image, and greatly reduced polarization at the opposite side.

Neutral Density Filters

Neutral density (ND) filters have limited utility with cameras that haven't been converted for IR photography, as the infrared filter you must use provides plenty of density on its own. The chief application of a standard ND filter is to reduce the amount of light passing through the lens so that longer shutter speeds and/or larger f/stops can be used to achieve particular effects.

For example, in a conventional photograph, instead of shooting at 1/800th second at f/5.6, you could use an ND4 (two-f/stop) ND filter to take the same picture at 1/800th second at f/2.8, or an ND8 (three-f/stop) ND filter to expose at 1/800th second at f/2 when you wanted greatly reduced depth-of-field for selective focus effects. ND filters are particularly handy in those situations for cameras that don't have shutter speeds higher than, say, 1/800th or 1/1000th second. (You could use 1/2000th or 1/4000th second, for example, instead of an ND filter with a camera that has those speeds available.)

You'll find that an infrared filter already provides you with at least the equivalent of an ND8 ND filter, so you won't need one with an unconverted camera, unless you're looking for *very* long exposures, on the order of 30 seconds to several minutes in full daylight. However, neutral density filters are just as useful for IR-converted cameras as they are for conventional photography. A camera that's been converted to IR photography uses exposures that are roughly the same as they were for visible light pictures, so an ND filter can be put to work to cut back light levels in situations where you want exceptionally long exposures or very wide apertures that might not be attainable otherwise.

For example, ND filters can produce several-second exposures of waterfalls, streams, and other examples of moving water, producing an interesting spun-glass effect from the moving water. The ND filter blocks several f/stops' worth of light or more, making a slower shutter speed possible and increasing the blur of the moving water. You can use ND filters to operate at a wider aperture to blur the background in portraits, too.

ND filters and IR work for people pictures, too. Sometimes a photographer wants to photograph a street scene without cars driving through the photo. By stacking neutral density filters (or using ND filters in conjunction with an IR filter on an unconverted camera), it's possible to create such a long exposure (say, 30 seconds or so) that no cars are in the scene long enough to register in the image. Obviously, a tripod is required.

A special kind of neutral density filter is a "split" ND filter. This filter provides half neutral density and half clear filtration, preferably with a graduated transition from the light-blocking half to the clear half. The main use for a split ND filter is for occasions when half the scene is brighter than the other. The most common example of this is a bright sky against a significantly darker foreground. This condition is typical of midday lighting conditions.

You can use a split ND filter in IR photography, as in the example shown in Figure 4.12. You must rotate the filter and frame the image so the ND half affects the portion of the image you want to reduce in brightness (in this case the sky). For this particular image, I also performed the red/blue channel-swapping trick explained in Chapter 12, because I knew that it would produce a blue sky that would contrast against the light brick-colored foreground without the need for additional filtration.

Figure 4.12 A split-density filter darkened the sky, which was converted to an ominous blue shade using channel swapping.

Other Filters

Many other filters that don't involve removing or altering color can be used successfully for infrared photography. These include star filters, which take pinpoints of light in an image and transform them into miniature starbursts (see the monochrome shot that's been green-tinted in Figure 4.13). Diffusion filters, which provide a blurring effect within the entire image, or only at the edges, can be used for a romantic effect in portraits, especially when combined with the dreamy milky-white skin quality you get from infrared photography. Close-up lenses, which aren't actually filters at all, can allow you to focus more closely and use infrared photography for macro effects.

As with all lens add-ons, these work best and most easily with a converted camera that allows you to preview their effect, but they can be used successfully with cameras that have an IR filter placed over the lens. You can often evaluate the effect first (with the camera mounted on a tripod to preserve the framing and composition) and then add the IR filter.

Figure 4.13 Star filters convert pinpoints of light into starbursts.

Making Your Own Filters

If you review the instructions for making your own IR filter in Chapter 3, you'll see that you can easily apply the technique to creating other types of filters. Any piece of transparent material that can be fitted to a Series adapter ring can become a filter. You can also take existing "neutral" filters, such as UV or skylight filters, and modify them to produce other filtering effects.

A helpful device I especially like, and have already mentioned several times, is a filter holder by the Cokin company (http://www.cokin.com) and sold by most camera outlets. One Cokin holder, designed for cameras that can't accept filters, mounts to the base of the camera via the tripod socket. This adapter allows the use of Cokin's square filters, which slide right into the adapter to provide a variety of effects and corrections.

Filters that are easy to create, and which can be used successfully for IR photography, include the following:

- **Star filters.** Take a piece of window screening, cut it into a circular shape so it fits inside a Series adapter ring (as described in Chapter 3). Use several pieces, each rotated at a different angle, to produce multi-point bursts.

- **Light diffusion filters.** Use a piece of women's hosiery between two pieces of glass (use old UV filters) to create a soft diffusion filter.

- **Heavy diffusion filters.** Apply petroleum jelly to a UV filter to create a heavy diffusion filter. Leave the center of the filter clear for a sharp image that fades away to a blurry one.

- **Split density filter.** Use a piece of gray ND material (the polyester/gelatin sandwich variety can be purchased in 3 × 3-inch squares) and cut it into a half-circle. Mount in a Series adapter ring and orient so the top and bottom (or, on occasion the sides) of the frame receive the neutral density effect.

Figure 4.14 shows several homemade filters.

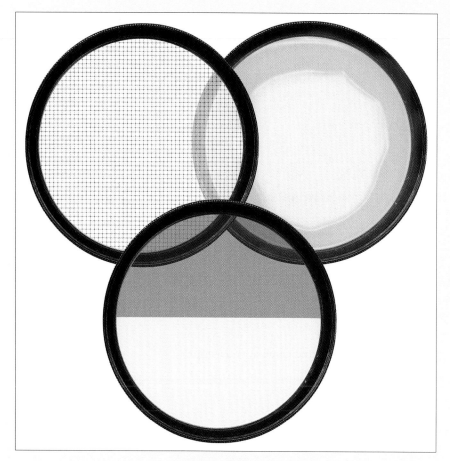

Figure 4.14 A star filter (upper left), heavy diffusion filter with petroleum jelly (upper right), and split density filter (bottom) can all be made from materials that are available inexpensively.

Getting Support from Tripods

A tripod is much more than a stand that holds your camera while you run to get in the picture before the self-timer trips the shutter. You'll find that a tripod is one of the most valuable accessories you can have for infrared photography. If you're used to walking about taking photos with only a camera and a lens, or perhaps with a camera and a few extra lenses and accessories in a shoulder bag, sling pack, or backpack, a tripod might seem like a cumbersome deadweight. Once you see all the ways that a tripod can improve your infrared photography, you'll either become accustomed to toting one around with you or perhaps will be moved to investigate some of the sturdy, but lightweight tripods that are available. You can also get some of the benefits of a tripod from a monopod, or a compact clamp device with camera mount that can be fixed to an object that will serve as a tripod "base."

Here are some of the things a tripod can do for you in an IR photography context:

- **Steady the camera for long exposures.** If you're using an IR filter, you'll often be using shutter speeds from 1/4 second to several seconds in length even in full daylight. A tripod or other support is essential for achieving sharp pictures at reasonable f/stops. You'll need a tripod when you're working with even longer shutter speeds to capture an image in dim light.

- **Counter telephoto shake.** While many IR pictures are taken with wide-angle lenses, telephoto shots are certainly not out of the question. While telephoto zoom settings magnify the image, they also magnify the amount of vibration and camera shake. Even tiny wobbles can lead to photos that look like they're out of focus when they're actually just blurry from too much camera movement. A tripod can help eliminate this sort of blur.

- **IR self-portraits.** Infrared people pictures can be quite interesting. Use your tripod to hold the camera in place so you can get in the picture, too, using your camera's self-timer feature. You'll only have to worry about how you look as you make a mad dash into the picture.

- **Improve your compositions.** If you're using an IR filter on the lens, you'll need the tripod to help you lock in framing and your composition before you mount the filter. But, even if you're using a converted camera, you'll appreciate the precise positioning a tripod affords, especially when you're shooting close-up/macro photos.

Types of Tripods

Tripods are available in various materials, styles, and sizes, and can range in price from about $100 to more than $1,000. Most tripods costing less than $100 really aren't suitable for infrared photography, because they are rarely sturdy enough to hold the camera steady for the long exposures often required. Although tripods can be built of wood, aluminum, basalt, carbon fiber, and other exotic materials, your ideal tripod is probably a compact model made of aluminum. Keep in mind that your digital camera must have a tripod socket to use a tripod. Most do—even the basic point-and-shoot models—but a few of the ultra tiny cameras that are about the size of a stack of credit cards may not. Here are the common types of tripods, available from manufacturers like Bogen, Manfrotto, Gitzo, Giottos, Benro, and Indura:

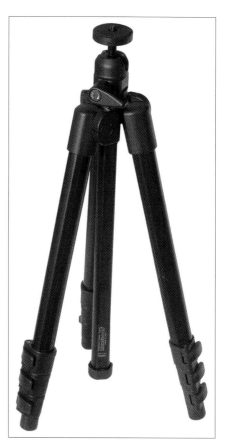

- **Discount store/big box retailer bargain units.** These range in size from one-foot tabletop tripods to versions that stand five feet tall, and are priced from $29.95 to $89.95. Often, they'll have leg braces—because they'll sway like a reed without them—and usually still are not sturdy enough for serious use. You might get by with one of these if you're shooting infrared with a tiny point-and-shoot camera, but for a little more money you can usually find a tripod that's actually smaller and lighter in weight, but significantly sturdier.

- **Full-size models.** These can be found in sizes from four to six feet tall, or taller, when fully extended with the legs divided into two to five collapsing sections to reduce size for carrying. The more sections, the smaller the tripod collapses. The downside is that the extra sections reduce stability and provide more points for problems to develop.

- **Traveling models.** These are full-size tripods designed especially for backpacking, hiking, and travel. They're most often made of carbon fiber, magnesium, and basalt (in various combinations), and feature four or more collapsing leg sections for a folded length of 14 to about 22 inches. You can pay $600 or more for one of these (and that's for the legs alone; a tripod head for mounting your camera is extra). I make do with a solid Manfrotto aluminum unit, shown in Figure 4.15, that folds up to 22 inches and fits inside a small duffel I carry on airplanes.

Figure 4.15 A sturdy but compact tripod can be light enough to carry with you everywhere.

- **Tabletop/mini-tripods.** These are promoted as an alternative to the pricy traveling models, and are lightweight, expandable, and easy to carry. They can be small enough to carry around comfortably. They're also sold as sturdy enough for a dSLR, which they probably aren't unless they're set to their lowest height. Most can handle a point-and-shoot digital camera, however. If used on a tabletop or braced against a wall with a small digital camera, these units can do a decent job. They can come in handy in places where there's not enough room to use a full-size tripod.

- **Monopods.** A single-legged support, a monopod won't steady your camera for multi-second exposures, but they work well in the 1/4 second and faster shutter speed range. That makes them ideal for use with converted IR cameras, providing an extra bit of support that can make the difference between a blurry shot and one that's tack sharp.

Tripod Features

All tripods aren't created equal when it comes to features. As I mentioned, most of the better tripods come as a set of legs only, usually with a center post that goes up and down to allow fine-tuning the height of your camera without fiddling with the individual legs. Collapsible tripods offer some way of locking the legs in position, often with a system of rings or levers that are twisted to loosen or tighten the legs in place. The best tripods let you open or close all the locks for one leg simultaneously when the legs are collapsed. You'll also want to investigate the range of movement of the legs, as some can be set at various angles from the camera mount, which is useful when you're working on uneven ground.

Inexpensive tripods may be furnished with a non-removable head, so make sure you like the one you're getting. Regardless of what type of head you decide on, consider getting a quick release platform for your tripod head, and quick release plates for your camera. These allow you to mount your camera on a tripod in seconds, and remove it even more quickly. The standard among advanced photographers is the Arca-style platform, which is built into tripod heads available from Arca Swiss, Kirk, and Really Right Stuff, and available separately to upgrade older tripods. The best tripod heads come with this style platform already built in.

However, I've also used the Manfrotto quick release system, shown in Figure 4.16, which can cost half as much and does a fine job. The Arca system only becomes essential when you want to attach an L-bracket to your dSLR camera that allows attaching the camera to the tripod head in either the standard horizontal orientation, or vertically, as the brackets for most dSLR models use the Arca mounting plates exclusively.

Figure 4.16 A quick release plate system allows you to mount your camera on a tripod or monopod in seconds.

If you're choosing a tripod head, here are some of the key types:

■ **Ball heads.** These are probably the most popular style with advanced photographers because they provide a full range of movement for the camera with a minimal number of controls. This type of tripod head, shown in Figure 4.17, uses a ball mounted in a cylinder. The ball has a stem with a camera mount on one end, and when the control knob is released, you can move your camera freely until reaching the top of the cylinder. A cutout on one side of the cylinder allows the stem to drop down low enough for the camera to be positioned vertically. Ball heads range in price from $29.95 to $500 or more.

■ **Pistol grip heads.** These are a special type of ball head that rotate around a swiveling ball, but you release and tighten the head's grip on the ball by squeezing a pistol-type grip.

■ **Pan/tilt heads.** These are the type of head that most amateurs equate with a tripod, because pan/tilt heads are furnished with most inexpensive models. That doesn't mean that there aren't good quality heads of this type, but they are really most convenient when using video cameras. This type of head allows you to rotate the camera from left to right (pan), and tilt the camera up or down, with a third control for rotating the camera around the lens axis to switch from a horizontal orientation to a vertical orientation. These heads are generally the cheapest and most labor intensive to use because you have to make adjustments to multiple levers to reposition the camera.

- **Fluid/video heads.** These are a more convenient variety of pan/tilt head, designed for smooth movement of a video camera. They usually have a longer handle that extends from the head. Twist the grip to loosen the head, and you can pivot and tilt the camera simultaneously.

- **Panorama heads.** This is a special variety of head designed for rotating the camera to take multipicture panoramic shots that you stitch together into one photo in your image editor. They have markings and detents that simplify taking the multiple exposures with the proper amount of overlap. Panorama features are often built into ball heads and other types, so you might not need a separate panorama head.

Figure 4.17 Ball heads allow a full range of movement with a minimum number of controls.

Electronic Flash

Electronic flash can be an excellent source of infrared illumination for your photos. It may be the most dependable form of "available light," because, if your camera is equipped with a built-in flash unit, it's always available, regardless of the time of day or season of the year.

You can also work with accessory flash units, which can be used off-camera or mounted on the accessory shoe found on top of more advanced cameras, such as electronic viewfinder (EVF) and digital SLR models. The advantage of add-on flash is that they are usually more powerful (your camera's built-in unit may be good for a range of only 10–12 feet or so) and provide a more flattering form of illumination. You probably won't use flash much for infrared landscape photography, but if you're doing IR portraits, experimenting with IR close-up photography, or investigating indoor architectural photography by infrared, you'll want to learn more about using flash.

In purchasing an add-on flash unit, you'll need to make certain that it works with your camera, and particularly with your camera's autoexposure system. So-called *dedicated* flash units are designed to connect to a particular model digital camera and take advantage of all its exposure features. Most of these are offered by the manufacturer of the camera itself, but a few third parties produce dedicated flash units for particular camera product lines.

You'll find more about choosing and using electronic flash for infrared photography in Chapter 10.

Next Up

If you're the adventurous type, you'll want to absorb all the information in the next chapter, which explains how to convert a camera you already own—or may soon purchase—to full-time infrared use. As you've seen in the chapters so far, there are lots of advantages to using a dedicated IR camera. You can do the work yourself—it's easy enough, and I've done it myself—or rely on a third-party service to convert your camera for you. Either way, the cost is modest, and the results are very rewarding. Once you've used a converted IR camera, you'll never want to take infrared pictures with anything else.

5

IR Camera Conversions

Converting an existing camera for full-time infrared operation is without question the best option for anyone who is serious about IR photography. However, I would wager that the vast majority of you won't be using a converted camera, or, at the very least, didn't plan to when you picked up this book. So, all the discussions so far, and most of the techniques in the remaining chapters, take into account that many, many readers will be using traditional digital cameras that have been outfitted with an external infrared filter. If you choose to go that route, I've got your back. Nearly every technique—except for Chapter 10's action and sports photography that require fast shutter speeds—can be accomplished without conversion.

However, I've been trying to blend in tips for those brave souls willing to sacrifice a camera to infrared photography. As you'll see, it's hardly a sacrifice: infrared conversion actually transforms a camera (perhaps an older model you don't use much anymore), giving it new life and new creative possibilities. The advantages of IR conversion are overwhelming, and the cost surprisingly low.

If you already own a camera that can be converted, your outlay for a do-it-yourself conversion can be as little as $95, plus the value of the camera (which can no longer be used for conventional digital photography). Even if you pay someone else to do the conversion, your additional cost may be about $250. If you haunt the online user groups as much as I do, you'll spot converted cameras for sale at attractive prices.

In this chapter, I'm going to explain the advantages of going full-time with an IR camera in more detail, show you the pros and cons of converting a point-and-shoot model versus a digital SLR, provide a list of cameras that can be converted, and then lead you step-by-step through a typical conversion that I did myself to show you how easy it is.

Advantages of IR Conversion

It's difficult to appreciate the advantages of using a camera converted to full-time infrared operation without actually using one. I thought I understood the technical implications when I began working with my first IR converted cameras, but was still pleasantly surprised at how the transformation made infrared photography so much easier and more enjoyable. Although each of the following points has been touched on before, I'm going to summarize them in more detail here so you can appreciate the full scope of IR conversion:

- **Multiple filters not required for interchangeable lens cameras.** There's no need for a filter over the lens. (Indeed, if you do mount an IR filter on the lens of a converted camera, you'll find that it has virtually no effect.) Should you use a camera with interchangeable lenses, you don't need to buy a filter for each different size lens thread, carry the filters around with you, nor remember to mount one on the lens. When I was shooting with a non-converted dSLR, I had to limit my lens choice to a small number of lenses that used a 67mm filter size, along with several optics with 62mm and 52mm filter threads that could use 67mm filters with a step-down adapter. My extreme wide-angle lens, which called for a 72mm filter, a long telephoto that used 86mm filters, and a fast intermediate zoom lens that required 77mm lens accessories were all out of the question. I can use any lens I want with my converted dSLR.

- **No clumsy adapter system for cameras without a filter thread.** If you're working with a converted EVF or point-and-shoot camera that lacks a filter thread, you don't need to cobble up a mounting system to attach a filter. The visible light cutoff filter in a converted camera is on top of the sensor.

- **View normally with a dSLR.** When you look through the viewfinder of a converted digital SLR, you see exactly the same view offered with a non-converted camera. You're framing your image through a big, bright optical viewfinder, with no optically opaque filter in the way.

- **Brighter view with non-dSLRs.** With an EVF camera or point-and-shoot model, the image *will* be tinted red in a converted camera, but your preview will be much, much brighter. Think about it. With an unconverted non-dSLR, the filter on the lens removes the visible light and the IR cutoff filter

over the sensor eliminates much of the IR light that remains, leaving you with enough illumination to capture an image with longer shutter speeds, but not much to view by on the LCD or EVF. With a converted camera, you get a brighter, red-hued version that can easily be used for framing.

■ **Autofocus and manually focus normally.** Your camera's autofocus system will continue to work as before with a converted camera. The focus point is slightly different for infrared and visible light, but the third-party firms who convert cameras normally recalibrate the camera's autofocus system to account for that difference. The smaller f/stops you can use with a converted camera will usually compensate for the focus difference because of the added depth-of-field, which can be useful when you're focusing manually and don't want to adjust the visual focus point to accommodate the "true" IR point of focus. With an unconverted camera, especially a dSLR, not enough light reaches the focus sensor to allow autofocus under any circumstances.

■ **Set exposure normally.** You'll find that the autoexposure systems of many cameras will provide acceptable exposure values for an IR-converted camera. Sometimes you'll discover that images are consistently under- or over-exposed by a half-stop or more, and you can dial in an EV change that will compensate.

■ **No tripod required.** You can use a normal range of shutter speeds and apertures. Instead of shooting at 1 second and f/5.6 in broad daylight, you'll find you can use exposures that are a more reasonable 1/500th second at f/8 or f/11 (if your camera offers those f/stops) at reasonable ISO settings. You won't need a tripod, except under circumstances where you would have used one anyway for conventional visible light photography.

■ **Reasonable ISO settings usable.** You won't need to work with noisy ISO 800 or higher settings to keep your shutter speeds within the several second (rather than several minute) range in dim light. ISO values of ISO 100 or ISO 200 will be fine, and your overall image quality will be much, much better.

■ **More useful picture review.** With a converted camera, you can set white balance to a preset suitable for IR photos, and then leave it at that setting for long periods. So, your images won't have the deep red cast and will instead be captured as grayscale or IR "brick and cyan" color tones that are more easily evaluated on your LCD after the shot. I find I can judge my pictures and even make exposure adjustments using histograms—something that was impossible with a non-converted camera. With a camera that will also be used for conventional visible light photos, you're less likely to set the white balance properly every time you take an IR photo.

Do It Yourself or Use a Conversion Service?

You can convert an existing camera yourself, send your camera in to a conversion service to have them do the work, or even purchase a brand new or gently used digital camera that's already been converted. The chief difference is cost and convenience. It might cost you $100 and a few hours of time to do the job yourself. Professional conversions are priced at $250 and up. Your choice should be based on how much time and money you have, and your manual dexterity.

I've gone both routes. I've paid to have a pricey digital SLR converted, and have converted less-expensive cameras myself. I'll cover both avenues later in this chapter. But, to cut to the chase, professional converters have been reported in the forums to do a fantastic job, returning your camera in spotless condition, with a dust-free sensor, and any necessary calibration done to perfection. The do-it-yourself path is a little more complicated.

Performing the conversion yourself means disassembling an electronic device with internals that you've probably never explored before. You can find instructions online for taking apart and reassembling many digital cameras, but information about your particular camera might not be available, and you'll be flying without a net.

The good news is that, for someone with some mechanical abilities, who has a knack for "seeing" how a device fits together (and comes apart), working on a digital camera is not that complicated. The trickiest part is figuring out how to open the camera shell (more on that later), followed by divining how to uncouple various internal components from each other. There are certain screws that must be removed, and others that must not be removed. Sometimes, you have to take apart the camera in a particular order. There may be internal springs that may spring at inopportune times. However, if you work carefully, using the guidelines I'll lay out, and have a degree of manual dexterity, it certainly can be done.

If you keep track of exactly what you did, you should be able to reassemble the camera after the conversion with a minimum of left-over parts. That process will go much faster. In fact, I've found that any digital IR conversion is almost ridiculously easy the *second* time you do it. I spent a couple hours converting one camera, only to discover the autofocus system no longer worked. I suspected that a tiny ribbon cable that needed to be reinserted when assembling the camera wasn't properly seated. I was able to take the camera apart again, fix the cable, and reassemble the camera in about 20 minutes. At that point, I was confident I could do any future IR conversions *on that model camera* in half an hour or less.

Of course, you may not have the luxury of doing a given conversion twice. The professional conversion firms do, and that's why they are so good at it. If you're working on an inexpensive camera, have some skills, and can readily acquire an

IR filter for your model, by all means do the conversion yourself. If you lave less confidence in yourself and are converting a more expensive camera, you should seriously consider using a conversion service. I'll address that option next.

Fujifilm Offers Best of Both Worlds?

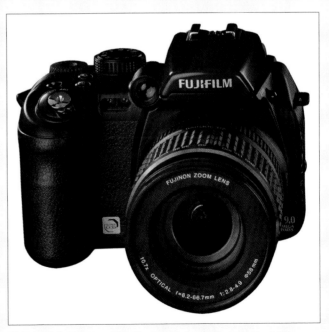

In a perfect world, the manufacturer of your favorite camera would be willing to convert a camera for you, so you could own a model suitable for infrared photography with the same precision assembly and design as a conventional camera. In a *really* perfect world, such a camera would be useable for both conventional visible light photography as well as IR imaging, and wouldn't cost any more than an ordinary, non-IR-capable model. Surprisingly, Fujifilm has done it, offering two of the best infrared "converted" cameras you've never heard of.

The reason for their obscurity is that the Fujifilm FinePix S3 Pro UVIR D-SLR and the Fujifilm FinePix IS-1 (see Figure 5.1) are sold specifically for law enforcement and scientific applications. The former is a version of the company's S3 Pro series digital SLR (first introduced in 2004) with some tweaking to allow it to capture light in both the ultraviolet and infrared ranges as well as visible illumination. It's an interchangeable-lens camera based on Nikon components, can use Nikon lenses (with the same 1.5X crop factor), and costs several thousand dollars. The IS-1 camera, on the other hand, is an affordable ($899) electronic viewfinder (EVF) camera with a fixed 10.7X zoom lens and the capability of shooting in both visible light and under infrared illumination.

The S3 Pro UVIR is less practical for photographers who don't have scientific or forensic applications for it. It's expensive, and doesn't really represent visible light subjects (shot without any filtration) very well. Its conventional photos have a bit of a red tint for many subjects, and quite a rich red or orange cast in plants and other IR friendly subjects. UV photos are taken using a black light, which produces illumination in the 300 to 600 nanometer range. IR pictures require a Wratten #89B filter, which, of course removes the visible light with this camera the same as it does with any other digital camera. Fujifilm's solution is to provide a 30-second grayscale preview image on the LCD, which can be used for framing and evaluation.

Figure 5.1 The Fujifilm FinePix IS-1 can shoot both visible light and IR photos.

I think the newer FinePix IS-1 is much more practical for serious infrared photographers, especially given its sub-$900 price tag. It's a 9-megapixel EVF model with a 28mm–300mm (full frame equivalent) f/2.8–f/4.9 variable aperture fixed lens, ISO settings up to ISO 1600, and many of the features you find in true digital SLR cameras, including shutter speeds up to 1/4000th second and continuous shooting at up to 4 frames per second. Most importantly, it is capable of taking both full-color visible light pictures (albeit with a pink color cast) and infrared photos when an IR-cutoff filter is placed on the lens.

However, unlike other cameras in its class, enough light is registered by the LCD that, with the built-in amplification (gain) provided by the camera's electronics, it's possible to view, frame, and even focus an infrared image with the cutoff filter in place. There's a tilting two-inch LCD on the back of the camera (see Figure 5.2) that can be used for previewing images with the IR filter installed on the lens.

Figure 5.2 A swiveling LCD on the back of the camera can be used to preview IR images even with a cutoff filter attached.

Indeed, Fujifilm recommends using manual focus in this mode, although the autofocusing system will operate if enough visible light is present. The IS-1 has a 10X center point viewfinder zoom that makes focusing on the LCD easier. Although the filtration does mandate longer shutter speeds, the camera's built-in Picture Stabilization technology and ISO 1600 sensitivity minimizes camera shake, making the slower shutter speeds more practical.

As with all Fujifilm and Olympus cameras, the IS-1 uses xD Picture cards, but also has a slot for the more common Compact Flash and Microdrive (mini hard disk) media. If you're considering converting an existing camera for full-time infrared use, this camera—converted by the manufacturer, so to speak—is a viable alternative. Although you don't get the unbridled viewing freedom of a converted dSLR, the IS-1's viewfinder is quite usable, and you end up with a camera that's able to shoot both IR photos and images using visible light.

Which Cameras Can Be Converted?

Whether you're doing the conversion yourself or relying on a conversion service, for the best results you'll need an IR filter (visible light cutoff filter) specifically made for mounting above the sensor in your camera. That limitation alone eliminates many possible cameras from easy conversion, unless you have a filter made for you specially. Still, that leaves almost four dozen different digital cameras that are solid candidates for conversion.

I'm going to list popular camera models that can be converted by a third-party service, or which can be converted by you using an IR filter you can purchase commercially. Keep in mind that many of these cameras are older models. That's not necessarily a bad thing. You might be willing to convert a particular camera *because* it is an older model that is judged less useful, or which has better IR response.

Table 5.1 shows a list of cameras that can be easily converted, either because internal IR filters are readily available to the consumer or because one of the conversion companies I list later in this chapter offers conversion for that camera.

Table 5.1 Convertible Cameras

Camera Manufacturer/ Camera Type	Model
Canon dSLR	D30, D60, 10D, 20D, 30D, Rebel/300D, Rebel XT/350D, Rebel Xti/400D, 1D, 1Ds, 5D
Canon point-and-shoot	Powershot G1, G2, G3, G5, G6, G7, SD800 IS, S3 IS, Powershot S30, S40, S45, S50, S60, S70, S80
Nikon dSLR	D40, D40x, D50, D70, D70s, D80, D100, D200, D1, D1x, D2x
Nikon point-and-shoot	Coolpix 5000, 5400, 8400, 900, 950, 995
Fujifilm dSLR and point-and-shoot	FinePix S3 Pro, FinePix F30
Sony	DSC-N2, DSC-R1

OTHER CAMERAS

There are lots of other cameras that can be readily converted, but which are not listed here. For example, the Sony Cybershot DSC F707 has a "NightShot" mode that actually flips the built-in IR cutoff filter out of the way, producing exceptional infrared sensitivity, especially considering the camera has a pair of IR illuminators that provide an IR light source even in total darkness.

Unfortunately, in that mode, the F707 and similar cameras really do assume you'll be shooting at night, and boost the ISO setting way up (as high as ISO 2500) and limit the use of shorter shutter speeds in favor of longer ones. That makes IR photography in normal daylight impossible. Even so, with special filtration and other tricks, the F707 can be converted into a nifty IR camera. You'll find plentiful tips for this particular camera if you do a Google search.

Using a Conversion Service

I've already outlined *why* you might want to rely on a conversion service. This section will address *who* and *how*. As with any specialized niche service, suppliers come and go. With the growing popularity of infrared photography, however, I would guess that more new conversion services are coming than going. Even so, it's best to check on the Internet, using Google to search for "infrared conversion" to produce the most recent list of services offering infrared conversion.

It's also a good idea to search for specific camera models that can be converted. The list in Table 5.1 was up-to-date when this chapter was prepared, but some of the older models might fall from favor as fewer and fewer owners seek conversion services for them. Conversely, it is likely that new models will be added as vendors update their camera lines. I was surprised to find conversion services offered for the Nikon D40 camera, which became widely available only in December 2006. It's probable that new cameras, particularly those from Canon, Nikon, or Sony, will become candidates as they are introduced. I'd be especially watchful for conversion possibilities for the Sony Alpha DSLR A100, because its built-in image stabilization makes it especially suitable for IR photography at all shutter speeds below 1/500th second, or with long telephoto lenses at any shutter speed.

The most popular services that either provide conversion of your camera or which sell new or used cameras that they have converted include:

LifePixel

LifePixel (www.lifepixel.com) is the undisputed leader in IR conversions and products. I've used this US firm several times and have always been delighted with their speed and quality. The company offers conversions for many different camera models, including popular Nikon and Canon dSLRs and point-and-shoot cameras. If you later want the camera converted back for conventional photographic use again, they'll do that, too, for half the price you paid for the original conversion.

The company also offers visible light cutoff filters you can install inside your camera, as well as replacement IR cutoff (hot mirror) filters, and clear glass (full-spectrum) filters for UV/IR photography, scientific work, and experimentation.

If that weren't enough, LifePixel provides online articles and videos that show you how to make conversions yourself and manipulate IR images in Photoshop. Their FAQs page alone should answer any questions you might have about having your camera converted by the company.

Khromagery

Khromagery (khromagery.com.au), which took over for a service formerly operated by David Burren Photography, is located in Australia, but offers infrared products and services worldwide, including the United States and Canada. The firm provides conversion for a broad range of Canon and Nikon dSLRs and point-and-shoot cameras.

The company specializes in darker Wratten #87C filters for infrared photography, which have an 850 nanometer cutoff point deep in the near infrared range. Cameras converted with this filter produce vivid black-and-white IR photos, with all traces removed of the visible light that makes false color infrared photography possible. In fact, the firm no longer offers conversions using the more common #89B/R72 (720 nanometer cutoff) for digital SLR cameras. If you want your dSLR converted using the #89B or R72-type filters, you'll have to go somewhere else. However, Khromagery does provide conversions using #87 (800 nanometer cutoff), #87C, or R72 filters for point-and-shoot cameras.

You can also opt for a full-spectrum (clear) filter for both point-and-shoot and dSLR cameras for UV, scientific, and astrophotography applications. IR-only photography with the clear filter requires the use of external filters to remove visible light.

LDP LLC

LDP Net (www.maxmax.com) is a New Jersey optical company that offers an extremely broad product line, for imaging from ultraviolet through visible light to infrared. These include IR-capable video camcorders, outdoor weatherproof cameras with infrared illuminators, indoor cameras with IR illuminators and audio, and, even thermal infrared cameras in the $10,000 price range that can image heat!

The company also offers IR conversions of many different Canon, Nikon, Sony, and Fuji dSLRs and point-and-shoot cameras, and will sell you any of these cameras already converted for infrared photography. Many of these can be outfitted as dual-threat visible/infrared cameras or as infrared-only models.

One interesting option is what LDP calls its maximum resolution "Visible Hot Rod" conversion. Not for the faint of heart, what this $500 conversion does is remove the camera's anti-aliasing filter (discussed in Chapter 2), and replaces it with a clear optical glass window with the same refractive index (which retains the camera's focus calibration). You'll recall that the anti-aliasing filter provides a slight blurring effect that reduces the possibility of moiré effects, at the cost of a little resolution, depending on how aggressive the AA filter provided by the manufacturer is. After the conversion, you may have a moiré problem from time to time that will need to be fixed in Photoshop (using Gaussian blurring), but your camera's sensor will be operating at its full resolution potential all the time. This Hot Rod effect isn't an IR conversion, of course, but it's unusual enough that I couldn't resist mentioning it.

Converting Your Own Camera

There are many reasons for wanting to convert your camera to infrared use yourself. Some want to save a little money, although for the most common camera types the difference between buying an IR filter and doing the conversion yourself and having a service convert the camera can be as little as $150. Unless you're already proficient at this type of work, it's likely to take a couple hours and there is always the small risk of doing something wrong (if you're fumble-fingered) and disabling the camera for *any* type of photography.

Others want to make the conversion for the challenge, for fun, or because they want to experiment. They might be using a low-cost camera, don't really expect much from their IR conversion, and want to do the job on a shoestring. In previous generations, these same people would be building their own color televisions from Heathkits, or building ships to fit into bottles.

Another rationale for a home-brew conversion is to adapt a camera that can't be converted by one of the commercial services. If you have an old Kodak DCS 460 digital SLR that you don't use much any more and want it converted for infrared photography, expect to put a lot of research and do-it-yourself labor into the project. Although I probably can't help you much in converting your old Kodak dSLR, this next section will provide some tips for modifying more common IR photography candidates.

There are two potential paths to follow. You can simply remove the IR cutoff filter inside your camera, producing a digital shooter that's much, much more responsive to infrared illumination, but which still can be used for visible light photography. Or, you can go whole hog, remove the internal IR cutoff filter and replace it with a visible light cutoff filter and end up with a camera that can take IR photos only. I'll explain each option to help you make the decision.

Full Spectrum Versatility

As I noted in Chapter 2, the unadorned digital camera sensor is quite responsive to IR illumination, so much so that camera vendors have been increasing the strength of their internal infrared cutoff filters to reduce the amount of IR contamination that appears in photos taken by visible light. If you want to restore the sensor's responsiveness to infrared light, all you need to do is open up the camera, remove the IR cutoff filter, and replace it with a clear piece of optical glass that otherwise has the same properties (that is, it refracts or bends incoming light in the same way) as the filter that was removed. Some of the conversion firms mentioned earlier in this chapter will be happy to sell you that glass component.

When the conversion is complete, you don't have a true IR camera. What you end up with is a camera that can take pictures using the full spectrum (potentially), from the UV end up through visible light, and into the infrared. Your visible light color photos will have a pinkish cast and any objects that reflect a lot of IR won't have accurate colors. You might be able to fix this IR contamination in your image editor, or you might want to use it as an artistic effect.

Note that because the camera is now responding to, more or less, what we can call the full spectrum, to take true IR photos you'll still need an IR cutoff filter over the camera lens. That makes this solution less than optimal for digital SLR cameras. A full-spectrum camera can take pictures using *much* shorter shutter speeds (because there is no internal IR cutoff filter removing most of the infrared illumination), but a dSLR viewfinder will still go dark when the IR filter is mounted.

This kind of conversion is a better choice for point-and-shoot and EVF cameras, particularly those point-and-shoot models with optical viewfinders. The red-tinted LCD view should be bright enough to allow composing the image and, if not, an

available optical viewfinder can be used instead. There should be enough IR light reaching the sensor to allow shorter exposures, making hand-held operation more feasible. So, a conversion of this type can enable you to take IR photos while retaining the visible light capabilities of the camera.

If a clear glass filter (it's actually a *window* because it doesn't filter anything) isn't readily available for your camera, this kind of conversion can turn into a major project. Several enterprising souls with glass-cutting skills have produced their own clear glass windows from microscope slides, using glass cover slips to build up to the proper thickness. Others have found optical companies that will custom-build a window for you for $75 to $100 or so. Several people have mentioned Rolyn Optics Company, of Covina, Ca. (www.rolyn.com) as a possible source.

Keep in mind that any optics firm willing to craft a clear glass sensor window for you probably doesn't have any formal digital camera/IR photography product line as such. They simply have the expertise to build the "filter" that you need. So, be prepared to provide them with full specifications as to the properties you are looking for, including length, width, and thickness (in millimeters), acceptable tolerance (say, +/– 0.1mm) from those dimensions, and even material to be used. You can measure the size of your existing filter using a micrometer (see Figure 5.3). So-called BK7 optical glass, a borosilicate crown optical glass, is most commonly used. It has a transmission range from 330 nanometers to 2100 nanometers, which makes it perfect for UV, visible light, and infrared photography.

Figure 5.3 You'll probably be using a better micrometer than my rusty old example to measure the dimensions of your existing UV cutoff filter when you go shopping for a visible light cutoff/IR filter or full spectrum plain glass window.

A Method for the Madness

In the section that follows this one, I'm going to provide step-by-step instructions for converting a Nikon Coolpix 995 camera. The procedure will also work for other 900-series Coolpix cameras, and should at least give you an indication of the sort of work that's involved in doing a conversion on your own digital camera.

And while I can't provide detailed instructions for every possible camera, you won't be working entirely on your own. You'll find that the Internet can be a treasure-trove of information on disassembling most cameras, locating the parts you need to modify, and, even, additional instructions on doing infrared conversions. In this section, I'm going to provide a recommended workflow you can use to perform your own conversion. Then, read through the Coolpix 995 conversion details to glean additional useful tips.

The steps that follow apply specifically to point-and-shoot type cameras, rather than digital SLRs. The process is very similar for dSLRs, so much of what is described also applies to those more advanced cameras. However, there may be some additional steps because dSLRs have more components. I urge you to get additional instructions before trying a dSLR conversion, if only because a more expensive camera is at risk.

Step 1: Obtain a Visible Light Cutoff Filter

I recommend obtaining the internal IR filter first, because if you are trying to convert a camera that isn't among the common types converted for infrared photography, you'll want to be certain that, at the very least, you have the filter in hand before you do anything else.

If your camera happens to be one listed in Table 5.1, you're almost home free. Contact LifePixel or one of the other IR conversion services to purchase a filter custom-made for your camera. Expect to pay about $100 for the filter alone. If you want to convert a camera other than one of the listed models, use Google to search for, say, "Kyocera+infrared+filter" to find possible sources. The more adventurous may be able to purchase a filter that is close in size to the one they need, and cut it down (or have it cut down) to fit their particular camera. You have to really, really want to convert an odd-ball camera to go to that much trouble, however. I recommend sticking to cameras for which ready-made filters can be easily located.

Step 2a: Search for Instructions on IR Conversion for Your Camera

Vendors that furnish IR conversion filters often provide online tutorials that lead you through converting a particular camera, step-by-step. Those sort of instructions should be your first choice, because they are heavily tested, debugged, and

will work. I've also found that there are an incredible number of online instructions for IR conversions prepared and illustrated by ordinary people like you and me, who have run the gauntlet of modifying their own camera, taken pictures, and posted them on the Internet.

For example, back in 2001, James Wooten created a page subtitled "How To Ruin Your New Camera" at www.parsel.abe.msstate.edu/james/camera/lense.html (it was still there as I was working on this book) with detailed information on removing the IR cutoff filter from a Nikon Coolpix 950 or 990 camera. (There does seem to be a plethora of pages relating to the Coolpix 900-series; they were all excellent cameras, and cameras that could be converted to IR rather easily.) It's no disadvantage that some of these instructional pages are a little old by now. The older cameras are the very ones that can be purchased cheaply and "sacrificed" for IR conversion, plus the instructions themselves have stood the test of time and are likely to have been updated long ago to correct any errors.

Step 2b: Search for Instructions on Disassembling/Reassembling Your Camera

If you can't find detailed information on modifying your particular camera for infrared photography, the next best thing is locating user-posted instructions for dismantling your camera to fix various problems (often unrelated to IR photography), with matching suggestions for getting the camera back together again. Search Google for *camera name+schematics* or *camera name+repair* and you'll find a lot of good information.

If you're lucky, you might even find repair manuals for older cameras, available from the original vendors, or others who have converted them into PDF form. Figure 5.4 shows the sort of diagram you might come across, although in this case I've removed the callouts and changed many elements of the original to comply with fair use restrictions. The actual repair manuals usually number each piece, show how they fit together, and provide instructions for dismantling and remantling the camera. These manuals are sometimes available directly from the manufacturer for a fee, but, usually, only certified repair technicians require them (and can acquire them); it's hardly worth purchasing a thick manual just for one quick IR conversion.

Figure 5.4 You can often find IR conversion instructions or repair manuals for your camera online.

Step 3: Collect the Right Tools

You'll need a set of good jeweler's screwdrivers (not the $2.99 set of 12 from the dollar store), and at least one and preferably two high intensity lamps with flexible necks to cast illumination on your workspace from all angles. I've purchased several pairs of reading glasses in various magnifications that let me work anywhere from a foot to a few inches from the component I am working on. Bifocals just don't cut it under these circumstances.

A hobby vice (with padding), if you have one, can hold your camera and its individual pieces at the various angles you might need to work on it after you get it apart. Don't forget tweezers, canned air, a bulb blower for cleaning the sensor, perhaps a magnetic wand (to catch and hold loose screws and parts as they fly off, and to search for them if they fall on the floor). I often work on a large piece of posterboard, rather than a patterned desktop or workbench so I can see every single component clearly, and reduce the chances of pieces rolling to the edge and onto the floor.

Step 4: Open the Camera Case

You'll find that taking the camera apart can be non-intuitive for the first few steps. Camera manufacturers like to keep idle hands and inquisitive minds from readily taking apart their products. Back in the film days, such do-it-yourself repairs could be disastrous. The many mechanical parts and gears and levers were often spring-loaded, and if you didn't know to hold down piece A, while unfastening piece B, the whole thing could fly apart, never to be reassembled again.

There's less danger with modern cameras, which are primarily electronics-based (but which can have lots of knobs and wheels that need to fit together properly). In addition, you'll want to keep dust from getting to the sensor which, unfortunately, happens to be one of the components you'll need to mess with as you perform the conversion.

So, after you've set up in a clean place as recommended earlier, have compressed air available (rather than canned air, which can contaminate the sensor with propellant) to blow dust off the surface of the camera, your work area, and the interior of the camera itself (but not off the sensor, which requires more careful handling), begin. Just follow these sub-steps:

1. **Remove the battery.** You'll want to remove the battery to prevent the camera from accidentally powering up during the procedure, particularly if the camera has an internal electronic flash. The flash is energized by a capacitor that can retain its charge for a period even if the camera is turned off and the battery is removed. The charge will drain away eventually, so it's probably a good idea to not only remove the battery, but take it out in advance of the

actual conversion. A couple hours might do it. Heck, let the camera sit overnight without its battery if you're the clumsy/nervous type. But even an overnight spell might not be enough—so continue to be careful around capacitors in any state.

2. **Figure out how to open the camera case.** Many cameras have a few exposed screws, but it's unlikely that you'll be able to get the camera apart simply by loosening them. There will be additional fasteners, often located under name-plates that can be pried off. Sometimes screws are recessed and hidden under rubber plugs that can be pried out to reveal the screw heads. Don't forget to look inside the battery compartment. You'll often find additional screws there, either near the battery compartment door or, sometimes, deep within the battery chamber.

3. **Gently pry the shell apart.** The external covering may come apart easily, or you may have to press a tab or lift a plastic or metallic finger to free the shell. Don't force anything. With enough careful examination of how the camera seems to fit together, you should be able to figure out how to take it apart.

4. **Set the external pieces aside.** Arrange the screws or other fasteners next to the holes they go into, so you'll be able to get the camera back together again. Various screws that look similar may be, in fact, quite different, so that they are not interchangeable. They may be slightly different lengths, some may be machine screws while others are self-setting screws. If you think you might mix them up, get several shades of nail polish and code the fasteners and their original locations with a small dab of color.

5. **Take notes.** Keep track of what you're doing for this step and all additional steps. The more paranoid sometimes take photos of a disassembly so they know exactly how to reassemble the component. Do whatever you need to.

Step 5: Find the Sensor Assembly

You should be careful of the electronic flash capacitor, as I noted previously, as you search for the sensor assembly in the camera. The capacitor is usually a large silver tube, generally located near the flash tube itself. The sensor will be located behind the lens, although in some cameras a mirror or prism may be used to direct light from the lens at an angle to the sensor. If you are working with a dSLR, the sensor is *always* near the back of the camera, behind the lens.

Sensors in many digital cameras are much smaller than you might expect—only 8.8×6.6mm on an 8-megapixel Sony DSC-F828, for example (about 0.34×0.25 inches), compared to 22.2×14.8mm (0.87×0.58 inches, which is 5.5 times the area) on an 8-megapixel Canon EOS Digital Rebel XTi. There may be several circuit boards in the camera, linked by small ribbon cables. You might have to

separate the boards by pulling the ribbon cables out of their sockets. The flat cables are usually locked in place, but can be freed by pressing on a release you'll find on the socket itself.

When you locate the sensor, study it to see how the IR cutoff filter (it will have a bluish cast as you can see in Figure 5.3) is fastened down. Often, it is inside a frame that can be lifted off by loosening a few tiny screws.

Step 6: Remove the IR Cutoff Filter and Install the Visible Light Cutoff Filter

Use tweezers, if necessary, to pick up and remove the IR cutoff filter. Set it carefully aside, as you may want to reinstall it someday to return your camera to its original condition. Then, pick up the visible light cutoff/IR filter and prepare to drop it into place. The filters often have one corner trimmed off to show proper orientation, and there will be a matching cutout in the frame where the filter is seated. Just before dropping the new filter into place, clean off the sensor with an air blower or sensor cleaning brush using the directions supplied with your sensor cleaning equipment. (For example, you may be directed to charge the brush with static electricity using compressed air or another method before brushing.)

When you're certain the sensor is clean, drop the filter into place and reassemble the frame holding it down. Clean the front surface of the filter before reassembling the camera, and use compressed air to blow any dust out of the interior. Non-dSLR cameras are usually well-sealed and don't have sensor dust problems until you break that seal to perform a repair or modification (like this one). So, if you're careful in putting the camera back together, you should be able to continue taking photos without worrying about future dust problems.

Step 7: Reassemble the Rest of the Camera.

Don't tighten all the outer screws of the shell just yet. When the camera is mostly together, re-insert the battery and turn the camera on. Try to take a few pictures. Pay special attention to the autofocus system. If the camera takes photos that are reasonably exposed, and the AF system seems to be functioning, go ahead and insert all the screws and lock everything together. Replace any trim or screw access covers. If you discover problems, disassemble the camera again and check the ribbon connectors. If you notice dust on the images, clean the sensor surface once more before putting the camera back together.

That's it! You've converted your camera. Now, go out and take some infrared photos!

Converting a Nikon Coolpix Camera

I'm going to take you through all the steps I took to convert my own Nikon Coolpix 995 (see Figure 5.5) for full-time infrared photography. The steps are similar for other "swivel lens" cameras in the Coolpix line, including the 800-series and 900-series cameras. You'll find that the procedures for other point-and-shoot digital cameras have a lot in common with my Coolpix conversion, so, even if you're converting another camera, you can pick up a few pointers from this sequence.

The Coolpix 995 I converted was the last in that particular product line, introduced in April of 2001. While earlier cameras in the series actually had better IR response in their unconverted state, the CP995 was a far superior picture-taker. Equipped with an exquisite Nikkor 4X zoom lens, this 3.3-megapixel camera produces better image quality than many 5-megapixel cameras I've tested it against. Its macro capabilities make it legendary for close-up photography, and, once the pesky IR cutoff filter has been replaced by a visible light filter, it makes a fine infrared camera, too.

Here are the steps you need to follow to convert this camera, and others like it. I'll include a few side notes that may help owners of other cameras make their conversions, too.

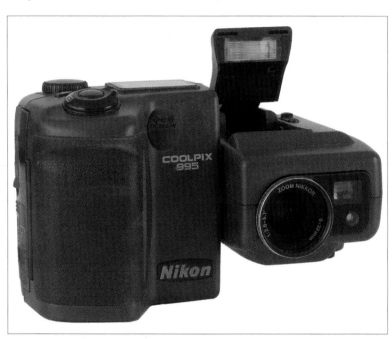

Figure 5.5 We're going to start with this fully functional point-and-shoot digital camera.

Step 1: Remove the Flash Sync Connector Cover

Unscrew the plastic flash sync connector cover, which is located on the underside of the lens-bearing half of the CP995 (see Figure 5.6). This cover must be removed so the outside shell can be separated from the innards. Place the cover in a safe place so it won't be lost, and can be replaced when you reassemble the camera. Many cameras have similar port covers that need to be removed when dismantling the camera.

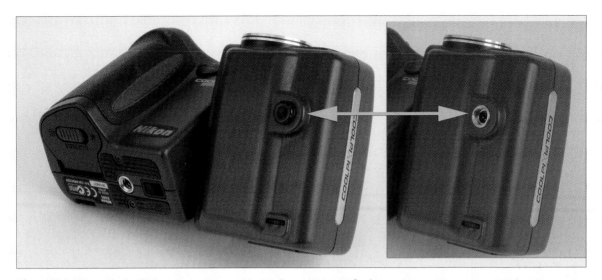

Figure 5.6 Unscrew the flash sync connector cover and store it in a safe place.

Step 2: Peel Off Coolpix Label

Nikon has hidden a couple essential screws under the decorative Coolpix label on the end of the camera. Peel off the label using tweezers, and then use a small Phillips screwdriver to loosen these screws and remove them. Place them next to the label where they won't get knocked around. (Inside a zipper sandwich bag is best; do this for all screws and components you remove.) (See Figure 5.7.)

Figure 5.7 Peel off the label and remove the two screws underneath.

Step 3: Remove Screws from Body Shell

Next, you want to remove the screws from the inner surface where the two swiveling halves of the camera meet. You want to extract all five screws from the half of the camera *that contains the lens*. (The shell of the other half, with the LCD and controls, is held together by four screws.)

First swivel the lens half of the camera so the viewfinder window is facing the front (the lens will be facing in the direction of the photographer in picture-taking mode.) Remove the three screws on the panel that is exposed. (See Figure 5.8.) Then, swivel the lens half so the lens is facing front, and remove the two screws that are exposed, as in Figure 5.9.

Figure 5.9 With the lens facing front-ward, remove the two screws shown.

Figure 5.8 With the viewfinder facing front, remove the three screws indicated.

Step 4: Remove Screw Inside Flash Mount

There's one more screw to remove. It's hidden by the CP995's flip-up flash. Press the flash release button next to the flash to pop it up, then unfasten the screw shown. (See Figure 5.10.)

Figure 5.10 The final screw to be removed is revealed when you flip up the electronic flash.

Step 5: Pry Camera Shell Apart

Once you've removed all the screws you should be able to pry the camera shell apart. You might have to insert a pry of some sort between the mating pieces to coax them apart. A thin-bladed screwdriver works. The plastic is soft, so avoid scratching it. The best place to pry is the portion covered by the Coolpix label; if you do slightly deface the edges there, the injury will be covered up when you glue the label back on.

Step 6: Remove Ribbon Cable from Top Circuit Board

The sensor is tucked under a pair of circuit boards next to the viewfinder window. Remove the bezel around the viewfinder window and set it aside. Extract the ribbon cable from the top circuit board to make it easier to detach this circuit board from its mate underneath. Push the brown tab that holds the ribbon cable firm, and then pull the cable free with tweezers. (See Figure 5.11.) Then wiggle the circuit board while pulling up slightly to separate it from the circuit board below.

Figure 5.11
Remove the ribbon cable to make it easier to separate the upper circuit board from the lower board.

Step 7: Remove the Upper and Lower Circuit Boards

Once the upper circuit board is loose, remove it and set it aside, as shown in Figure 5.12. You can see the white plastic mating connectors at the far edge of the circuit boards in the figure. Then, remove the two screws shown and flip the lower circuit board forward. It's not necessary to remove the ribbon cable; the cable serves as a hinge so you can pull the board forward to reveal the sensor mounted on the other side.

Figure 5.12 Remove the two screws shown and flip the lower circuit board forward.

Step 8: Remove the IR Cutoff Filter on the Sensor

You'll find the cyan-tinted IR cutoff filter over the sensor (see Figure 5.13). It's held in place by a rubber grommet. Use tweezers to remove it to expose the sensor itself (see Figure 5.14). If necessary, use a blower to remove any dust that falls on the sensor during this dismantling process.

Figure 5.13 The IR cutoff filter is held in place by a rubber grommet.

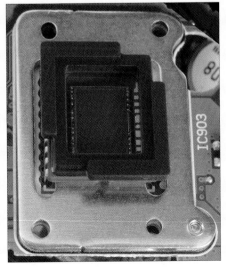

Figure 5.14 When the sensor is exposed, avoid allowing any dust to fall on it.

Step 9: Clean Visible Light Cutoff Filter

Pick up the visible light cutoff/IR pass filter you will be installing with tweezers and inspect it for dust (see Figure 5.15). Blow off any dust you find using a bulb blower.

Figure 5.15 Inspect and clean the IR pass filter you'll be installing.

Step 10: Install Visible Light Cutoff Filter

Gently insert the filter over the sensor using the tweezers. It will squeeze into the rubber grommet. Make sure the filter is seated tightly to prevent dust from getting past it onto the sensor. When you're finished, the sensor and its filter will look like Figure 5.16.

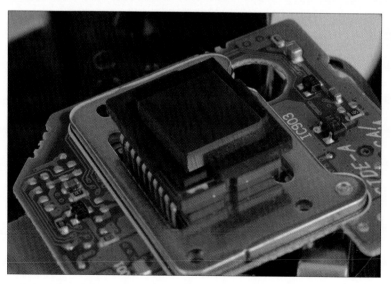

Figure 5.16 The visible light cutoff/IR pass filter has been installed.

Step 11: Reassemble the Camera

Reassemble the camera by following Steps 1–7 in reverse order. Pay special attention to inserting the ribbon cable correctly and locking it in tight. Reinsert all screws into the holes they were extracted from, and tighten carefully to avoid stripping their heads.

Step 12: Take Test Photos, Checking for Dust

Take a few test photos immediately to check for dust. If necessary, dismantle the camera again (it will go much quicker this time!) and remove any dust that has crept in using a bulb blower.

Next Up

This concludes the getting-ready-to-shoot portion of our program. The next section of the book will be filled with example photos of the kind you can expect to take, whether you're using a converted camera or an unmodified model with a visible light cutoff/IR filter. You'll find that there are lots of things to shoot in IR other than landscapes, although I'm going to provide a healthy dose of nature, foliage, and scenic photography examples in the mix.

Part II

Oh, Shoot! Infrared Photo Techniques

In this part of the book, I'm going to show you some specific digital infrared photography techniques, with plentiful example photos, and explain the methods you need to take photos like that on your own. I'm going to begin with the most traditional IR subject matter—landscape photography—before branching out into other challenging subjects, including people photography and sports/action photography. By the time you've finished this part, you should have plenty of ideas for creative images of your own.

6

First Steps with Infrared Landscape Photography

Your first real infrared photos will probably be landscapes, so I'm going to use this chapter to ease you into shooting IR pictures by using scenic images as your subject. The techniques you learn here can be applied to later chapters dealing with close-up photography of plants, architecture, people photos, and action.

Landscapes are, of course, the most popular subjects for infrared photography. The dramatic rendition of a cloudy sky and the ghostly white appearance of foliage make for compelling IR images. There's also the undeniable advantage of having a patient subject—Nature's scenic bounty—which will pose (relatively) unmoving for the lengthy exposures required for infrared photography with an unconverted camera.

Indeed, landscape photos taken with shutter speeds of a second or more can emphasize parts of the image that *do* move, such as the water of a babbling brook, cascade of a waterfall, or gentle movement of leaves on the trees. These elements will be represented as silky blurs, which can be effectively contrasted against the rock-solid, nonmoving components of your image. You'll see a lot of infrared landscape photos because there are lots of different pictures you can take using scenic subject matter. I'm going to show you a wide variety of different types of pictures in this chapter.

For creative reasons and for the sake of variety, I'm going to present several traditional types of infrared images in this chapter, and those which follow. You'll find a few straight black-and-white IR photos, similar to what you could have gotten using black-and-white infrared film back in the pre-digital age. Many will use the "brick, black, and cyan" color scheme that you get straight out of the camera when white balance has been set properly for infrared photography. There will be a complement of shots that have been manipulated using a technique called "channel swapping" to give the sky a realistic blue color. And, finally, there will be a few pictures that have been modified in other ways, including a special technique or two I invented exclusively for use in this book. In general, I won't single out any of the three most common techniques in this chapter or the others in Part II. I'll show you how to apply them to your own photographs in Part III.

I will make note of some more unusual techniques as they crop up, and will show you how to work with them in the Part III image editing chapters. If you find a particular image you want to learn more about, feel free to jump ahead to see exactly how it was done. All these methods depend on your having set the white balance of your digital camera correctly, so I'll address that process first.

The Importance of White Balance

If you're old enough to remember when color film was popular, you might recall that films were always standardized, or *balanced*, for a particular "color" of light. Amateur photographers generally used daylight-balanced films (whether they were aware of it or not) while more advanced photographers, including professionals, also used specialized films balanced for indoor or *tungsten* illumination.

Different film color balance was necessary because the color content of the light we photograph by varies significantly, depending on time of day and location. Sunlight is much redder at dawn and dusk, and has an extremely blue cast at midday. Indoor light sources are usually warmer yet, and can take on greenish or other hues under fluorescent illumination. These differences could be partially accounted for when prints were made from color negatives, so a single "daylight" balanced film was sufficient for amateur snapshots. Daylight- and tungsten-balanced color negative and transparency films were reserved for more exacting applications.

Digital cameras have only one "film"—the sensor—so it's necessary to compensate for the different colors of light using the camera's *white balance* adjustment. Your camera has several standard settings, including Auto, Fluorescent, Indoor (or Tungsten), and Daylight. Auto attempts to adjust the white balance for the kind

of illumination the camera thinks it is shooting under, but doesn't always function perfectly (which is why the additional settings are available). You may also have options to account for variations in illumination, such as Fluorescent 1 and Florescent 2, and various types of daylight, such as Cloudy/Overcast, or Shade. More advanced fixed-lens cameras and all digital SLRs will also have a setting called Custom, or Preset.

Unfortunately, none of these will match the color balance of infrared illumination. You can, however, adjust the Custom or Preset setting so that it does provide the white balance required for taking infrared pictures. An infrared photo taken using Auto or Daylight settings will have a distinct red cast, as you can see at left in Figure 6.1. When white balance has been set properly for infrared, you'll get the results shown at right in the figure, producing the basic brick-and-cyan look. As you'll learn in Part III, images of this type can be converted to other looks, including straight black and white, channel-swapped false color, and other variations.

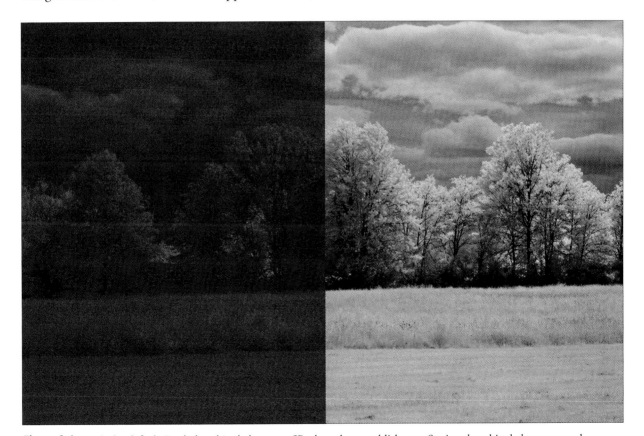

Figure 6.1 With the default Daylight white balance, an IR photo has a reddish cast. Setting the white balance correctly produces a more traditional infrared look.

Although you might actually want to work with a red-saturated image for creative reasons, and you can manipulate an uncorrected IR image in post-processing, most of the time you'll want to capture infrared photos with the proper white balance, if only because the non-reddish version is much easier to evaluate on the camera's LCD after exposure.

White balance is measured using a value called *color temperature,* from about 2,800K (degrees Kelvin) to 10,000K, with visible light illumination falling along a yellow-blue axis somewhere between 3,200K (incandescent lamps) and 6,000K (daylight at high noon). There is also an additional factor, *color bias,* which is oriented along a green-magenta axis. Figure 6.2 offers an over-simplified illustration of the factors involved. The actual white balance for a specific scene might fall outside the color temperature axis onto an intermediate point in the color balance space, represented by a cyan rectangle in the figure.

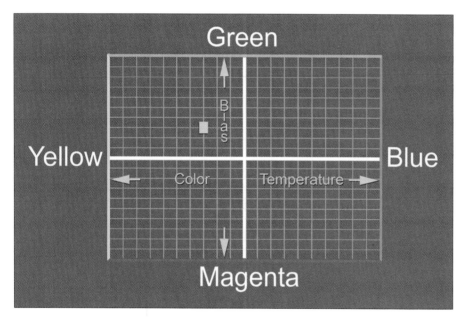

Figure 6.2 White balance can be set for both the color temperature (horizontal axis) and color bias (vertical axis).

Setting White Balance

You'll find that the most advanced dSLR cameras let you set specific white balances using a variety of parameters, including color temperature in degrees Kelvin (often in increments as small as 10 degrees); standard color temperatures such as Daylight or Tungsten (with the added ability to "tweak" those settings within a plus/minus range); or in a combination of color temperature and color bias. Canon digital SLRs, for example, include a dialog box much like the one shown in Figure 6.2 that lets you dial in a "shift" in white balance along either of the two axes. Advanced cameras also may allow you to bracket white balance, shooting a succession of images at different balance settings.

Fortunately, none of these shenanigans are necessary to achieve the right white balance for infrared photos. With many cameras, you can measure the actual color balance and use that custom/preset value for your IR photos. If your camera doesn't allow setting a custom or preset white balance, the Tungsten setting is better than nothing, because a typical IR white balance will be at a color temperature of about 2,000K, which isn't too far off from the 2,800–3,200K offered by most Tungsten settings. The image will have a colorcast, because the Tungsten option doesn't take care of the bias portion of the setting, but you can usually correct the tint in your image editor.

Most digital cameras that allow customizing white balance have some provision for measuring the white balance of an object under particular illumination, and using that as a preset value. Usually, you'll point the camera at a neutral object, such as a gray card, tell the camera to measure that, and store the value as a custom white balance setting.

That's not exactly what we want here. The goal is to set the white balance based on the IR reflectance of an object, and the best way to do that is to measure white balance from a subject that reflects a lot of infrared. Most experienced shooters use the grass or leafy trees as their "neutral" WB target. The procedure varies, depending on your camera. Usually, you'll have to choose White Balance from the Menu system, select Custom, and then a choice named Measure or Set that allows you to point the camera at a subject and measure its white balance by pressing a button, such as the shutter release.

The value is then stored as a preset. If you're lucky, your camera will have several preset slots so you can re-use that WB setting the next time you shoot under similar conditions. If you're *very* lucky, your camera is like mine, and allows you to type in a name for the setting, so you can remember what that preset value is used for. Presets aren't a panacea, however; any time you shoot under different lighting conditions, you'll want to set your IR white balance again.

CHECKING OUT A WHITE BALANCE LIBRARY

Many cameras allow using an existing image as a reference white balance setting. The function works like this: After accessing your camera's white balance custom feature, you choose an image residing on your memory card. Then, you tell the camera to change its white balance setting to match that of the image on the card. It may be worth your while to dedicate a small-capacity memory card to images with various white balance settings, including several for typical IR subjects. You can insert this card into the camera and switch to the WB setting of a particular photo.

Taking Your First IR Landscape Photo

Once your white balance is set up properly, you're ready to take your first infrared photo—probably of a landscape subject. This next section will lead you through the basic steps, showing you some of the things to watch out for, and providing some examples of the kind of photos you can expect to take.

Mount the Camera on a Tripod, Compose, and Focus

Unless you have a converted camera, it's unlikely that you'll be able to take your infrared photos hand-held, so your next step is to mount your camera on a tripod. (If you're using a camera that's been modified for infrared photography, you can skip several of the steps in this chapter, although using a tripod is still a good idea when shooting landscape photos, because they steady the camera at any shutter speed, virtually eliminating camera shake.)

Frame your picture carefully and then twist all the proper knobs and levers to lock the tripod's position solidly. Once you mount the IR filter on the lens, you'll no longer be able to view your composition, so you'll want your camera to remain in position without shifting. If you're using a shift/tilt tripod head, lock both the vertical and horizontal swivels; with a ballhead, tighten the ball adjustment so the camera no longer can be moved. With either type of tripod, if there is a panorama adjustment, lock that down, too.

Before you mount the IR filter, focus your image. Although autofocus will work in some cases (particularly with cameras converted for IR photography), for locked-down landscape photos it's usually best to focus manually. Strictly speaking, infrared light doesn't focus at the same point as visible light (which accounts

for some of the softness of IR images, caused by chromatic aberration), so any visual focus point you set will not be 100 percent accurate.

Back in the olden days, virtually all lenses were marked with IR focus indicators, often colored red. You could focus visually, then set the distance shown by the normal focus mark opposite the IR marker to achieve sharp IR focus. The correct point will be slightly *farther* than the point of visual focus.

For example, when my 85mm f/1.8 lens is focused at 10 feet for visible light, the correct infrared focus point is closer to 11 feet. If I am shooting an object 5 feet away, IR focus is approximately 5 feet, 3 inches. The difference in focus points will be less with longer lenses, and greater with wider optics, and at infinity with any lens the difference isn't very much at all.

The IR indicator lives on today, but usually is found only on high-end lenses. Because the correct focal point for IR varies with the zoom setting of the lens, zoom lenses must have more than one infrared correction mark. The 28mm-70mm f/2.8 zoom lens shown in Figure 6.3 has just two marks, for 28mm and 50mm. When the lens is focused at 4 feet for pictures using visible light, focus needs to be reset to 4 feet, 4 inches when the lens is zoomed to its 50mm focal length, and to about 4 feet, 10 inches when shooting at 28mm.

Figure 6.3 Some lenses have IR correction marks on their distance scales, so you can reset focus for IR photography.

Your best bet is to use a small enough f/stop that the depth-of-field provided will cover the discrepancy. Your lens may even have a depth-of-field scale that shows the range of sharp focus at a particular f/stop. Working in your favor are the facts that the most popular IR subjects are landscapes, with proper focus at infinity, and that wide-angle lenses, with their bounteous depth-of-field are most frequently used for IR photography.

NO ADJUSTMENT NECESSARY

If your camera has been professionally converted for infrared photography, the service may have recalibrated focus for IR picture taking, as a converted camera is no longer capable of shooting visible light pictures and has no need for the original focus calibration. Calibration works best when done for a specific lens; LifePixel, for example, uses the popular 18-70mm zoom lens for Nikon interchangeable-lens cameras as its focus baseline when converting Nikon dSLRs. The company can also recalibrate to another lens of your choosing for an additional fee.

Set Exposure, Mount the IR Filter, and Shoot

With your composition and focus locked in, it's time to go ahead and set exposure. If you're using an unconverted camera, you'll want to use manual exposure, although you can make a reading by visible light as a starting point. Any exposure reading your camera makes with the filter in place won't be much more useful, in any case. You might want to activate your camera's long exposure noise reduction feature, which can help eliminate the noise you're going to get from the lengthy exposures that ensue. Shoot in RAW format, if your camera offers that option, so you'll have the ability to adjust your image as you import it into your image editing software.

Mount the IR filter, being careful not to change the focus point. Then, if you're using an unconverted camera, manually set exposure so it's 10 or 11 stops more generous than your initial reading/guess (using either shutter speeds or lens aperture). It's probably a good idea with dSLRs (which read exposure from the focusing screen) to close the eyepiece shutter at the viewfinder, or cover the opening with your hand, as light can flow into the camera and affect your reading.

The basic exposure is only a starting point, because IR exposures can vary so much depending on the camera, filter, and other factors that you can't expect to be very close on the first try. After you've gained a little experience, you'll know whether to start out at f/11 and 1/4 second, or f/11 and 15 seconds under a particular set of conditions.

Now you're ready for your first exposure. You might want to use a cable release or remote control to trigger your camera, to better avoid camera shake during the beginning of the exposure. If my subject is not moving, I usually use my camera's self-timer, set to a two-second delay. Some dSLR cameras also have a "mirror up" or M-UP setting, which flips up the viewing mirror as soon as the shutter release button is pressed, but doesn't take the photo for several seconds, allowing the camera to settle down from any vibration induced by mirror movement. Mirror up is especially useful for pictures that can be particularly affected by vibration, such as close-up photos, pictures taken with a long lens, and, oddly enough, *shorter* "long" exposures in the 1/30th second to 1 second range. (With multisecond exposures, the duration of mirror vibration is such a brief part of the exposure that it has less effect on the image.)

Whether you use the self-timer or mirror up feature, the delay allows enough time for the camera and tripod to stop vibrating, but isn't so long that you idle around like an idiot waiting for the exposure to begin. You'll have plenty of time to stand by looking dumb during the long exposure. I've actually taken 30-second exposures which were followed by 30-second dark frame/noise reduction "exposures," so I had enough time to get caught up on my reading between shots.

Once the exposure is over, review the image on your LCD. You might need to shield the LCD with your hand so you can get a good look at the image. You may not be able to tell if the exposure is good, but you can certainly see if the photo is unspeakably dark, or completely washed out. Adjust your shutter speed appropriately (if you change the aperture instead, the focus point can change) and take another photo. It may take two or three pictures, but eventually you'll arrive at the right exposure for your infrared photos.

When you've finished taking your IR pictures, it's time to go back to your computer and process them, using the techniques I explain in Part III of this book.

Infrared Landscape Examples

The rest of this chapter provides a showcase for some of the kinds of landscape photos you can take using infrared illumination, with special emphasis on the importance of watching how the tones in your image mesh to provide a realistic—or non-realistic—photograph. I'll present each image in turn, provide a few details of how it was taken, and offer some suggestions on how you can achieve the same look—or do even better. If post-processing is involved, you'll learn the exact techniques in some detail in Part III.

Capturing Beacons of Light

Landscape photos traditionally are unpopulated by humans. An occasional seagull or other wild creature won't ruin the shot, and picturesque human-made structures such as barns, old shacks, or lighthouses are also fair game. If your subject matter isn't in some remote location, or is, as in the case of the beacon shown in Figure 6.4, actually a popular tourist attraction, removing the human element can be tricky.

I discovered that this lighthouse reflected enough infrared illumination that it presented a brilliant, stark white look that contrasted well with the IR-darkened sky. So, I visited the site in the middle of the first week in October when the daily hordes had subsided, arriving late in the day when the lighthouse itself was closed to visitors and the state park surrounding it was almost devoid of visitors. There were still a few stragglers wandering around, so I set up my camera on a tripod, framed my composition, and snapped off pictures when the humans had stepped behind the tower or had finished gawking and made their way back to their vehicles.

In this case, the sky was almost cloudless, making a smooth gradient background for the proud lighthouse structure.

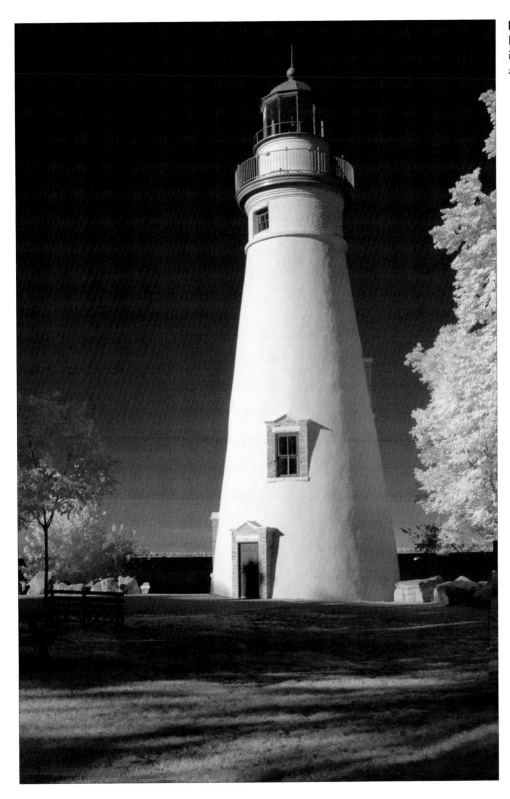

Figure 6.4 This old lighthouse adds an interesting element to a landscape shot.

Treetops

I didn't have to travel any farther afield than my backyard to capture the treetop landscapes shown in Figure 6.5 (parts A and B on the facing pages). By pointing the camera skyward, I grabbed an arboreal image that didn't include any of the typical suburban/rural yard paraphernalia that would have ruined the landscape mood.

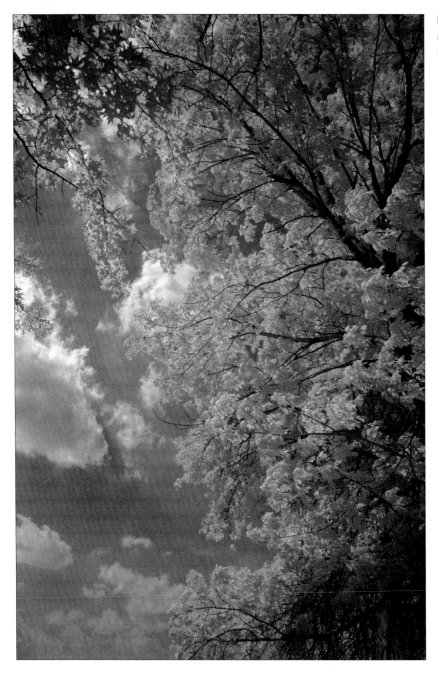

Figure 6.5a This is the straight shot without any hue manipulation.

Figure 6.5a is a straight infrared shot. For Figure 6.5b, I moved so that the sun was directly behind the top of the tree, producing a backlit effect. Then, in my image editor I used the Hue slider to give the overall color tones a greenish bias, while still leaving the foliage as the typical IR eerie white.

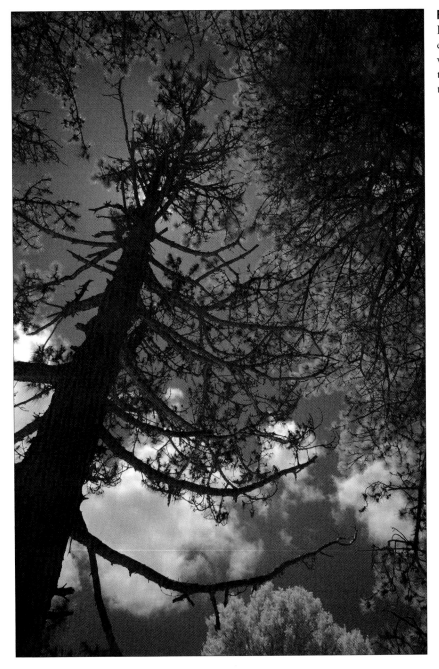

Figure 6.5b Manipulating the Hue slider in your image editor can provide several color variations of the same basic theme, such as this green-tinted version.

Haze-Piercing IR

Infrared illumination pierces right through the haze that often cloaks distant subjects, so that mountains off at the horizon can be seen clearly, and maritime horizons appear as vividly sharp as they do in Figure 6.6. The picture was taken late in the day, so the setting sun provided an interesting dappled effect on the trees in the middle foreground. The only post-shot manipulation required was a bit of lightening to make the detail in the rocks in the extreme foreground more apparent; they were almost hidden in shadow in the original photo.

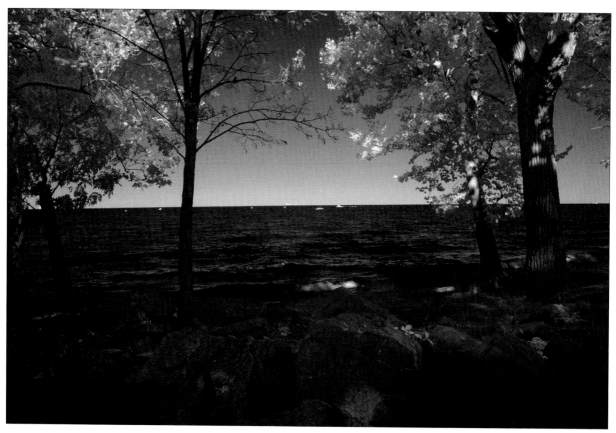

Figure 6.6 Infrared cuts right through the haze, producing a sharp, clearly defined horizon.

Figure 6.7 shows a different shore, with the almost otherworldly demarcation between sky and water at the horizon emphasized by using an image editor's Hue adjustment to give a greenish tint to the upper two-thirds, and a bluish appearance to the lower third. No real-world landscape on the planet Earth resembles this view, and that's what makes the image so eye-catching and, perhaps, a little disturbing. You may not even like the effect, but the picture does stand out.

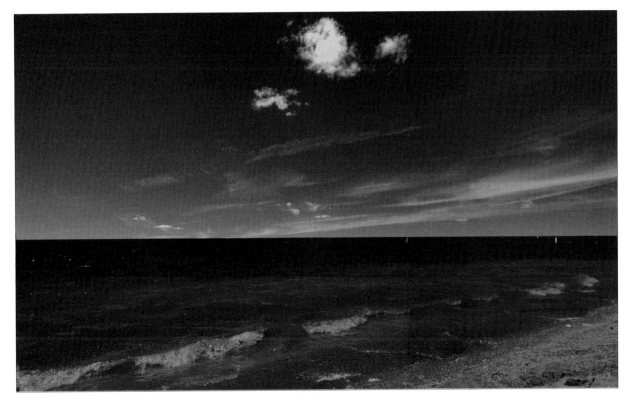

Figure 6.7 Wild color variations between the upper and lower portions of the image produce a jarring effect.

Dramatic Skies

Most color IR shots are obviously infrared renditions because of the strange colors assigned to familiar objects. The image shown in Figure 6.8 could easily pass as an ordinary color photo, because there are fewer clues to its origin. For example, the channel swapping technique (described in Chapter 12) gives the sky a realistic blue appearance. The foreground snow is white (with a slight blue cast), exactly as you'd expect from a mid-winter scene. Only the band of trees in the middle looks odd. They've been converted from their barren, dark look under visible light to a brighter light tan color, because even without foliage the trees reflect IR illumination.

No matter what time of year you shoot, you'll find that any day with a sky filled with clouds is an excellent opportunity for dramatic landscape photos. The water vapor in the clouds reflects a lot of IR illumination, and the sky itself tends to absorb much of it, providing a contrast that's even more vivid than you'd get in a visible light photo with a polarizer filter.

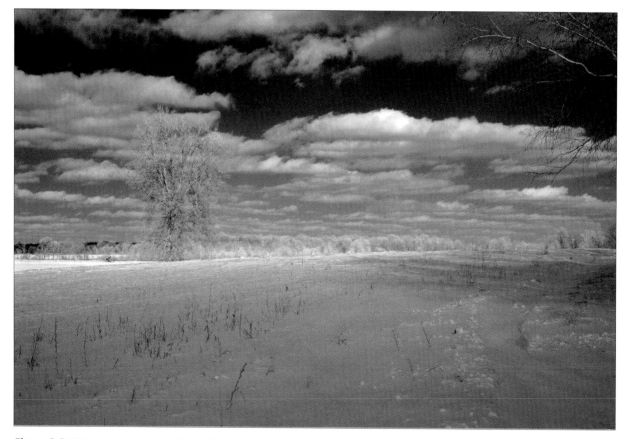

Figure 6.8 This wintery scene could pass for a conventional visible light photo with its natural-looking, if slightly odd, coloration.

Sunrise, Sunset

Don't avoid shooting landscape photos by infrared illumination at dusk and dawn simply because the brilliant ruddy colors of sunset and sunrise won't be visible. More monochromatic photos taken late or early in the day can still be interesting.

For the image shown in Figure 6.9, I waited until the sun had actually set behind the trees and dipped below the horizon, so that the sky was more evenly lit. This rendition is moodier and allows the reflection of the sky to echo in the lake more delicately. The straight brownish tint of the infrared image gives the photograph an old-timey, sepia look without the need for any color manipulation in an image editor.

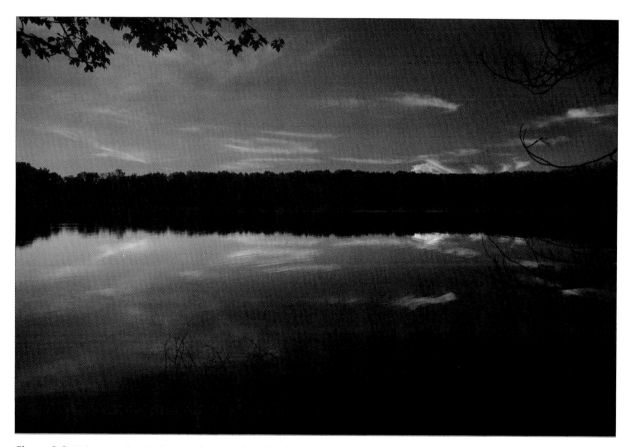

Figure 6.9 Who says that landscape photographs taken late in the day have to be dominated by vivid reddish hues? After the sun has set, more subtle coloration can take over in an infrared image.

Amber Waves of Grain

You'll find that grain won't actually be shown in amber hues in infrared images, because plant life in all its forms often is portrayed in stark white tones. I was captivated by the four distinct bands of tone in this cornfield (see Figure 6.10)—the dark brown of the sky; the vivid white of the upper leaves of the cornstalks; the medium white of the lower, shaded halves of the stalks; and the dimmer, slightly blue-toned hues of the rooted areas. I shot the entire expanse, but cropped the final image into a vertical rendition that emphasized the stacked "layers."

Such fortunate arrangements of tone won't be readily apparent when viewing your subject matter under visible illumination, so you must be prepared to evaluate the images you've taken to uncover possibilities hidden within the frame.

Figure 6.10 Four distinct bands of tone give this cornfield photo an abstract look.

Fall Colors, De-Colorized

As leaves change their colors in the Fall, their ability to reflect high quantities of infrared illumination isn't appreciably diminished. You'll want to go out and take traditional visible light color photos filled with reds and oranges, yellows, and greens, of course, but autumn is also a time to explore the possibilities if IR photography.

It was an overcast day when I shot the picture shown in Figure 6.11, so the sky is bright and less dramatic than it would have been on a sunnier day. But the diffuse illumination provided a more muted look to the leaves that remained on the trees and those that covered the roadside. My test shots revealed an almost wintery scene, with the leaves resembling a coating of snow, so I went ahead and captured this image and converted it to a straight black-and-white shot in my image editor.

Figure 6.11 Autumn resembles winter in this black-and-white shot of fallen leaves on an overcast day.

Infrared in Winter

There's no need to pack up your infrared photography gear as winter approaches. You'll find there are some interesting possibilities for IR images even when the trees are barren of leaves, as this pair of photographs reveals. All you need is a little imagination, and an unusual viewpoint to produce an interesting wintertime infrared landscape.

We had a surprise snowstorm the day the folks who drive the brown delivery trucks brought me my new 10-17mm fisheye zoom lens. I wasn't eager to venture out for a slog in the snow, but did take a few steps outside my front door to shoot this hedge laden with a foot of the white stuff (see Figure 6.12) with the trees and sky in the background to provide contrast. The brown-tinted sky, white snow, and bluish tones of the "evergreen" foliage in this unmodified shot gave the image some interesting "color." The fisheye zoom, set to a distortion-filled 10mm focal length provided a bit of curvature to an otherwise "straight" photograph.

Figure 6.12 A fisheye zoom lens captured this hedge laden with snow following a winter storm.

The rural byway shown in Figure 6.13 appeared virtually untouched by human passage (although some animal tracks can be seen) when I visited shortly after a snowfall. I captured the quiet scene while venturing only a few feet from my car, then used the ever-popular channel swapping technique to render the sky blue in this almost realistic but distinctive landscape photo.

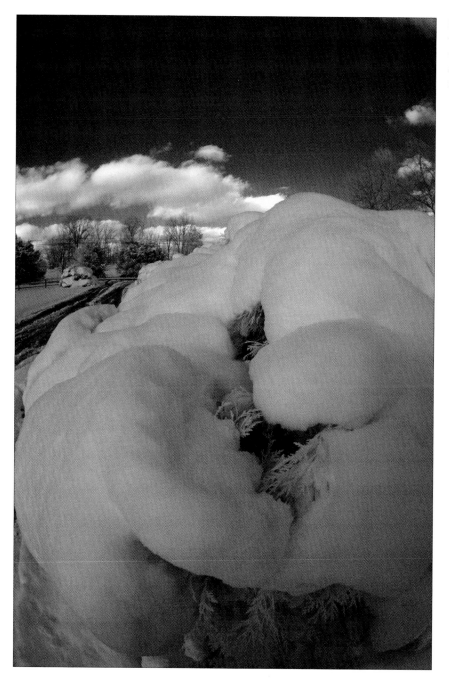

Figure 6.13 This quiet rural vista was given a realistic treatment through channel swapping, rendering the sky a natural-looking blue.

Multi-Color Magic

In experimenting with infrared photographs for this book, I managed to develop a technique I'd never seen applied to infrared photography before. It's a variation on the time-honored Harris Shutter technique, in which a single visible light image, typically of about one-second duration, is exposed through a succession of red, green, and blue color filters, so that fixed objects receive "normal" exposures and are rendered with their normal color schemes, but moving objects receive individual red, green, and blue exposures as they pass through the frame. Those parts of the image that are in motion are rendered in a rainbow of colors. I'm going to show you how to reproduce the Harris Effect in an infrared photo without the need to construct a Harris Shutter or use any separate filters.

The traditional way to produce this multicolor effect was developed by Kodak technical whiz Bob Harris for the *Here's How Book of Photography, Volume VII* back in the 1970s. A strip of cardboard containing red, green, and blue filters is dropped through a slot in a frame affixed to the front of the lens during an exposure of about 1/4 second (see Figure 6.14). As you can see in the normal visible light photo shown in Figure 6.15, the water, which is flowing, is rendered in an array of colors. There are directions for creating a Harris Shutter in my book *Digital SLR Pro Secrets*, also from Course Technology.

You can't easily use a Harris Shutter for infrared photography. The RGB filtration will be affected by the infrared filter used; plus, if you're working with an unconverted camera, shutter speeds are likely to be too long for the partial-second exposure required. You'll have to use my technique, which uses a composite of three separate images, instead, to produce a picture like the one shown in Figure 6.16. Notice that colors are produced not only in the moving water of the waterfall, but among the clouds in the sky, which were also in motion while the pictures required for the composite images were taken.

Figure 6.14 The traditional Harris Shutter allows making a single exposure through a succession of red, green, and blue color filters.

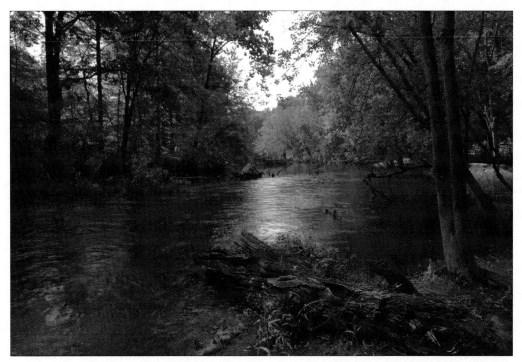

Figure 6.15
A visible light photo taken through a Harris Shutter looks like this.

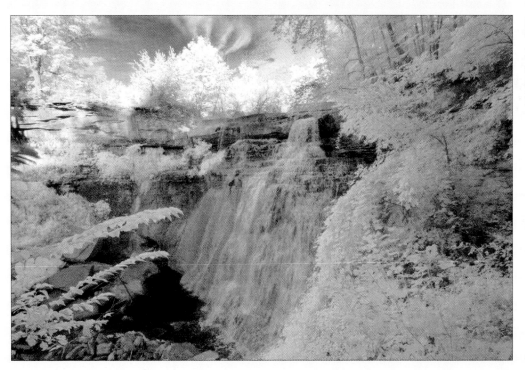

Figure 6.16
The Harris Effect can be simulated in infrared photos.

To mimic the Harris Effect in infrared, you'll need to use a tripod, even if you have a camera that's been converted for full-time infrared use. My technique uses three separate photos, taken seconds apart, combined into a new image using the red channel from one photo, the green channel from a second image, and the blue channel from a third. There is enough variation in the individual channels to create the multi-colored effect you see. Just follow these steps:

1. Set the camera on a tripod, compose your image, and lock the camera down securely.

2. Take a test shot, if necessary, to make sure you've selected the correct exposure.

3. Expose four to six pictures, one after another, being careful not to move the camera between shots. You can use a remote or wired release to trigger the camera without introducing camera shake, or switch the camera into continuous shooting mode and take a series of pictures. If you use the latter technique and press the shutter release button with your finger, you'll find the first one or two images won't register exactly with the others because the camera will shake a little when you first press the shutter button. Discard those shots and work with the last three you took.

4. Load three images you want to work with into your image editor and copy them into separate layers in a single image. This will allow you to flip back and forth between layers and see if all three images are in perfect register. If not, you can nudge any errant layers into alignment.

5. Switch to Channels view (the Channels palette in Photoshop, for example) and select the Red channel of one layer. Copy that layer.

6. Create a new, blank document, switch to Channels view, and paste the Red channel you copied down into the empty Red channel of the new document.

7. Back in the original, layered document, change to the second layer (which is a different image from that of the first layer) and copy its Green channel. Paste that channel into the Green channel of your new document.

8. Repeat Step 7 using the third layer and the Blue channel of that layer and the empty Blue channel of your new document.

9. Activate all three channels and you should have a multicolored image like the one shown in Figure 6.17.

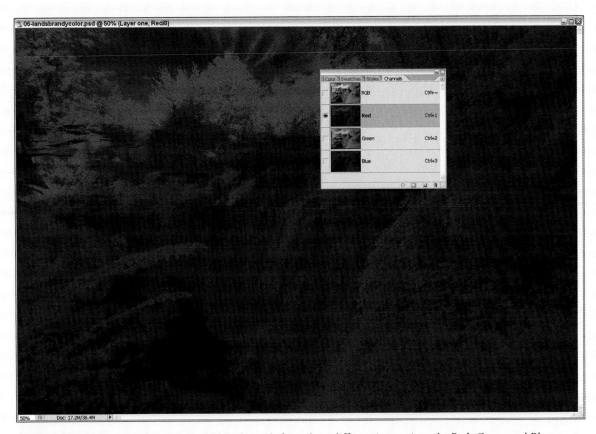

Figure 6.17 Copy the Red, Green, and Blue channels from three different images into the Red, Green, and Blue channels of a new document.

Next Up

Flowers and other plants rendered in close-up or distant views make for interesting infrared photo subjects. In the next chapter I'm going to show you how to get both realistic and abstract effects using plantlife. You'll discover that traditional infrared photography techniques are only the starting point for interesting images.

7

Flowers, Plants, and Close-Ups

Photography of flowers and plants offers some of the same allure as landscape shooting—the eerie pale leaves and petals, the interesting grain and slightly soft-focus effect that sometimes crops up, and the false colors that are unusual in their own right, but can be manipulated in an image editor for truly alien-world looks.

But plant life also has a charm of its own, especially when photographed in close-up. You'll be surprised to discover that not all parts of a given plant reflect IR illumination the same. Some components, such as the petals of a flower, reflect a large percentage of the infrared light that falls on them. In fact, plants can actually *fluoresce* in the near-IR range when struck by sunlight, contributing additional infrared illumination to the image. (As a practical matter, though, this extra IR is very small.) Other parts of the plant, such as seedpods and some stems, absorb more of the IR than the leaves and petals, producing an effect like the one shown in Figure 7.1.

Plants and flowers can be one of the best subjects for infrared photography, because the results you get are always unpredictable and interesting, and, unlike landscape images, can be captured at any time of year, in any weather. If it's dark and dreary outside, you can slip out to your local florist, pick up a bouquet, and scurry home for a satisfying photo session indoors. Incandescent lamps or electronic flash both emit enough infrared light for successful IR photography, and, when shooting in your home "studio" you can select backgrounds, choose your subjects, and position them any way you like.

This chapter provides some examples of infrared photography of flowers and plants, both indoors and out.

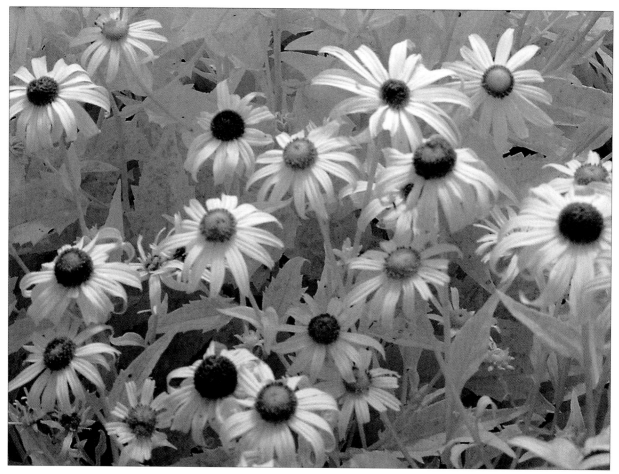

Figure 7.1 Seeds reflect less IR than leaves and petals, producing an interesting contrast in photos like this one.

Stalking the Elusive Stalk

Flora can be photographed using the same techniques described in Chapter 6, using a tripod to steady the camera if you're using an unconverted model with an external filter attached to the lens. As with landscapes, it's still a good idea to use a tripod to capture plant life in close-up, because focus and composition are especially critical for macro photography. That's particularly true outdoors, where any gust of wind can move your subject out of the plane of sharp focus. Here are some things to consider when taking IR pictures of flowers and plants:

- **Focus carefully.** As I mentioned in Chapter 6, the infrared focus point isn't exactly the same as the focus point for visible light, and the difference in focus point is greater for shorter focal length lenses than for longer optics. You'll have less depth-of-field when shooting close-ups, too, so the added focus range

of a small f/stop won't always save you. If your lens doesn't have IR indicator markings on its focus scale (or lacks a focus scale entirely), after you've achieved sharp focus, reset focus manually about 10–20 percent farther than the actual distance. For example, when focusing at 12 inches, measured from the subject to the *focal plane* of the camera (usually close to the back panel of the camera), not the front element of the lens, the IR focal point is likely to be at 13 or 14 inches. You may have to experiment to learn the exact amount of adjustment to make to ensure correct focus. Take photos of a subject at the visually indicated focus distance, as well as at 5 percent, 10 percent, 15 percent, and 20 percent farther, and see which is actually in focus. Then use that amount as an adjustment.

■ **Watch for breezes and movement.** The bane of outdoor flower photographers (by visible or IR light) is the slight breeze that moves the blossom out of the plane of focus, or even completely relocates it in the frame, just as the picture is taken. If you're using the camera's self-timer to avoid camera shake the problem is worse; at least two to ten seconds may elapse before the picture is taken, plenty of time for a gust of wind to appear out of nowhere. If you use a very long exposure (1 to 30 seconds) because you want the added depth-of-field of a small f/stop, you increase the chances that your subject will be moving for at least part of the exposure. Veteran floral photographers carry along pieces of foamcore board or other reflectors both for their light-bouncing abilities, and because they provide a shield against the wind.

■ **Keep your tripod and its shadows out of the picture.** Another common problem is keeping the tripod from intruding on your picture. The best angle for illuminating your subject might produce distracting shadows that fall on your subjects. A stray tripod leg can find its way into the picture area, too. More expensive tripods offer various solutions, including a tilting "boom" arm that can be extended several feet out from the tripod legs to bring the camera close to the subject. However, even inexpensive tripods usually have a center column that can be reversed so it drops below the tripod legs. Extend the legs as far as possible to keep them and their shadows out of the picture area, and then lower the camera (which is mounted upside down as in Figure 7.2) down to the level of your flowery subjects.

■ **Create your own backgrounds, if necessary.** That reflector you use as a wind shield can also make a plain background that will help show off your bloom without distracting elements behind it. A reflector that's black on one side and white on the other can be used to good effect, but I always carry a piece of black velvet that I use to provide a dark background as required. (See Figure 7.3.)

Figure 7.2 Reverse the center column of your tripod to take close-up pictures without worrying about the tripod itself introducing into the photo.

Figure 7.3 A dark background provides contrast for this photograph of a red, red rose that appears almost white under infrared illumination.

Adding Interest to Infrared Flower Close-Ups

There's one constant challenge to shooting floral infrared photos: the resulting images tend to be monochromatic. You'll find that black-and-white or black-and-blue or black-and-sepia flower photographs can be interesting in their own right, but one of the reasons we love these blossoms so much is that their colors are so brilliant. You'll need to exercise your creativity to make your IR photos as interesting as possible, despite the absence of saturated reds, greens, blues, yellows, and oranges all in the same photo.

As with any kind of nominal black-and-white or monochrome photography, it's important to train yourself to see the mergers between objects in your frame that are clearly differentiated in full color. Figure 7.4 shows a bed of flowers that looked great in color, but when rendered in infrared the leaves in the background took

Figure 7.4 In black and white, the flowers are dull and lifeless, despite the relatively high contrast lighting.

on the same tone as the flowers themselves. In black-and-white, all the details seem to blur together. Applying a blue tint in an image editor adds a little color, as you can see in Figure 7.5, but the resulting photo is still seriously blah.

Figure 7.5 Adding a little color does little to help, because the leaves and petals still tend to blend into each other.

Selecting a different angle, in which the background is much less brightly lit, isolates the flowers through the magic of selective focus. Channel swapping also introduced some false color, as you can see in Figure 7.6. Some of the inner parts of the flowers were active and rendered in a delicate blue, while others had served their reproductive functions and had shriveled, no longer reflecting infrared illumination. A simple change in shooting angle produced a more interesting photo.

Figure 7.6 Changing the angle and using a false color rendition made a more interesting image.

Color Transformation

You'll find that post-processing techniques, like those explained in Part III, can lift your infrared shots out of the monochrome doldrums by applying false color to otherwise mundane photos. I'm going to show you how to take the flat-looking image shown in Figure 7.7 and transform it into the colorful version you can see in Figure 7.8, using nothing more than the basic tonal and color control tools of Photoshop, combined with standard layer merging techniques.

Figure 7.7 You can take this unmodified infrared shot…

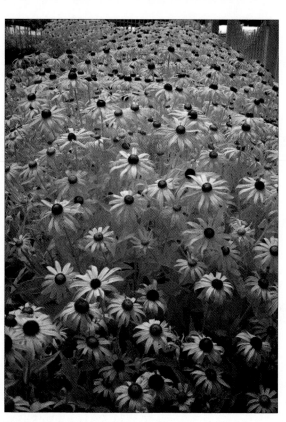

Figure 7.8 …and transform it into this colorful version using only a few steps.

To effect this transformation, just follow these steps:

1. Make a duplicate of the base layer of the image.
2. Rename the duplicate layer Auto Colors (to help keep things straight).
3. Rename the base layer as Auto Levels.
4. Highlight the Auto Levels layer and choose Image > Adjustments > Autolevels.
5. Highlight the Auto Colors layer and choose Image > Adjustments > Auto Colors. The two layers will look like those shown in Figure 7.9.

Figure 7.9 Apply Auto Levels and Auto Color to two different versions of the base layer.

6. With the Auto Levels layer still selected, choose Hue as the merging mode from the Merge menu, shown in Figure 7.10.

7. Use Layer > Flatten Image to combine the two layers.

8. Select Image > Adjustments > Hue/Saturation and move the Saturation slider to the right to get the rich, full-bodied image I showed you in Figure 7.8. That's all there is to it. You'll find other post-processing tricks in Part III of this book.

Figure 7.10 Merge the two layers using the Hue merge option.

More Flower and Plant Ideas

I'm going to round out this chapter with some example photos showing the kinds of pictures of plants and flowers you can take using infrared imagery. All of them are more-or-less straight shots, using either images right from the camera or with channel swapping applied.

Indoor Close-Up

It was a dreary day, so I brightened up the place with some bought'n flowers, including this bloom that I placed in a vase and set up on a table with high-intensity desk lamps on either side and a black velvet backdrop behind. The lamps were placed slightly behind the vase, so that the flower was slightly backlit, and most of the illumination fell on the edges of the blossom. A little spilled over onto the background.

I was surprised at the results, because the background reflected a lot more IR light than it did visible light, and different parts of the flower responded to the infrared illumination in different ways (see Figure 7.11). When shooting close-up photos indoors, you can learn a lot about how plant life absorbs or reflects infrared light.

Figure 7.11 This backlit blossom takes on a delicate appearance under infrared illumination.

Experiment with different types of flowers and plants, change your backgrounds to investigate how they behave under IR, and look at other effects that can be used creatively. You may be surprised to learn that black marking pens reflect more IR than most types of black cloth, so you can write messages on black fabric that appear only in infrared photographs. Or, you'll learn exactly which parts of plants reflect the most IR light, and can use that information to create images of familiar flora that look very different from what you might expect to see.

Lily Pads in a Pond

When I took a visible light photo of the lily pads in this rural pond, the colors were bright enough to verge on being distracting, as you can see in Figure 7.12. Plus the pads themselves were starting to turn brown, and looked a little ragged. Infrared photography gave the lily pads renewed life, adding a cool, abstract look to the arrangement, shown in Figure 7.13, taken from a slightly different angle.

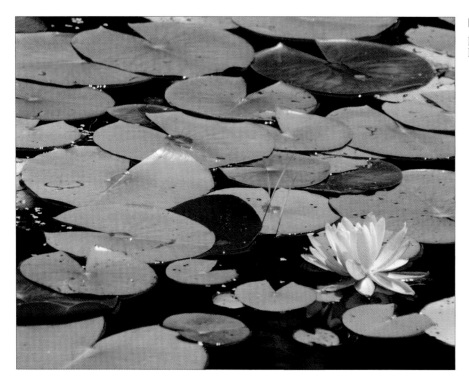

Figure 7.12 This visible light photo of lily pads in a pond has an almost garish quality.

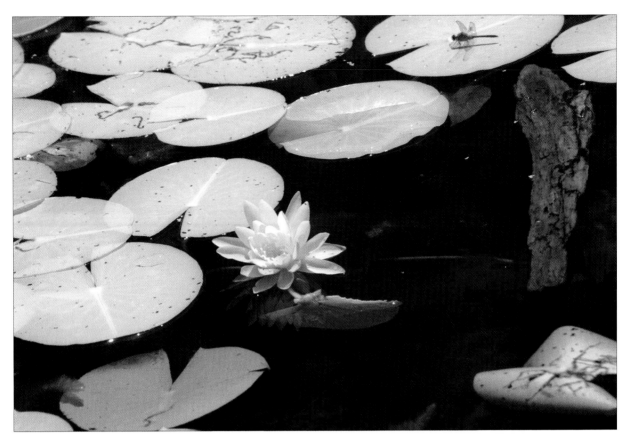

Figure 7.13 The colors have been toned down considerably in this infrared version, producing a more tranquil look at a quiet rural pond.

Dominated by the off-white of the pads themselves and the light color of the flower, the brown tones in the rest of the image add just enough color. You'll find that infrared renditions of familiar subjects can produce images that are fresher and more interesting than the real thing.

Beach Scene

I was making a long trek down a beach to photograph a lighthouse when I sat down on a log to rest, and spotted this plant, pictured in Figure 7.14, which was, like me, taking advantage of the shade. I took several lackluster photos by visible light, but found I liked the look of the plant and the surrounding sea grass much better in this infrared version.

The day was almost cloudless, so the water and sky in the upper quarter of the image provide a band of sepia tone that contrasts with the lighter tones of the sand and plant life. When shooting infrared at the beach, venture far enough from the waterline to discover some interesting vantage points that show more than just the shore itself and the ocean or lake. These nooks away from the busy action on the beach may provide shelter for small creatures you can include in your IR images.

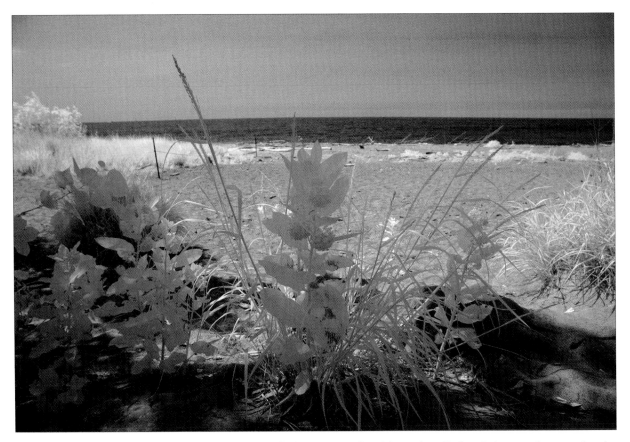

Figure 7.14 Move away from the shoreline, and you'll find interesting plant life worthy of infrared photography at any beach.

A Formal Garden

I'm a frequent visitor to this early 20th century "castle" built from an original design for a Midwest industrial magnate, and not copied from any European counterpart. (You'll find a picture of the castle itself in Chapter 9.) The formal gardens make an especially interesting subject for infrared photography, with the charming stone steps and benches, flora arranged in beds and pots, and the tasteful design.

I climbed the steps leading to the back entrance of the castle so I could shoot down the display of flowers and plants shown in Figure 7.15. I had to crop the image at the top to remove the sight of two ugly trees that were badly in need of a tree surgeon. Formal gardens usually benefit from careful selection of angles so you can emphasize the geometric design and (usually) fastidious care that the showcase plants receive.

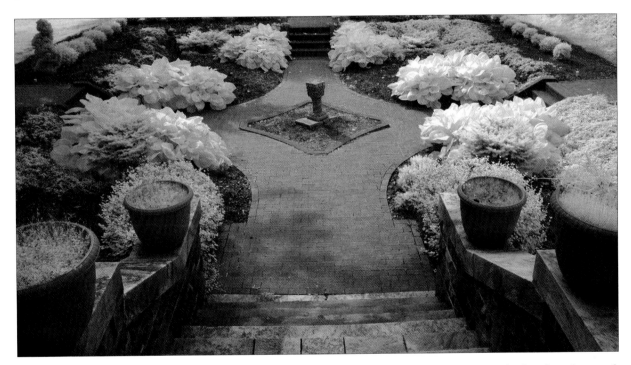

Figure 7.15 The symmetrical design of this portion of a formal garden is evident in this IR photograph taken from the top of the steps leading from the home.

Next Up

People, and the events where they congregate, are prime sites for creative infrared photography. Unlike the landscapes and flower/plant photography showcased in the last two chapters, people and their artifacts are always on the move. You'll find the subjects highlighted in the next chapter to be perfect fodder for cameras that have been converted to full-time infrared photography. Even so, with a little imagination and planning, you can apply the advantages of IR imaging to these subjects when using any camera.

8

People, Places, and Things

Professional photographers are just like the rest of us in many ways, but they are quicker to recognize a very good thing when they see it, and adapt that innovation to their work whenever it provides them with a photographic or creative edge. Infrared photography is one type of imaging that has recently become *very* popular among the pros, and not just because IR imaging can lead to some stunning landscape photographs.

No, IR photography is now very trendy in some of the bread-and-butter professional photo arenas, including commercial product photography, fashion photography, wedding photography, and portraiture. Infrared illumination renders familiar objects in a new light, and renders human skin in a special way, camouflaging skin problems and defects. Brides love the romantic look IR photography adds to traditional wedding photography, even though they don't understand exactly how the high-key black-and-white effect is produced.

I've even seen infrared *motion picture* photography applied in non-traditional ways. (You may not have noticed the black-and-white automobile commercial with the sporty coupe speeding down a winding road surrounded by trees with stark white leaves. But I did.) Infrared photography of people, places, and things was the Next Big Thing for a long time. But now, it's Here. Big time.

There are serious challenges to be met. In comparison, infrared photographs of landscapes and flowers are a snap. Nature's subject matter won't impatiently get up and leave in a huff after enduring a series of 10 to 30 second exposures. People, on the other hand, are likely to lose some of their spontaneity after the rigors of

a few lengthy IR pictures. You can certainly set up your camera and shoot infrared portraits of family, friends, and colleagues, but you'll need to work more quickly, think faster, and apply your creativity as rapidly as you can.

Human beings are the most fascinating subjects of all. The person you photograph today may look completely different tomorrow, or might even adopt several different looks in a single afternoon with a quick change of clothing or hairstyle. Change the environment and surroundings, and you can change the way you capture your subject's personality. Modify the lighting, and a person can be pictured as sinister, powerful, or glamorous. It's your choice.

The events people attend also make for some interesting IR photo opportunities. Concerts, balloon lift-offs, car shows, air shows, county fairs, parades, and memorial services can be pictured in new ways using infrared photography. While most of these can be captured using a tripod-mounted camera and an external visible light cutoff filter attached to the lens, photography of active people, the places they visit, and the things they interact with make perfect fodder for cameras that have been converted to full-time IR use. Many of the best pictures in this chapter were taken with a converted camera. Even so, more than half of them could also have been captured with longer exposures and a camera on a tripod, so no matter how you're capturing your IR pictures, you'll find something of interest in this chapter.

Working with Tonal Values

In picturing people and their artifacts using infrared illumination, one thing you'll have to deal with is the way tones are represented. With some kinds of subjects, particularly landscapes, the weird tonal values are what make the photograph interesting. When you're shooting people, you'll want a more realistic rendition, even if it's one that takes advantage of the special tonality of IR photography.

There are three things, all related, that you need to consider: colors are represented as different tones than they are in visible light photos; the monochrome results you get show the tonality of the image in different ways; and some colors don't even show up at *all* in an infrared photograph. The first three figures help you understand how colors are represented differently.

Figure 8.1 is a straight visible light photo of a figure that adorned a kiddie ride at a county fair. You can see the reddish tones of the creature's cheeks, inside his nostrils, and on his belly, all in vivid contrast to the green of his skin. Figure 8.2 is an infrared shot of the same figure, taken a few seconds later (which you can deduce from the movement of the background clouds toward the right side of the frame, and the presence of a little bit of infrared flare at the right side of the image). The creature has taken on an overall blue and gray tone and the red of his cheeks and

Figure 8.1 The full-color version shows the dragon in all his multi-hued glory.

Figure 8.2 In the infrared rendition, many of the tones have vanished or merged.

nostrils has blended in with the skin so there is no longer any differentiation. The same thing can happen when you're photographing people and other subjects: tones that you expect to be there to separate one portion of the image from another are no longer visible under IR illumination, so it's possible for objects to blend together in ways that you don't want.

Figure 8.3 is the same image as Figure 8.2, but with the red and blue channels swapped, as explained in Chapter 12. Now, the sky is a more realistic blue (instead of brown) and the blue creature has taken on the brown hue. The red blush of its cheeks is still not visible.

Figure 8.3
Swapping the red and blue channels creates a more realistic sky, but the dragon remains monochromatic.

Add a person to the image, and things become more interesting, because we *know* what people are supposed to look like. Figure 8.4 shows a Civil War re-enactor cleaning his rifle. The infrared shot gives him a pinkish hue, but, oddly enough, his cap comes out blue rather than the Johnny Reb gray it really was in the original scene. You might like this rendition because of the interesting color scheme. Or, you might prefer the sepia-toned version created in an image editor (shown in Figure 8.5), because we're all accustomed to seeing old-time photos with a coffee-colored hue. You'll find that many IR photographs of people or artifacts look best in monochrome, rather than false color, using either a black-and-white interpretation or a version that's been tinted sepia brown, cyanotype blue, or some other color.

Figure 8.4 The colors are a bit odd in this photo of a Civil War re-enactor cleaning his gun.

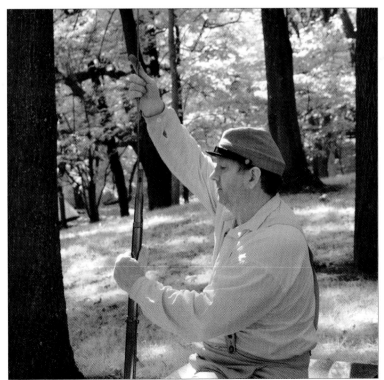

Figure 8.5 Changing the tones to sepia provides a more believable War Between the States look.

There's one final consideration that you absolutely must be mindful of when taking photographs of people. Infrared illumination has a tendency to ignore or mask the dyes in clothes, rendering them white, so that darker objects underneath may show through what would otherwise have been obscured by the colors. That's a tactful way of saying that IR photography *does not* see through clothing, but in removing the colors you may be able to see some details that wouldn't be quite so apparent otherwise. In Chapter 10 you'll find a few action photos of baseball and basketball players who were wearing colorful jerseys, complete with stripes, numbers, and other decorative features, but which appear solid white in my IR pictures.

All cloth and dyed fabrics suffer from the same anomaly. The hot air balloon shown at the bottom of Figure 8.6 isn't really a diaphanous plain white color. As with most balloons of this sort, it's colorfully festooned with multi-hued panels and decorations, as you can see in the shot taken by visible light a few seconds later at top. Modesty reasons aside, you'll want to take into account that colorful clothing and other bits of fabric won't be quite so vivid under IR as they are in visible light.

Infrared Portraits: Informal, Formal, and Candid

Infrared portraits can be taken in three general types of venues. You can informally pose the person you want to capture, using the light you have available to create a particular mood or look. It's also possible to set up a studio environment in your home, and use multiple lights to create a formal portrait using time-honored lighting techniques. Finally, you can grab a candid portrait on the run, capturing your subject in the middle of whatever activity they are engaged in. All three are valid types of portraiture, whether you're using visible light or infrared.

Informal and candid portraiture is something of a new art. For many years, most portraits—including the painted variety created before photography was invented—were crafted in a studio of some sort. Unless you were a high-born noble with the privilege of doing exactly as you pleased, you had to go to the artist or photographer's studio, where the lighting, background, props, and other elements were assembled and could be easily controlled. That soft and flattering "north light" used to illuminate portraits could be best guaranteed by painting or taking pictures in a space designed for that purpose.

Studio portraits remained the norm until the late '60s and early '70s, when an emphasis on more natural, less formal, realistic photography emerged. "Candid" wedding photography was sought after, and even the most disciplined professional photographers became eager to set up lights in your living room to create family portraits in your own habitat, or take environmental portraits in your backyard or nearby parks.

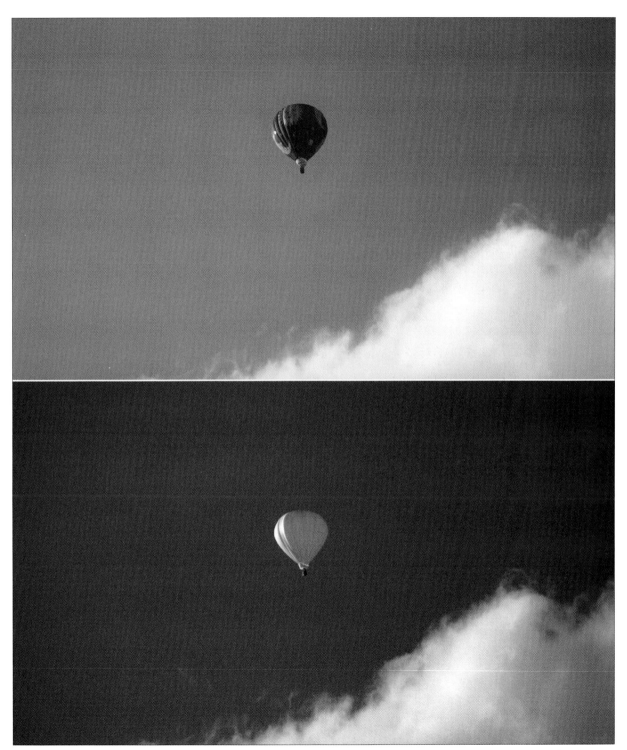

Figure 8.6 The colorful hot air balloon snapped by visible light (top) appears a dramatic pale white when captured under infrared illumination.

We still place value on formal portrait sittings, but it's more common to shoot our people pictures in natural images that reflect the surroundings of the person pictured. Figure 8.7 doesn't look much like an infrared portrait, but it actually is. It's a black-and-white image of a teenager shot using only window light as the illumination. The chief advantage of taking this picture by infrared is that infrared light tends to soften skin tones, hide blemishes, and create a softer look. This particular image was taken using a soft-focus lens to further disguise any skin problems that remained.

IR photography can also be used for more formal studio portraits, with the added twist of the special rendition that infrared illumination provides. Studio portraits are usually more formal. With a professional-looking backdrop or a "serious" background such as those omnipresent shelves of professional journals you see in so

Figure 8.7 Infrared photography is kind to teenage skin, as this soft-focus portrait taken by diffuse window light shows.

many executive portraits, a studio portrait can have a formal or official appearance. Even the crazy Mylar backgrounds and wacky props they're using for high school portraits these days retain a sense of "this is a professional portrait" in the finished product.

All you really need to shoot more formal portraits are a decent background, supports to hold the background, and a tripod if you're going to be using incandescent illumination (you won't need a tripod with a converted camera and electronic flash). You'll also need to learn how to work with multiple lights, because studio portraits usually use several sources of illumination to provide the most flattering look. These lights are often bounced off photographic umbrellas, held up by light stands or another support, to create a soft, indirect type of illumination, as you can see from the results in Figure 8.8.

Figure 8.8 Simple lighting effects can create a more formal portrait look.

You can bounce light off an umbrella onto your subject, or, in the case of translucent white umbrellas, shine your illumination through the fabric for an especially diffuse effect. In either mode, a soft-white umbrella provides very diffuse illumination, but you can also purchase umbrellas with opaque shiny silver or gold interiors that provide a broad light source that still has snap and contrast. Umbrellas produced for professional photographers are compatible with various lighting clamp systems that make them easy to set up and manipulate.

Three lights are often used. The most important and most powerful should be the *main* light, located at roughly a 45-degree angle from the axis of the camera and subject, and placed a little higher than the subject's head. One thing to watch out for is the presence or absence of catch lights in the subject's eyes. You want one catch light in each eye, which gives the eye a slight sparkle. If you imagine the pupils of the eyes to be a clock face, you want the catch lights placed at either the 11 o'clock or 1 o'clock position. You might have to raise or lower the main light to get the catch light exactly right.

The *fill* light is usually the second-most powerful light used to illuminate a portrait. Fill light lightens the shadows cast by the main light. Fill lights are usually positioned on the opposite side of the camera from the main light, and often at the camera position.

Additional lights can be used, too, such as a *background* light, a low power light that provides depth or separation in your image; and a *hair* light, which is usually a small light directed at the hair of the subject to provide an attractive highlight. You can learn more about portrait lighting in my books *Mastering Digital SLR Photography* and *Mastering Digital Photography* (for non-digital SLR cameras).

Candid portraits require the least amount of time to take, because you generally do very little arranging of your subject, his or her surroundings, and the lighting. Figure 8.9 is such a picture, taken of an Abraham Lincoln impersonator who posed under the canopy in front of his tent at a Civil War re-enactment. In this case, I took his photo using both visible light and IR illumination, but found that the infrared version, with its slightly washed out monochrome tones (rather than full color) really looked more like we'd expect an 1860s-era photo of our 16th President to appear.

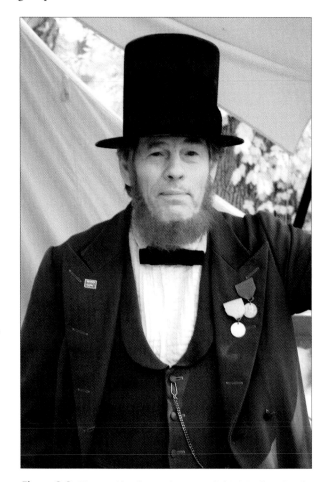

Figure 8.9 Honest Abe (honest!) assumed this Matthew Brady pose outside his tent for a 21st Century infrared portrait.

Concerts and Special Events

For the showcase photos in this chapter, I'm going to provide a mixture of pictures taken at a variety of special events that took place while I was collecting infrared photos for this book. Not all include people—some interesting photos popped up at a car show, air show, and Veteran's Day memorial.

Musical Events

Unless you're looking for some blurry special effects, musical concerts almost always require a converted digital camera that can take photos at shutter speeds measured in fractions of a second rather than multiple seconds. If you have such a camera, you can get some exciting photos, using either the available light or, if flash is permitted, by the strobe that accompanies your camera.

Figure 8.10 shows a concert shot taken from in front of the stage, using a shutter speed of about 1/160th second and a lens aperture of f/2.8. A slightly slower shutter speed might have allowed the guitarist's hands to blur slightly, but I wanted a

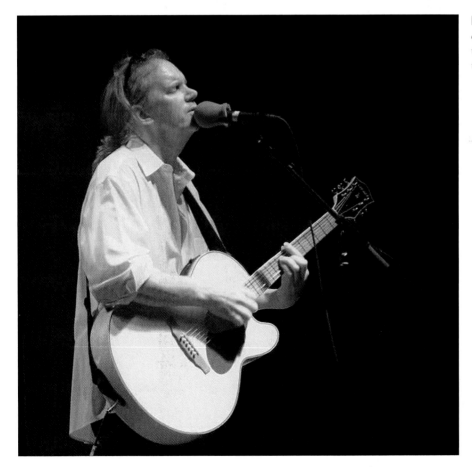

Figure 8.10 This guitarist didn't really have red hair—but that's the look he assumed for this infrared concert shot.

sharp image. The guitar, the player's clothing, and even his hair were rendered in an odd combination of colors that made this image more interesting. The photo shown in Figure 8.11 is a straight black-and-white IR picture taken in full daylight under the roof of a stage.

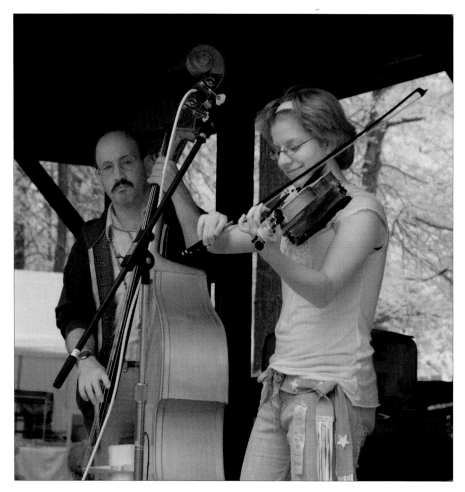

Figure 8.11 These old-timey musicians made good subjects for a black-and-white performance shot using IR illumination.

Car and Air Shows

I love to photograph car shows and air shows, because of the opportunity to see vintage automobiles and aircraft up close. The detail that can be seen in these restored machines is impressive, and always makes for some one-of-a-kind images under infrared illumination. I'm always surprised to see how custom paint jobs are rendered in IR. Two examples are shown in Figures 8.12 and 8.13. I used a wide-angle lens (the equivalent of 18mm on a 35mm full-frame film camera) for both photos, which distorted and emphasized the front ends of the autos.

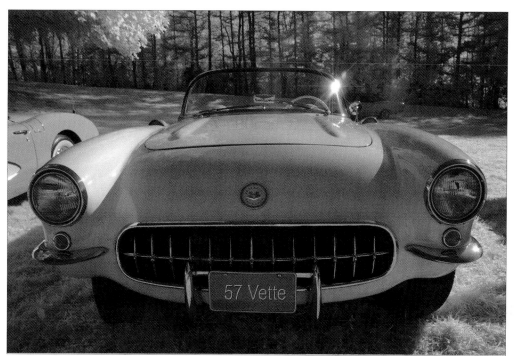

Figure 8.12
The owner of this bright red Corvette would probably be shocked to see this canary-yellow rendition by infrared illumination.

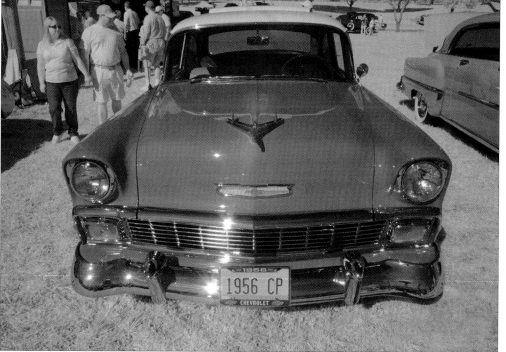

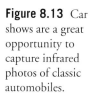

Figure 8.13 Car shows are a great opportunity to capture infrared photos of classic automobiles.

For the prop plane picture (see Figure 8.14) I waited until the aircraft taxied back to its parking spot after a spectacular flying show, then grabbed this picture of the plane's nose as the engine cooled. Air shows are a double delight, because you can see the aircraft in action, performing fly-bys or stunts, and then visit with the pilots and ask questions about their planes as you take photographs later on.

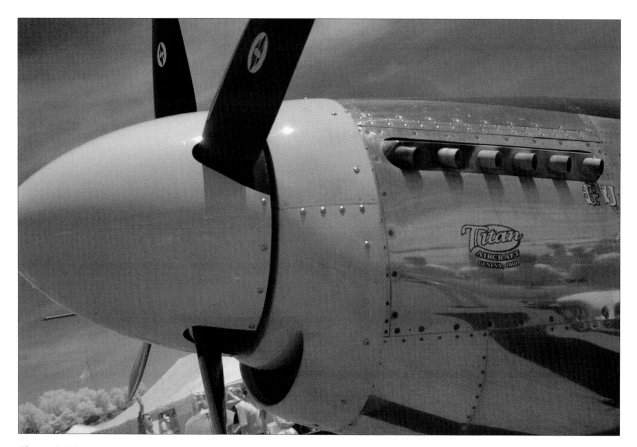

Figure 8.14 Air shows let you see vintage aircraft in action, and you can photograph up close the exquisite detail in restored planes.

Festivals and Memorials

County fairs, parades, memorials, and other festivals always serve up lots of opportunities for lively photographs, and there are always some angles and subjects that lend themselves to infrared photography. One Veteran's Day a local group set up 2,500 flags commemorating fallen soldiers in a public park. I spent a couple hours at the site, taking photos during bright daylight, at dusk, and then late in the evening when it was dark and the flags were illuminated by spotlights erected by cranes on the periphery of the park. My favorite shot is shown in Figure 8.15, taken about an hour before dusk.

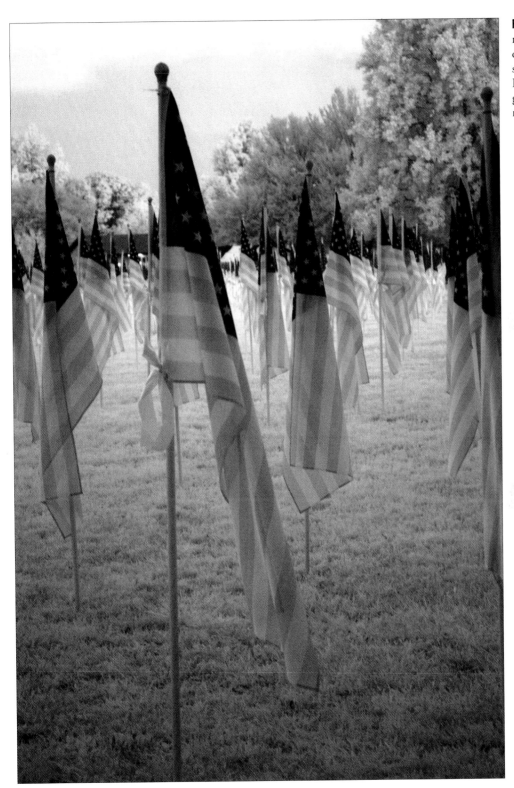

Figure 8.15 The red, white, and blue of these flags aren't shown realistically by IR light, adding a ghostly touch to this memorial scene.

The somber scene had a ghostly quality about it, which was emphasized by the infrared photograph, with the pale white trees, overcast sky, and the false-color flags themselves. The red, white, and blue colors of the flags were transmuted by the IR illumination, giving them an ethereal look of their own.

Next Up

Architecture is another one of those subjects suitable for infrared photography with any type of camera, whether you're shooting with a converted camera or one that needs a tripod and IR filter on the lens. Like landscape subjects, architecture can be infinitely patient, giving you lots of time to compose and frame your picture. The only tricky part of taking IR photos of buildings and structures is the human element. You'll need to decide whether you want people in your pictures, or not, and plan accordingly. The next chapter provides some hints on taking eye-catching infrared architectural photos.

9

Architecture

Of all the best subjects for infrared photography, architecture is the arena in which the challenges relate more to technical aspects of the type of photography, rather than infrared concerns. There's nothing special about the infrared response of buildings and other structures. You'll find that they reflect a healthy amount of IR illumination and can be pictured with no problems. The key to interesting infrared architectural photos is what you do with the sky, clouds, and foliage that also appear in the photo (see Figure 9.1), and how you handle the technical problems, such as managing perspective distortion, that apply to all forms of architectural photography.

I'm going to provide hints about both aspects in this chapter.

Your Architecture IR Arsenal

In many respects, architectural infrared photography is similar to landscape photography. Your images will simply be populated by more buildings and (usually) fewer trees. Likewise, the equipment required is similar. You need either a camera with an external IR pass filter installed on the lens or a camera that's been converted for full-time infrared use.

Wide-Angle Foibles

That camera should be equipped with a wide-angle lens (if it has interchangeable lenses), or be used with the fixed lens's widest setting. You can also zoom in if you want to capture a detail of your subject, but there are more architectural photos taken at the wide-angle position than otherwise.

The wide-angle lens offers several advantages:

- **Wider view.** Exterior photos require a wide-angle setting so you can take in the entire structure without needing to have your back up against surrounding buildings. If that's the case, you can back up only so far. A wide angle is required to grab an image from the best (or only available) vantage point.

- **Grab foreground details.** There was plenty of room to back up when I shot the picture shown in Figure 9.1. But a wide-angle lens let me include foreground details—such as landscaping, which is rendered in that inimitable infrared way—that are frequently an important part of an architectural shot.

Figure 9.1 One of the key aspects of IR architectural photography is what you do with the sky and greenery that appear in the photo.

■ **Room indoors.** Interiors are ambitious architectural specializations that are beyond the scope of this short chapter. But, as you might guess, you'll need a wide zoom setting to capture most rooms or spaces. Unless you're shooting inside a domed stadium, cathedral, or other large open space, you'll find yourself with your back to the wall sooner or later. A wide-angle lens helps you picture more of a room in one image.

Unless you have a digital SLR, you may find that your camera's wide-angle view is sorely lacking. Many point-and-shoot cameras that can be adapted to IR photography have a zoom lens that is the equivalent of a 35mm to 38mm lens on a full-frame film camera (which barely qualifies as a wide angle at all). Some advanced models offer the equivalent of a 24mm to 28mm wide-angle view, which is a moderate wide-angle perspective at best. Digital SLRs, on the other hand, frequently offer add-on lenses with focal lengths that are the equivalent of 15mm to 18mm, which qualifies as ultra-wide.

It's unlikely that you'll change cameras to get a wider view simply for architectural photography—infrared or otherwise—and, even if you own a dSLR you may not be able to afford a super-wide interchangeable lens, which runs $400 to $1,000, nor, perhaps can you afford to buy the huge IR filters they require on an unconverted camera. But you need to be aware that when it comes to architectural photography, a wider view is generally better.

Another optical consideration for IR architectural work is lens distortion. Some digital camera lenses produce lines that are slightly curved when they are supposed to be straight. For most types of photography, you might not even notice this distortion. Unfortunately, architectural design often depends on straight lines, even in structures that have curves, and any warps introduced by your lens stick out like a sore thumb.

Figure 9.2 shows an image taken with an ultra-wide angle lens that displays *barrel distortion* (often found in wide-angle lenses), in which the straight lines are bowed outward toward the edges of the photo. In a photograph in which the straight lines form such an important part of the composition, this distortion is objectionable. Fortunately, Photoshop and some other image editors have corrective features (in Photoshop it's the Lens Correction filter) that can fix these bent lines to a certain extent. Figure 9.3 shows the same image with most—but not all—of the barrel distortion removed. Telephoto lenses, which you probably won't use very much for infrared architectural photos, sometimes suffer from the reverse problem, *pin cushioning*, with lines that curve inward toward the center.

Figure 9.2
Wide-angle lenses sometimes suffer from barrel distortion, seen here, in which straight lines bow out at the edges of the image.

Figure 9.3
Photoshop's Lens Correction filter can fix a moderate amount of barrel distortion.

Perspective Control

Landscapes are usually taken from a head-on perspective, with the camera held level and pointed directly at the subject. The back of the camera is roughly parallel to the plane of the subject. The lines of the subject itself are generally at right angles or parallel to the ground. So, key elements of the subject, top to bottom, and side to side, are roughly the same distance from the camera's digital sensor. This perspective gives you an undistorted viewpoint.

The problems start as soon as you tilt the camera up or down to photograph a tall building or other vertical structure. Tilting the camera lets you take in the top of the structure, but the subject appears to be falling back, as you can see in Figure 9.4. In this case, I managed to incorporate the distortion into the composition of the photo, so the soaring building appears even more dramatic at the extreme angles captured.

Figure 9.4 Sometimes you can incorporate perspective distortion into your composition.

In other cases, the distortion is not pleasing at all, as you can see in Figure 9.5. The structure has a slight, but distinct set of converging lines that give it an odd appearance. Once again, Photoshop or another image editor can come to your rescue, using built-in perspective control features to straighten out those lines, as shown in Figure 9.6. The trick is to leave enough space around the structure you're photographing, so when the image is warped, to realign the vertical lines, you can trim the trapezoid frame that's produced to restore the original rectangular composition.

Of course, the most obvious solution for avoiding perspective distortion is to step backwards far enough to take the picture with a longer lens or zoom setting while keeping the camera level. But that option isn't always available.

Figure 9.5 In other shots, the converging lines will be objectionable.

Figure 9.6 An image editor can often correct the perspective.

Making Problems Work for You

Some structures aren't buildings at all but, rather, are monuments or artwork. Peter Wolf Toth has erected at least one giant wood carving of notable Indian chiefs in each of the 50 states, but his very first was crafted near Akron, Ohio, where he grew up. His 51st statue, Rotaynah, carved out of a 20-ton Kentucky Red Oak now stands in front of an elementary school. It's 36 feet tall, and 25 feet in circumference. I'd been meaning to photograph this work of art for a long time, and finally made the trip out to its location one warm spring day.

I was shocked to see that the statue was surrounded by scaffolding on all sides, as you can see in Figure 9.7, with barely three feet between the railing and platforms and the carving itself. I discovered that the artist was planning a visit from his home in Florida to repair the statue and apply a new coat of varnish.

My situation was a perfect example of how you can make problems work to your benefit. I crawled over and around the scaffolding, and even up on the platform, looking for a good angle. Finally, I discovered that by crawling down between the structure and the statue and shooting upwards, I was able to get an unobstructed view of the chief. Indeed, it turned out that this angle was probably the best one I could have hoped for (see Figure 9.8). Photographers need to constantly be on the lookout for a new perspective on their subjects, but sometimes an angle that's forced on you is exactly what is called for.

Figure 9.7 This 36-foot-tall Indian chief was surrounded by scaffolding when I arrived.

Figure 9.8 It turned out that the obstacles forced me to choose a new perspective for my infrared portrait.

Realistic Color

You may have seen infrared photographs and not even realized it. I'm always amazed at how natural-looking some IR pictures appear when the normal clues aren't present. Figure 9.9 is a good example of a conventional-looking photograph that's actually an (almost) straight infrared photo. The only real manipulation done to it was to swap the red and blue channels, so that the sky appears a more natural blue and the hues take on a brownish look.

Why is this picture so successful as a "visible light" picture? There are no leaves on the trees, so the normal ghostly white appearance that would have been a tip-off at other times of the year didn't apply. The browns of the tree branches appear plausibly natural in color, too. Of course, the snow has taken on a blue cast, but, then, snow often *does* appear somewhat blue under mid-day lighting conditions. What seals the deal is that the viewer has no way of knowing that the side of the barn was actually a deep reddish brown in real life and that the stuff clinging to the corner of the barn closest to the camera is actually ivy.

The resulting picture is an infrared photo that doesn't have an infrared appearance, but which offers a different kind of look that couldn't be captured using visible light.

Figure 9.9 Infrared photo? Or not? There are few clues to make it possible to tell the difference.

Old-Time Look

Rustic subjects often benefit from sepia or cyanotype (blue) toning to give them a look that's more old-timey. This restored cabin was moved to the grounds of a local county historical society and put on display to show how settlers in the Western Reserve lived in the early 19th Century. The white foliage of the surrounding trees and the grass around the cabin set off the stark structure's character, but I felt that the standard infrared treatment detracted from its appeal.

So, I used an image editor's toning features to give the photo shown in Figure 9.10 a sepia tone. It no longer looks like an infrared photo; instead, the picture almost seems as if it could have been taken in the 1850s using early photographic equipment.

Figure 9.10 Sepia toning is often a good effect to apply to historical-type images.

Ominous Day

Figure 9.11 is another view of the grounds of that faux castle, the gardens of which are pictured in Figure 7.15. It was late in the afternoon, and clouds covered the sky, but I wanted to capture an infrared portrait of the stately old mansion. I backed up, used a medium-wide angle lens (the equivalent of 27mm on a full-frame film camera), and grabbed this shot.

The foreboding overcast actually established a better mood than light, fluffy cumulous clouds would have. The castle was deserted at this time of day, and it stood in stark watchfulness over the carefully manicured lawn and gardens.

Figure 9.11 Gloomy skies are contrasted with the bright foliage surrounding this castle, providing a sort of visual contradiction that makes for an interesting photo.

Using Framing

Using parts of an image such as trees or components of a structure to frame an image is an excellent way of adding a three-dimensional look to an otherwise flat photo, while drawing attention to both the framing elements and the portion of the image being outlined.

If you look at the right side of Figure 9.11, you can see the portico where the original owner's cabriolets would pull in to allow disembarking into the home from a sheltered area. After photographing the front of the castle, I ducked around back to take the picture shown in Figure 9.12, which uses the entranceway itself to frame an image of the trees and shrubs of the front yard.

I used channel swapping to give the sky a blue color, and I let the framed view be slightly overexposed to provide a bright contrast with the framing entryway.

Figure 9.12 Framing is an excellent way of adding a three-dimensional look to an otherwise flat-looking image.

More Lines and Angles

I love to include moving water in my architectural photos, so if a building has a fountain, waterfall, or other element with liquid motion, I'll capture it if I can. I found this fountain outside the student center at a university, and liked the way the straight lines—including the descending steps—created different angles. The strong sunlight emphasized the texture of the stone fountain.

In this case, I stooped down low so that the pool of water itself wasn't visible, as it was filled with unsightly floating debris on the day of my visit. You can see another view of this same fountain in Figure 9.3. For this version (see Figure 9.13), I used channel swapping to create cool blue tones that worked well with the water; for the earlier photo, I let the original brown tones provide warmth.

Figure 9.13 Sharp angles contrast with the softness of falling water.

Next Up

Did you think that action photography was impossible to achieve when shooting by infrared illumination? Think again! The next chapter shows you exactly what you can do with IR imaging in the realm of moving subjects. You'll need a converted camera for most of the effects I'm going to show you. If you haven't taken that leap, perhaps what you're about to see will convert you.

10

Experimental Action

When people ask me why I shoot action and sports photography in infrared, I respond, "Because I can!" If you love to experiment, you'll find that action is the great unexplored frontier of IR photography. A few years ago, a sane person would say that taking photos of fast-moving subjects by infrared illumination was virtually impossible, at least without the use of expensive camera and lighting equipment. Today, anyone who has made the investment in a camera that's been converted for full-time IR use has the same opportunities for capturing sports as any visible light photographer. And, as you'll learn in this chapter, there's one special trick you can use to grab action shots with an unconverted camera.

This chapter is going to be more experimental than most. Many of the images you find here were taken for no reason other than to see what I could do. I'll be the first to admit that some kinds of sports photos, such as the baseball and basketball pictures used as examples in this chapter, probably are a bit more compelling when taken using visible light. The unusual look that infrared illumination adds doesn't really make such photos any more effective from an artistic or creative standpoint. But, I have to say I had a great time taking them, and learning about the limitations of IR action photography.

Later in the chapter I'm going to explain some of the special considerations for using electronic flash for IR photos, particularly because flash has some advantages for shooting action pictures.

Digital Cameras, Action, and IR

Even without the infrared aspect, digital cameras are great for shooting fast-moving action. Even the least expensive digital cameras have continuous-shooting "burst" modes that let you snap off sequences of shots quickly—often two or three shots per second in clips of 5 to 10 images. More advanced digital cameras have long zoom lenses (up to 18X) with the equivalent reach of very long telephotos on a 35mm film camera. At the top end, digital SLRs provide even more action photography prowess, with even faster burst rates (as many as 10 frames per second with a recently introduced Canon EOS model) and virtually zero lag time between when you press the shutter release and when the photo is taken.

Although when we think of action photography, we automatically think of sports, this kind of picture taking is not limited to spectator sports, as you'll see in this chapter, which includes photos taken of amusement rides at county fairs, aircraft in flight, a demolition derby, and even sledders careening down a snow-covered hill. Action photography is a great tool for capturing the excitement of participatory events, from skydiving to golf, and non-events that involve moving objects, such as juggling or driving your favorite car around a tight mountain curve. If it's in motion, you might well want to photograph it. Action photography, on any level, is not a spectator sport.

But what does IR bring to the table? For traditional sports photography, there's not much that infrared imaging adds to the picture. Figure 10.1 shows a typical visible light action shot taken at a college basketball game. The accompanying photo, Figure 10.2, was taken in the same venue using an IR-converted camera. The most interesting thing about the second photo is that, like the piano-playing monkey, it isn't how well it was done, but that it could be done at all. Thanks to the camera that had been converted to full-time infrared use, I was able to capture a grainy, monochromatic image at the same 1/500th second/f/2.8 settings as the full-color version.

Figure 10.1 This visible-light action photo is exactly what you expect to see in a sports picture.

Figure 10.2 Does an infrared treatment add anything to this similar picture taken with an IR-converted camera? Maybe not, but it was fun to shoot.

A more interesting application of IR to fast-moving subjects might be found in Figure 10.3. The twirling amusement ride at a county fair was painted in multiple colors and would have looked "busy" if pictured under visible illumination. The infrared version, on the other hand, with the dark sky and stark contrast of the ride components, offers a more striking appearance that, to me, is reminiscent of some of the black-and-white photography of the 1950s. I like the look very much.

As I noted earlier, infrared photography using unconverted cameras with a visible light cutoff filter on the lens forces you to shoot at long shutter speeds, which isn't especially good for stopping action. To get the best results, you'll need to use relatively brief shutter speeds (usually 1/250th second or shorter), or take advantage of the brief duration of electronic flash (more on that later). So, for almost all of the techniques in this chapter (the ones requiring a fast shutter speed), you'll need to use a converted camera. However, even unconverted cameras can use the "open flash" technique I describe later in the chapter.

Figure 10.3 Infrared imaging does add something to this stark photo of a ride at a county fair.

Action Photography Considerations (Any Light Source)

One key to good action photography by infrared light is to follow the same rules that apply to capturing movement under visible light. Your shot must be a good action shot first before it can be a good IR action photograph. All types of action photography require a little technical knowledge to ensure the right exposure, and selecting the shutter speed that will freeze action when you want to, or allow for some creative blurring effects when you want to do that. The two most important things you must master are:

■ **Choosing the right subject.** Know who to photograph, why they are important, what they might do that's photo-worthy, and where to stand to capture them. (As photojournalism immortal Robert Capa once said, "If your pictures aren't good enough, you're not close enough.")

■ **Choosing the right moment.** Snap a photo a fraction of a second too late (and that's easy to do with a slow-responding digital camera) or too early, and you may capture the immortal instants that happen just *after* or just *before* the decisive moment. Figure 10.4 is a good example of a crucial moment. A fraction of a second later, and the rebounder would have pulled the ball to his chest, probably obscuring the triumphant look on his face. A moment earlier, and he might not have had the ball in his grasp.

Figure 10.4 Capturing the right moment is essential for any good action photo.

In short, the two most important things about capturing an exciting action photograph are knowing *what* to photograph, and *when*. If you stop to think about it, action is a continuous series of moments, each a little different from the last, all leading up to *the* moment. It's the instant when a shooting guard releases the basketball at the apex of a jump shot, and you *know* that it's going to sail over the arms of a defender and swish through the net of the basket. Or, the moment might come from the look on a goalie's face as a soccer ball sails past her outstretched hands into the goal. It might be the instant when the bat connects with a baseball for the winning run. The moment might involve almost no motion at all, as when a field goal kicker lowers his head in shame when he sees his boot is tumbling wide of the goalposts. Capturing the right moment is important.

Dealing with Shutter Lag

One thing that can prevent you from capturing the decisive instant is the shutter lag that is present in some digital cameras. That's the interminable gap between the time when you press the shutter release on your camera and when the picture is actually taken. You know the sequence: you see a great shot, put your camera's viewfinder to your eye, and press the shutter button. Then, nothing happens. There's a lag of what seems to be several seconds before your camera takes the photo.

Fortunately, the lag time of point-and-shoot cameras has been diminishing. When I first started testing digital cameras for *Computer Shopper* and CNet Networks, it was common to see delays of 1 to 2 seconds. Today, shutter lag times of 0.4 to 0.6 seconds are quite common with non-dSLR cameras. And, of course, digital SLRs, have always averaged 0.2 seconds or less (it's hard to measure shutter lag when it's almost non-existent), and so owners of these cameras should experience negligible delay.

If you find that your digital camera does suffer from significant shutter lag, there are several things you can do:

- **Anticipate.** Press the shutter button a fraction of a second before the action peak. If you understand a sport or activity well, you'll be able to predict a key play often enough to improve your odds of capturing one in pixels.

- **Shoot bursts.** Use your camera's sequence mode to grab a series of photos, starting just prior to the big moment, and ending after it has passed.

- **Go manual.** Use your digital camera's manual exposure and focus settings. Preset the exposure (lighting doesn't change rapidly in most action situations) and set the focus distance to a point where you anticipate the action will take place. With the automatic features turned off, you should find your shutter lag problems dramatically reduced.

- **Lock in.** If you must use automatic mode, aim the camera at the point where you expect the action to happen, partially depress the shutter button, and hold it until the big moment arrives. If your camera is set to lock in exposure and focus when the button's partially depressed, pushing it down the rest of the way should trigger the actual exposure without much further delay.

- **Over-shoot.** Take as many photos as possible. The more pictures you take, the better your chances of overcoming shutter lag and ending up with a picture that truly captures the action.

- **Watch your buffer.** Be aware of the time it takes to offload images from your camera's internal memory to your memory card. If your camera's memory is sparse, you may have to wait a few seconds between shots or a series of shots before you can start shooting again. Good pictures can be lost in the interim, so you might want to limit the number of pictures you take in one sequence if you think you might want to shoot another photo during the time your camera is downloading to the memory card. Many digital cameras provide a readout that shows how much room is left in the buffer. With non-SLRs, this may be a bar on the rear-panel LCD that expands or contracts. Digital SLRs may offer a buffer-frame counter in the viewfinder.

Stopping Action

Freezing a fast-moving subject in its tracks seems to be the primary goal of action photographers. However, a moment frozen in time may not be the best or most interesting way to capture your subject. Frequently, a little motion blur adds to the feeling of motion, as in Figure 10.5, in which the blurriness of the baseball player's arm and raised leg help convey the action.

In fact, including a little blur in your pictures is more difficult and challenging than simply stopping your subjects in their tracks. Some of the best action pictures combine blur with sharpness to create a powerful effect. Now that you understand that, I'll explain a little about how to freeze and semi-freeze the action.

The first thing to understand is that motion looks different to the camera, depending on the direction, speed, and distance of the subject. You can use this information as you plan your image. Here are the basics:

- **Cross-frame motion.** Movement that's parallel to the plane of the sensor (that is, across the width or height of an image in a horizontal, vertical, or diagonal direction) appears to move the fastest and will cause the most blur. So, an automobile passing in front of your camera at 200 mph is likely to be blurry, no matter how short your shutter speed.

Figure 10.5 The blur of the pitcher's arm and leg add to the feeling of motion.

- **Motion coming towards you.** Movement approaching the camera appears much slower, and will cause a much lesser amount of blur. That same race car headed directly toward you can be successfully photographed at a much slower shutter speed.

- **Diagonal movement.** Motion coming toward the camera on a slant (perhaps a runner dashing from the upper left background of your frame to the lower right foreground) will display blur somewhere between the two extremes.

- **Proximity.** Subjects that are closer to the camera blur more easily than subjects that are farther away, even though they're moving at the same speed. That's because the motion across the camera frame is more rapid with a subject that is closer to the camera.

- **Movement is relative.** Blur is relative to the camera's motion, so if you pan the camera to follow a fast moving object, the amount of blur of the object you're following will be less than if the camera remained stationary and the object darted across the frame. Of course, the *background* will be blurred, but that often adds an additional feeling of motion to the image.

Choosing a Shutter Speed

A fast shutter speed can stop action effectively, no matter what the direction of the motion or other factors involved. The trick is to select the shutter speed you really need. A speed that is too high can rob you of a little sharpness because you've had to open the lens aperture a bit to compensate, or use a higher ISO rating that introduces noise. There are no real rules of thumb for selecting the "minimum" fastest shutter speed. As you've seen, action stopping depends on how fast the subject is moving, its distance from the camera, its direction, and whether you're panning or not.

The minimum shutter speed can vary by the type of subject, too. Veteran motor sports photographers will tell you that it's essential to use a shutter speed *just* slow enough to allow the wheels on a motorcycle to blur slightly. If you freeze the tires on a race car in mid-spin, your picture will look as if the vehicle is parked, not in motion. In Figure 10.6, there's just enough blur to show that the wheels of the demolition derby car, along with the gobbets of mud being thrown by the treads, are in energetic motion.

Figure 10.6 The shutter speed was just fast enough to stop the motion of this car, while allowing the tires and flying gobs of mud to blur slightly.

CAPTURING A PEAK MOMENT

There's one trick for freezing action that's often ignored: wait for the motion to stop. Some kinds of action include a peak moment when motion stops for an instant before resuming again. That's your cue to snap a picture. Even a relatively slow shutter speed can stop action during one of these peak moments or pauses.

The end of a batter's swing, a quarterback cocking his arm to throw a pass, a tennis player pausing before bringing a racket down in a smash. These are all peak moments you can freeze easily. Other peaks are trickier to catch, such as the moment when a basketball player reaches the apex of a leap before unleashing a jump shot. If you time your photograph for that split second before the shooter starts to come down, you can freeze the action easily.

Non-sports action sequences also have peak moments. An amusement park ride might pause for as long as a second between hair-raising swings, as shown in Figure 10.7. Your child leaping about on a trampoline reaches the top of a jump and can be captured in mid-flight. A bird in flight, like the seagull in Figure 10.8, flaps its wings furiously to gain altitude, then stretches out to glide leisurely for minutes at a time. If you study the motion of your action subjects, you'll often be able to predict when these peak moments will occur.

Figure 10.7 At the top of its arc, this amusement ride pauses for a moment, and can be captured with ease.

Figure 10.8 A seagull's wings are motionless as it glides silently through the air, so freezing this moment is easy.

Most digital cameras have top shutter speeds of 1/500th to 1/2,000th second, which will stop just about any action. Some even have top speeds that, in practice, you really can't use. The highest practical speed tops out at around 1/2,000th second. With a fast lens and a higher ISO rating, you might be able to work with 1/4,000th second under bright illumination. Yet, there are digital cameras available that offer shutter speeds as brief as 1/16,000th of a second. So, the bottom line is usually that, to freeze action with your shutter speed alone by both IR and visible light, you'll probably be using a speed from 1/500th second to 1/2,000th second, depending on the illumination and what your camera offers.

Electronic Flash

Electronic flash units, originally called "strobes" or "speedlights," emit plenty of infrared illumination, so you can use them for your IR portraits or, to keep with the topic of this chapter, for action photography. The duration of an electronic flash is extremely brief, and if the flash provides the bulk of the illumination for a photograph, some great action stopping results. One of the earliest applications of electronic flash was by Dr. Harold Edgerton at MIT, who perfected the use of stroboscopic lights in both ultra-high-speed motion and still (stop-motion) photography capable of revealing bullets in flight, light bulbs shattering, and other phenomena.

While most strobes provide bursts of light of about 1/1,000th second duration at full power, some units have a duration of 1/50,000th second or less when used to photograph subjects very close to the camera, which is very brief, indeed. It turns out that if the subject is relatively close, only *part* of the available energy is required for the photograph, and only that much is supplied to the flash tube, producing only a brief burst of light. Yet, even the longest full-power flash exposure is likely to be shorter than the shutter speed your camera uses to synchronize with the flash (typically 1/250th second or shorter), so electronic flash is an excellent tool for stopping action.

The chief problem with electronic flash is that, like all illumination, it obeys the pesky inverse-square law. Light diminishes relative to the inverse of the square of the distance. So, if you're photographing a subject that's 12 feet away, you'll need *four* times as much light when the subject is twice as far away at 24 feet, not twice as much. Worse, if an athlete in your photograph is 12 feet away when you snap a picture, anything in the background 24 feet away will receive only one quarter as much light, giving you a dark background. That generally means that a digital camera's built-in electronic flash is probably not powerful enough to illuminate anything two dozen feet from the camera. You might be able to use your camera's flash at a basketball game, but not at a football game where the distances are much greater.

In addition, you should be aware that electronic flash can produce a "ghosting" effect, which occurs when the main exposure is made by the flash, and a secondary, blurry exposure is produced when the available light is strong enough. Some cameras won't synchronize with the electronic flash at particular shutter speeds, particularly if your digital camera uses a mechanical shutter.

Because the electronic flash exposure is over in such a brief instant, the flash needs to be triggered at a point when the entire sensor is exposed to the light. For some cameras, that happens only when shutter speeds of 1/125th of a second or slower are used. For faster shutter speeds, a smaller opening is passed vertically or horizontally in front of the sensor, and only the portion exposed when the flash is triggered will show up in your photo. The slower the shutter speed you must use to sync with your flash, the more likely you are to get ghosting effects.

Some cameras will synchronize at higher shutter speeds with some electronic flash units, reducing the ghosting effect. This high-speed sync is a luxury found on more expensive cameras, and it may even be undocumented. You *may* be able to shoot action photos at higher than your camera's listed top sync speed. A few cameras have a high-speed sync mode, and others may be fooled into producing it. HS mode does allow you to shoot at higher shutter speeds (up to 1/8,000th second or more) using flash. What happens is that the flash produces a longer burst of light, or a series of short bursts that overlap enough to produce an even exposure over the full frame, even though only part of the sensor is exposed at one time.

The camera may be able to trigger this sequence automatically, or you might be able to fool the flash into firing in this way. One common trick is to tape over all the flash contacts on a camera's hot shoe except for the center contact. The flash responds by firing off a longer burst at reduced power. High speed sync generally works only very close to the camera, and is best suited for close-up action photography, rather than sports.

There are lots of potential problems when shooting with flash, but, fortunately for you, I managed to take one real stinker of a photo during my infrared photography testing that includes most of them. Inspect Figure 10.9, then read the notations for explanations of the goofs included in this example.

1. **Inverse square law at work.** This fellow was significantly closer to the flash than the other people shown. So, he's overexposed, while the others are underexposed slightly. Nothing in the photo is actually properly exposed. If you can, try to arrange your photo so that everyone in the frame is approximately the same distance from the camera.

2. **Infrared equivalent of red-eye.** The fellow to the right of the numeral in this shot has piercing white eyes, because he was looking directly at the camera, his pupils were dilated, and light from the flash bounced off his retinas directly

back into the lens. The fact that under IR illumination the red-eye effect produces white eyes instead doesn't make it any more objectionable. You may have to retouch this defect in your image editor.

3. **Ghost image.** It may be hard to see on the printed page, but the chap to the left of the numeral is slightly blurred, because he was illuminated both by the electronic flash and the streetlights around him. There's a faint ghost image. Using a higher shutter speed would have helped, but would also have made the background subjects in the image much darker. I chose an intermediate speed to help fill in the detail beyond the reach of the flash, knowing I might get some ghost images.

4. **Lens hood shadow.** It was already known to me that the 18mm (27mm full-frame equivalent) wide-angle lens I was using would produce a shadow of itself in any picture taken with flash. I wasn't thinking. Fortunately, my goof produced this shot that documents something that *you* want to avoid. When using a wide-angle lens with flash, consider removing the lens hood to avoid shadows if your camera is prone to such.

Figure 10.9 How many problems? Let me count the ways…

Shooting Sequences

Whether you call it sequence shooting, burst mode, continuous advance, or "motor drive" mode, the ability to take multiple shots of fast-moving action is a valuable capability found in an increasing number of digital cameras. On the plus side, ripping off five or ten shots as the action unfolds can increase your chances of catching the peak moment(s) in one or more of them. Unfortunately, you can also end up with the best shot of all occurring *between* frames. Sequence shooting is a valuable tool, but it's not a panacea. It's no substitute for good timing.

Clicking off a picture at exactly the right moment will almost always yield better results than blindly capturing a series of frames at random. Use your camera's sequence mode as a supplement to your customary techniques to grab a few pictures you might not have gotten otherwise, or to create sequences that are interesting in themselves, as shown in Figures 10.10 and 10.11.

Figure 10.10 Sequence shots can tell a story of their own....

Figure 10.11 ...or just provide alternate views of an event.

Sequence shots are traditional in sports photos, such as the pair of baseball images shown in Figure 10.12. You can see the batter poised for the pitch, and then a second later check his swing to bunt. Incidentally, these shots show just how infrared illumination distorts the colors of clothing—you can barely make out the #23 on this batter's jersey!

Figure 10.12 Sports sequences show a play in progress.

Stopping Action with Flash and an Unconverted Camera

Although most of the techniques in this chapter require a camera that's been converted for full-time IR use—in order to make the high shutter speeds needed available—action photography isn't entirely out of reach for those of you who are using unconverted cameras. In fact, you can use the action-stopping abilities of electronic flash to freeze action—and you won't even need a filter on your lens. This frees you to experiment with IR action photography in a limited, but interesting way.

Nikon at one time made a special electronic flash unit, the SB-140, designed for UV and IR photography. Although it's no longer available, you can construct a reasonable facsimile, at least for IR photography. The SB-140 had an uncoated flash tube, which didn't limit its UV output, whereas modern flash units do have the yellowish appearance that filters out the UV. But, luckily, they have no such filter for removing IR light from their bursts.

To create your own IR flash unit, you'll have to cover the flash tube area with a visible-light blocking filter that passes infrared illumination, the same type of "IR" filter you place in front of your lens to shoot infrared photos with an unconverted camera. The good news is that, because this filter is *not in the optical path* in front of the sensor, it doesn't have to be of the same high quality as a filter you'd use in front of your lens. A flash filter can be made of cheap material, can be translucent instead of perfectly transparent, and might even have a few scratches on it, with no effect on your finished image. All it needs to do is filter the visible light from your flash's burst, leaving behind the IR portion.

That means you can use any of the alternative IR filter options I mentioned in Chapter 2, including several layers of Ektachrome sheet film, or Roscoe or Lee lighting filters. Cut a filter of the proper size and place it over the flash tube of your electronic flash. If you are using a point-and-shoot camera, you may be able to tape it over the flash area on the front of the camera. For digital SLRs or models with a pop-up flash, you may have to construct a holder out of cardboard or rig some other way of attaching the filter. External flash units usually have flat flash tube surfaces (and may even have a slot to hold filters).

You won't be using a filter over your camera's lens, because the visible light cutoff/IR pass filter is over the flash. That means you'll be able to frame your photo normally through the viewfinder. But it also means that the pictures must be taken in total darkness, so that no visible light is present to make the photo. You can turn on a lamp so you can see to compose your picture, then turn the lamp off just prior to exposure. Follow these steps:

1. Place the camera on a tripod in a darkened room.
2. For best results, use a black background, so that only the portions of your subject illuminated by the electronic flash will appear.
3. Set up your subject. For example, you might want to freeze a spinning child's toy, or stop falling flower petals, or, as in the case of Figure 10.13, capture the spray of water being spewed from a plastic bottle.

4. Arrange your filtered electronic flash (or flashes) to illuminate your subject. The best arrangement is often with external flash set to one side of the object being photographed, but you can also use flash at the camera position. Note that if you use more than one flash unit, you'll have to use some sort of slave attachment (some external flash have these built in) so that both flash units fire at once.

5. Adjust your flash to its Manual setting. It's unlikely that your camera's automatic flash exposure system will function when the flash unit is heavily filtered to remove visible light.

6. If you're using an external flash unit (or units), set the camera for an exposure of several seconds.

7. Focus and frame your composition using light from a lamp you've set up for that purpose. When you're ready to take the picture, turn off the lamp.

8. In darkness, trip the shutter, start the event you want to capture, and trigger the electronic flash unit. With more advanced cameras and external flash units, such a sequence isn't all that complicated (although it sounds a bit tricky). You just need a bit of coordination. With an exposure of several seconds, the shutter will open, but no picture will be exposed, because the camera is still in total darkness. So, you can drop the flower petals, or squeeze the water bottle (see Figure 10.13), or whatever, and then *quickly* trigger the flash unit using its "open flash" button. The exposure won't take place until the flash actually goes off. I usually find that I need four or five tries to do it right, especially when photographing unpredictable events such as splashing water droplets.

Figure 10.13 An IR-filtered flash can be used to stop action even with the camera set for a slower shutter speed.

If you're using a simpler camera and flash with no "open flash" ability to trigger the strobe at will, you'll need a bit more luck and coordination. You'll need to start the action, and *then* press the shutter release on the camera so the picture is taken. The flash will go off instantly, and, with a measure of good fortune, will capture the moving object at a fortuitous instant. If your exposure is incorrect, try a different f/stop. You may find that your electronic flash is too weak even at the widest aperture (see Not a Panacea below).

If not, repeat the sequence until you get one that you like. Flower petals are easy to drop over and over. If you want to capture a breaking egg, good luck. But I think you'll find this experiment a lot of fun.

NOT A PANACEA

Note that this technique allows you to bypass the limitation on using fast shutter speeds to stop action by taking advantage of the short duration of the electronic flash. It doesn't change the fact that your camera's IR cutoff filter is still in place and that you need high light levels to take a picture by infrared illumination. Add in the amount of IR light filtered out by your camera's internal cutoff filter, and the reduction of light from your filtered electronic flash, and you can see that your flash must be fairly powerful, and operating at full strength to produce a picture at all. If you find that your camera's built-in flash is too weak, try using an external flash, triggered by a slave unit, to provide additional illumination.

Next Up

By now you should have more than enough infrared photography techniques to play with, so I urge you to go out and take as many different images as possible, using your full arsenal of tricks. Then, continue with Part III of this book, which will show you how to use post processing in an image editor to turn basic IR photos into eye-catching shots, and transform great infrared photos into prize-winners.

Part III

Ex Post (Processing) Facto

Often, your IR photos won't be usable as is. If you haven't bothered to set the correct white balance, they'll have a bright red cast. Infrared exposures can be tricky, so you might end up with some great shots that are either too dark or too light. Others will cry out for some additional post-processing fixes. You might even have some creative inspiration for adding a special effect or two.

This next part of the book shows you exactly what you need to do to optimize your images and create totally new pictures from your original shots. I'm going to use Adobe Photoshop or Photoshop Elements for my examples, but other image editors have similar tools you can work with.

11

Fixing Up Your Images

Photographers tend to fall into three categories. Some like to put all their energy into capturing their vision in the original photograph, going to great lengths to achieve exactly the right exposure and composition in the camera. These are the folks who, back in the film days, would make enlargements that showed the sprocket holes of the 35mm frame so you could be reasonably certain (at least in the pre-Photoshop, non-digital-darkroom days) that the image on paper was the image produced by the photographer in the camera.

With the advent of scanners and image editors, photography started down the slippery slope that led to Oprah Winfrey's head appearing on Ann-Margret's body on the cover of *TV Guide*, and the Great Pyramids relocated to produce a better composition for *National Geographic Magazine*. By the time digital cameras came along, any image that was possible was also probable. Pixels became just the starting point for various types of digital imagery.

I belong to a third camp that likes to combine traditional photographic techniques with new digital capabilities where appropriate. In some cases, there is no difference between my digital images and those I would have taken with a film camera. In other cases, conventional and digital techniques combine to create something entirely new. And, I've even been guilty of producing more than a few images that rely more on digital manipulation than I'd like to admit.

But, because I was involved with photography long before the digital age, I see the capabilities of digital cameras and editing as being an *addition*, not a substitute. Infrared photography is one arena in which digital imaging has made it possible to do new things with a camera using a part of the spectrum that was difficult to experiment with in the past. In this chapter, I'm going to show you how to improve your IR images in an editor with techniques that will work with most editors (although I'll be using Adobe Photoshop CS3 for my examples).

Working with RAW Files

Virtually all digital cameras can produce JPEG files, but more advanced models offer the option of shooting RAW files, which are image files that contain the basic digital information captured by the camera, after it has been processed and converted from analog form. RAW files can't be considered "unprocessed" in that respect, but they do contain the image information *and the settings you selected in the camera*, including white balance and tonal corrections, which are applied when a JPEG file is created. They can be thought of as a kind of digital "negative" that you can return to again and again.

Working with RAW is your chance to intercept and modify those in-camera settings. You can make changes before the image reaches your image editor, where certain types of modifications (such as white balance correction) are more difficult to make. If you have a choice (that is, your camera can shoot RAW files), you'll almost always be able to get slightly better results in your post-processing if you start with the RAW information. The advantage to shooting JPEG is that, if you've fine-tuned your camera settings so that the images require very little modification in an editor, you can view and evaluate large numbers of photos very quickly. In the non-IR world, wedding and sports photographers who shoot 1,500–2,000 pictures in an afternoon generally try to get the best JPEGs they can, right out of the camera. Those shooting landscapes, macro photos, flowers, and so forth who want to retain the ability to fine-tune individual shots choose RAW.

There are several different software options for working with RAW files. All cameras capable of producing such files are furnished with utilities that can import and tweak RAW images. These programs can be your best bet, because they are free (Nikon asks a fee for its Capture NX software, but also supplies a basic no-cost RAW utility) and are guaranteed to support all the options of your camera's RAW format.

Other third-party applications, such as Phase One's Capture One (available in various "lite" and full-featured incarnations) and Adobe Camera Raw (ACR) must be purchased, either as a standalone program (Capture One) or bundled with other software (ACR comes with Photoshop and Photoshop Elements). These utilities may not immediately support the latest cameras, of course, but that's only a problem if you're shooting infrared with one of the latest cameras on the market. With any luck, vendors who are on the ball will have an updated version to support any given new camera within a few weeks of its introduction.

In this chapter, I'm going to use Adobe Camera Raw to illustrate RAW file processing options.

Adjusting White Balance

If you haven't set the white balance properly for infrared in your camera, the most practical way to fix it once the shot has been taken is by processing the RAW file (if available). Figure 11.1 shows such an image loaded into ACR. The most relevant controls for adjusting WB are shown in the White Balance area in the right-hand column.

The White Balance drop-down list shows As Shot as the current setting, which is generally the white balance determined by a camera set to the Auto White Balance setting. You'll also find preset values in the drop-down list for Daylight, Fluorescent, Incandescent, and other options that might have been set in the camera (and which can now be chosen by you manually within ACR). None of them are likely to be any better for your image than the As Shot setting.

If you'd set white balance in the camera for IR illumination, the White Balance drop-down list might display the Custom setting. Alternatively, you can choose a Custom setting now, in ACR, using the Temperature and Tint sliders. In Figure 11.1, you can see that the color temperature has been set to 4300 and the color

Figure 11.1 An IR image with the default daylight color balance looks like this when loaded into Adobe Camera Raw.

bias along the green/magenta access (Tint) is set to +54. Those settings account for the red/magenta look of the preview image in the left panel of the ACR window.

To adjust the white balance more accurately for infrared photography, move both sliders. In this case, I set the color temperature to 2000 and the tint to a greenish –79, which I've determined to be a better choice for photos shot under daylight conditions. The Custom setting appears in the White Balance drop-down list. (See Figure 11.2.)

Adobe Camera Raw also has a White Balance tool that you can experiment with. It's the eyedropper icon located immediately to the right of the hand icon (it's third from the left) in the top row of the ACR window. You can click the eyedropper in areas of your image that you feel should be a neutral gray, and ACR will automatically set color temperature and tint for you. This tool is useful if you want to quickly move among various tints chosen by ACR to see what the effect will be.

Figure 11.2 Adjust the color temperature and tint before importing into your image editor.

Other RAW Adjustments

You can also make adjustments for other image parameters in a RAW converter. Most of these are settings you can also make in your image editor for things like brightness, contrast, saturation, and sharpness. If you're comfortable with your RAW utility, go ahead and make them when the image is imported into your image editor. You'll find that it's often better to adjust these settings here, before the camera defaults have been applied to the image, than to wait and try to override the camera's settings in your image editor.

Adobe Camera Raw divides the options among seven tabs, shown as icons near the top of the right-hand column. There's also an eighth icon, which provides access to a tab of preset RAW settings you've saved. As you click on each tab, a series of options and controls appear. From left to right, the icons and their tabs include Basic (for the options shown in Figure 11.2); Tone Curve (similar to the Curves command in Photoshop and other image editors); Detail (sharpening and noise reduction); HSL/Grayscale (hue/saturation/lightness and monochrome options); Split Toning (correcting highlights and shadows separately); Lens Corrections (to fix chromatic aberration and corner darkening problems); and Camera Calibration (for creating color profiles for specific camera models).

Several entire books have been written about using Adobe Camera Raw, so it's not possible to cover all its tools in a portion of a single chapter.

Creating a Black-and-White IR Image

For the most part, the infrared images you capture *won't* be black-and-white photos right off the bat. Unless you're using an IR pass/visible light cutoff filter (on your lens, or internally in a converted camera) with a high cutoff point (as discussed in Chapter 2), at least some visible light will make it through to the sensor. There is enough color information in the vestigial visible wavelengths to produce a false-color image, the familiar brick-and-cyan look of an IR photograph taken with white balance set for infrared illumination. Probably half the photos in this book were produced using this default setting.

But your images don't have to retain that look. One of the first decisions you can make about your infrared photo is whether you want to keep it as a false-color IR image or convert it to the traditional IR black-and-white look. The decision is not a permanent one; if you retain your original RAW or JPEG image, or save an unaltered version of that image in another format, you can always return to the original and produce another version at any time.

There are several ways to convert a false-color infrared image to black and white, and I'm going to show you the most common methods.

Desaturating Your Image

Photoshop and most other image editors make it very, very easy to convert a good infrared false-color photo, like the one shown in Figure 11.3, into a bad black-and-white IR image. In Photoshop, all you need to do is select Image > Mode > Grayscale from the menu bar, and, presto change-o, your color image has been converted to an inaccurate black-and-white rendition. Or, perhaps, you decide to use Image > Adjustments > Desaturate, which does much the same thing, but only operates on a particular layer or selection. Your image editor probably has the equivalent commands. You'll end up with a photo like the one shown in Figure 11.4.

Of course, images converted this way always seem to have low contrast (whether they were taken with infrared illumination or visible light). So, your next step would probably be to use Image > Adjustments > Brightness/Contrast to boost the contrast a bit. In a process that took only a few seconds, you've managed to convert a decent false-color infrared image into an excessively contrasty black-and-white photo that doesn't necessarily offer a good representation of the original. (See Figure 11.5.) What happened? You've fallen for the same trap that has snared photographers for decades. It has long been common to increase contrast when

Figure 11.3 The various components of this photo are easy to discern in false color, despite the limited range of hues.

Figure 11.4 Converted to grayscale using either of Photoshop's default methods tends to blend the colors together as similar tones, creating a low-contrast image.

Figure 11.5 The knee-jerk response to a low-contrast grayscale conversion is to increase the contrast and/or brightness. Bad plan, as you can see in this example.

making a black-and-white print from a color negative, and the practice has become standard operating procedure in the digital world, too.

The fallacy lies in the fact that in a black-and-white photo, the contrast, or apparent differences between objects in an image that makes them distinct, is determined solely by the relationship between the light and dark tones. That's not true when an image is presented in false color. In an IR color photo, *three* separate factors determine true visual contrast among objects. Those include the hue (the various colors of the image, which are typically of a limited range in a false-color photo), saturation (how rich they are), and brightness (the lightness or darkness of a tone).

Converting to Grayscale with Channels

Another popular way to convert an image to grayscale is to examine the individual color channels—red, green, and blue—and choose the one channel that provides the best grayscale representation of an image. In Photoshop, the easiest way to copy one channel of an image is to visit the Channels palette (choose Windows > Channels if it isn't visible), shown in Figure 11.6, and highlight each of the channels in turn. The image in the main window will show the image as represented in that channel only.

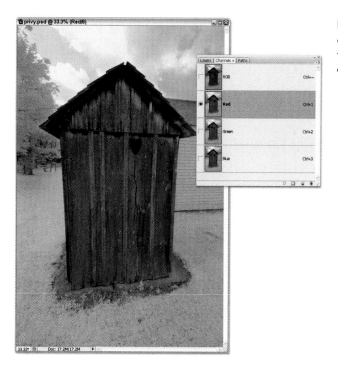

Figure 11.6 Choose a single channel with the black-and-white rendition you like, and copy it to a new file.

When you find a channel you want to use, press Ctrl+A (Command-A on the Mac) to copy the information in that channel, then Ctrl/Command+N to create a new file. Press Ctrl/Command+V to paste the image down into the new file.

A more advanced technique for converting channels to black and white is to use the Photoshop Channel Mixer as an Adjustment Layer (which allows you to play with different combinations of channels and reverse what you've done at any time). Just follow these steps:

1. Choose Layer > New Adjustment Layer > Channel Mixer. Click on OK in the New Layer dialog box that pops up to create the Channel Mixer adjustment layer (see Figure 11.7).

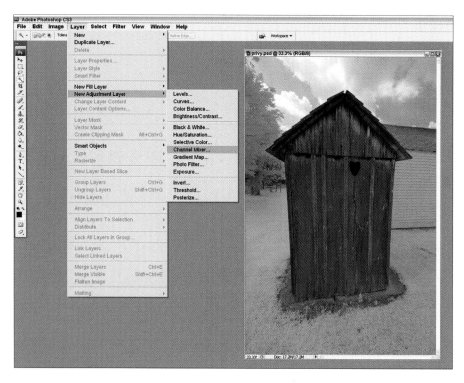

Figure 11.7 Create a Channel Mixer Adjustment Layer to allow non-destructive changes.

2. Click the Monochrome box in the Channel Mixer dialog box to direct your changes to a gray channel.

3. Adjust all the sliders in the red, green, and blue channels until you see a preview image you like (see Figure 11.8). I typically emphasize the red channel (I used a value of 70 percent in this case), but add in some green and blue to get the balance I like. Note that if the percentages you dial in are greater than 100 percent, your image will be lighter, whereas if you use less than 100 percent total values, it will be darker.

4. Use the Constant slider to adjust the overall grayscale values of the image. Negative values add black; positive values emphasize lighter tones.

5. Click on OK to apply the change. If you want to make additional modifications or cancel the channel mixture you've created, double-click the Channel Mixer Adjustment Layer.

6. When you're satisfied with your image, flatten it (use Layer > Flatten) to create your grayscale image to produce the version shown in Figure 11.9.

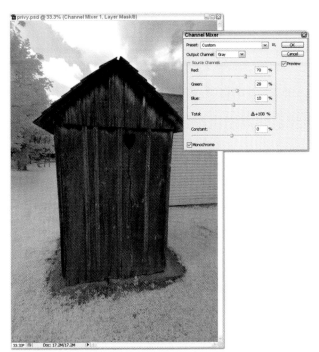

Figure 11.8 Mix the channels until you get a rendition you like.

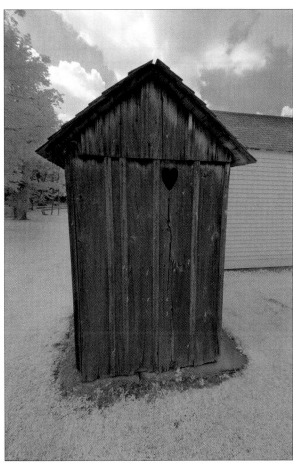

Figure 11.9 A final version might look like this.

Adjusting Tonal Values

One key step in adjusting digital infrared images (or any image, for that matter) is optimizing the relationship between the dark, light, and middle tones, what we call the *tonal range*. For example, a given image may appear to be too dark, so all you have to do is lighten all the tones, right? Wrong! If you lighten all the pixels equally, you'll probably make the very lightest pixels in your dark image *too* light, so the detail in them is lost. The same is true for an image that appears to be too light. Darken all the pixels equally and you end up with dirty highlights. A typical infrared image might look like the one shown in Figure 11.10; overall, it's too dark even though all the tones we'd like in an optimized image are there.

Image editors like Photoshop offer several graphically based tools that let you visualize the current distribution of gray tones in your image and adjust that distribution to suit the photo. One of these is the histogram, which you might think of as a bar chart that displays the distribution of particular gray tones. A glance at the histogram can show you whether the gray values are bunched at one end of the spectrum, evenly distributed, or arranged in groups. Photoshop uses the Levels command to put this kind of histogram information to work.

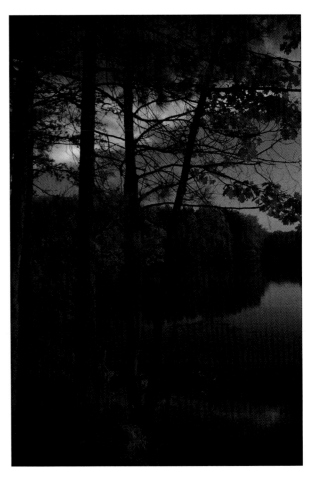

Figure 11.10 This image has all the tones we need, but it's too dark.

Using Levels

With an image of normal contrast and typical subject matter, the bars of the histogram will form a curve of some sort, with the dark tones represented at the left edge of the chart (see Figure 11.11) progressing to the light tones at the right edge. You'll notice that, in this excessively dark image, the preponderance of tones is lodged at the left edge. The histogram is used to measure the numbers of pixels at each of 256 brightness levels. The horizontal axis displays the range of these pixel values, with 0 (black) on the left and 255 (white) on the right. The vertical axis measures the number of pixels at each level. There are several ways we can use Levels to correct the brightness and contrast.

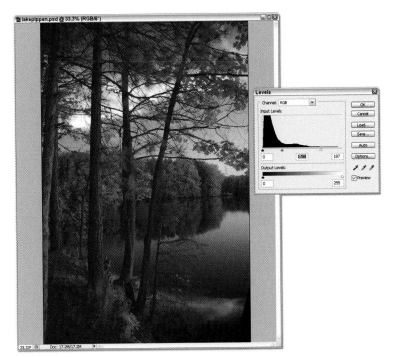

Figure 11.11 The Levels command allows individually adjusting black, midtone, and white points in your image.

To adjust this image, I opened the Levels dialog box by pressing Ctrl/Command+L (selecting Image > Adjustments > Levels also works). I moved the middle slider (it's a gray triangle) towards the left to lighten the middle tones, and adjusted the right slider (a white triangle) to the left until it pointed to the lightest tones that register on the histogram. Using the Levels command of most image editors simply involves placing the black (left) slider at the point in the chart where black tones begin making an impact, the white slider at the point where the lightest tones are represented, and adjusting the middle gray slider until the middle tones look the way we want.

You can reset the white and black points by moving the position of the white and black triangles on the input sliders immediately below the histogram. As you move the white and black sliders, you'll see the values in the left and right Input Levels boxes above the histogram change. Once you've gotten proficient at using Levels, you can also directly enter numbers in these boxes, which represent the black, gray, and white triangles, respectively.

If you like letting Photoshop do things for you, the easiest way to adjust the levels is to click the Auto button in the Levels dialog box and let Photoshop apply its own suggested changes. (You can also use Image > Adjustments > Auto Levels.)

This resets the white point and the black point to the positions in the histogram that actually have tones, and redistributes the gray values of the pixels in between. Afterward, the histogram shows that the pixels fill the complete range from white to black.

If you want even more control, you can select the darkest portion of your image that you want to contain detail, as well as the lightest portion, by sampling those areas in the image itself. Use the eyedroppers in the Levels window to set the black and white points. First, select the White Eyedropper tool and drag it around the image while watching the Info palette. You are looking for the lightest white in the image. Select that point by clicking it. Next, use the Black Eyedropper tool to select the darkest black in the image (the deep shadows in the lower right). The combination of these two choices redistributes the pixels from pure white to pure black.

Using Curves

The chart displayed by the Curves command in Photoshop (Image > Adjustment > Curves or Ctrl/Command+M) shows you some of the same information presented by the Levels command, but in a different way. An unaltered curves display shows a straight line at a 45-degree angle connecting the two corners. As the shortest route between the pair, the 45-degree angle means that the gray tones of the image are reproduced exactly as they appear in the original, with no deviations. In the default mode, the lower-left corner represents 0,0 (pure black) and the upper-right corner is 255,255 (pure white).

Changing the shape of the curve tells the image editing software that you want to alter the grays used to represent a given tone at that point. For example, the middle tones of an image are represented by the middle part of the ramp curve. In Figure 11.12, I've grabbed hold of the middle of the curve and lifted it up, lightening the middle tones without affecting the lighter tones or deepest blacks. You can also adjust the right side of the curve downward to darken light tones, or elevate the left side of the curve upward to lighten dark tones.

Curves is one of the most advanced Photoshop tools, offering the user subtle control over the brightness, contrast, and midtone levels in an image—control that is far beyond that offered by the Levels command and (especially) the Brightness/Contrast dialog box. Your best bet in learning to use it is to play with the various controls by dragging the curve points around until the image looks the way you want. If you click at any point on the curve other than the endpoints, a control point will be added that shows your position. You can move a control point to change the shape of the curve. To remove a control point entirely, drag

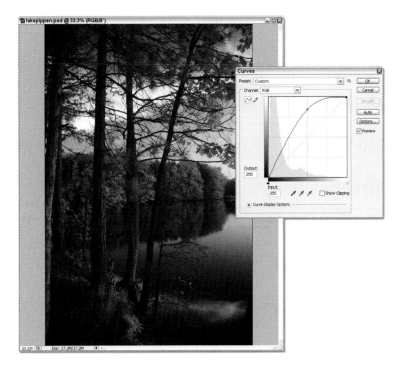

Figure 11.12 The Curves dialog box allows adjusting dark tones, midtones, and highlights separately.

it downward until it is completely off the graph. The shape of the curve will seem to bend momentarily, but it will spring back unaffected.

You can also create a new curve, or portion of a curve, by clicking the pencil icon at the lower center of the dialog box and drawing a curve in the shape you want. Hold down the Shift key to constrain the pencil to a straight line, clicking to create end points for the line. It's unlikely you can draw a smooth curve freehand, so Photoshop provides you with a Smooth button. Click it and your pencil line will be automatically smoothed for you.

Like the Levels command, the Curves dialog box has an Auto button (or use Image > Adjustments > Auto Curves) to let Photoshop take a first stab at adjusting the curves for you. As you click on the Auto button, the darkest pixels in the image (the deep shadows) are reset to black and the lightest areas (the highlights) are remapped to white. As it was in the Levels dialog box, this is the easiest way to make corrections, but it doesn't use the subtle power of Curves any more than the Auto button did in Levels, and you might not like the result in either case.

Next Up

This chapter covered basic techniques for importing infrared photos into an image editor, and tips for converting a false-color IR picture to black and white. In Chapter 12, I'm going to show you some additional fun things you can do to your infrared photos, including more detail on the infamous Channel Swapping technique, use of filters, and how to create some interesting IR special effects.

12

Color IR

Although infrared images seem somewhat monochromatic in nature on first glance, as you work with IR photographs, you'll discover that the color information that *isn't* removed by your visible light blocking filter can be used to create some interesting effects.

False-color IR images have long been used for scientific and reconnaissance purposes by the military. Infrared film (and, today, IR satellite imagery) enables urban foresters to spot ailing trees from afar, because foliage that looks healthy to the naked eye has reduced infrared reflectance when stressed by disease or lack of water. Similarly, military intelligence workers use IR to differentiate between actual trees and ground cover, and cut branches and artificial materials used for camouflage.

Readers of this book will probably be using false-color infrared techniques simply as a creative outlet, rather than some high-tech or high-intelligence application. This chapter provides a quick overview of some of the tricks you can use to spice up your IR photos, starting off with the legendary Channel Swap technique.

Channel Swapping Plus

In a normal infrared color photograph, the elements of an image are rendered in a combination of brick-copper and cyan tones, with the sky shown in various shades of the brick hues, which is a terribly vague way of describing the basic IR false-color effect.

Image editors like Photoshop that provide a readout of the color information of a specific tone within a picture have a way to quantify colors. In Photoshop, for

example, you can pass the Eyedropper tool over a tone in an image and see the proportions of red, green, and blue colors in that sampled tone. A pure black would be rendered as 0,0,0 (0 out of 256 red, 0 out of 256 green, and 0 out of 256 blue), while a pure white would be shown as 256,256,256. A middle gray is described as (surprise!) 128, 128, 128. A midtone in a typical infrared photograph might have a distribution of color tones of 128, 120, 98. You can click around with the Photoshop Eyedropper within any IR image and see the color distribution of any of the tones in the Info palette.

Channel swapping does nothing more than *exchange* the color values found in the red channel for those in the blue channel (leaving the green channel alone). Your original 128, 120, 98 middle gray (yellowish brown) would then have a readout of 98, 120, 128, and appear to the eye to be a middle blue. For most landscape and nature-oriented infrared photos, exchanging the browns found in the sky, water, and similar elements (see Figure 12.1) for blue, while swapping the bluish/cyan tones of foliage for browns, produces a more "realistic" image, as shown in Figure 12.2.

You can swap channels using Photoshop's Channel Mixer. Just follow these steps:

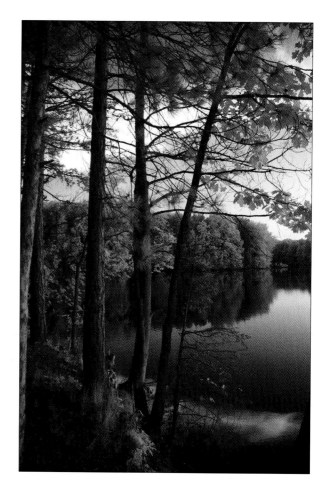

Figure 12.1 This landscape photo is a typical candidate for channel swapping.

1. Load the photograph you want to use with swapped channels.

2. Choose Image > Adjustments > Channel Mixer. The dialog box shown in Figure 12.2 appears.

3. Select the Red channel from the drop-down list. Place the cursor in the box to the right of the Red slider. Type in the value 0.

4. Place the cursor in the box to the right of the Blue slider and type in 100.

5. Select the Red channel from the drop-down list. Place the cursor in the box to the right of the Blue slider. Type in the value 0.

6. Place the cursor in the box to the right of the Red slider and type in 100.

7. Click OK. That's all there is to it. Your finished image will look like the one in Figure 12.3.

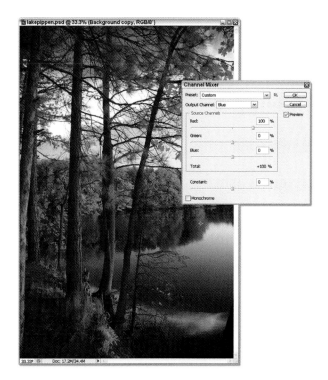

Figure 12.2 Exchange the values of the Red and Blue sliders in both the Red and Blue channels of the image.

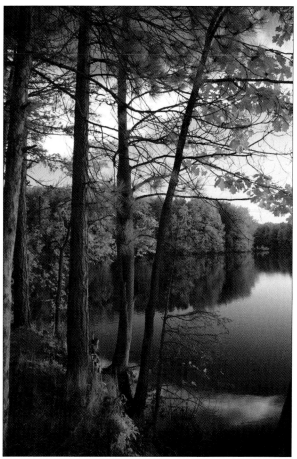

Figure 12.3 With the Red and Blue channels exchanged, the false-color infrared photo has a more "realistic" appearance.

Saving Time with Actions

If you shoot infrared photos regularly, you'll be doing channel swapping often enough that you really should create a Photoshop Action to perform the simple steps for you automatically. Just follow these steps:

1. If the Actions palette is currently set to Button mode (the actions are displayed as colored buttons with appropriate labels), click the flyout menu at the right side of the palette, and unmark the Button Mode choice.

2. Load an image you can use for the channel swapping procedure.

3. Access the flyout menu again, and choose New Action to begin recording. A dialog box like the one in the upper left of Figure 12.4 appears. You can type in a name for the action, specify a shortcut key, and select a color used for the new action's button. Then click the Record button.

4. Follow Steps 2–7 in the channel swapping instructions listed earlier.

5. Click the Stop button in the Actions palette (with the square icon, in the bottom row of the palette) when you're finished recording your action.

6. If you want to resume using Button Mode, click the flyout menu and select the Button Mode choice once again. The Actions palette will have a new action embedded, as shown at the bottom of Figure 12.4.

Figure 12.4 The New Action dialog box (upper left) lets you record and name a new action. Button mode (lower right) makes it easy to start an Action by clicking on a labeled button.

Using Channel Swapping

Keep in mind that not every IR photo taken outdoors needs to be subjected to channel swapping. Figure 12.5 shows an action shot that works quite well as an ordinary false-color infrared shot. On the other hand, some might prefer the image taken a few seconds later (see Figure 12.6), which still shows slightly bizarre colors, even though the sky is now a more realistic blue.

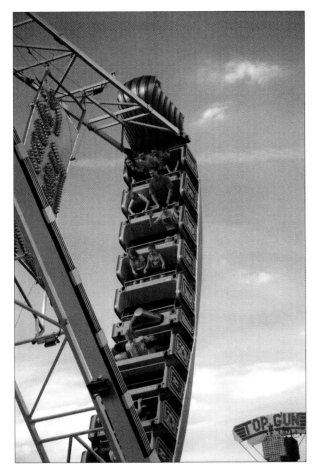

Figure 12.5 This is a straight, unswapped infrared action shot.

Figure 12.6 This photo, taken a few seconds later, has a different mood thanks to channel swapping.

Other Color Effects

Just about any color technique you can apply to visible light photos can also be used experimentally with infrared images. You might not get the exact look you expect, but the results are usually interesting. Use the Color Balance, Hue/Saturation, or other color controls to change the hues of your image subtly. Your image editor's built-in filters can also produce compelling effects. Experiment with different techniques, and if you come up with a look that's fairly compelling, you can always reassure your admirers that "I *meant* to do that!" (That's what I do.)

At various points in this book I've given you examples of other color manipulations you can make with infrared photos. Here are a few more that work especially well with color IR images.

Tricks with Hue

Figure 12.7 shows the lighthouse pictured in Chapter 6 from a different angle, in an unmanipulated false-color photograph. For the stranger version seen in Figure 12.8, I did nothing more than use Photoshop's Hue/Saturation sliders to change the basic hues of the photo, while enhancing the richness of the color by moving the Saturation slider to the right until I got the look I wanted.

If you want the otherworldly effects of IR photography to take you to even wilder new worlds, boosting the saturation and bending the hues is a great way to achieve a special look.

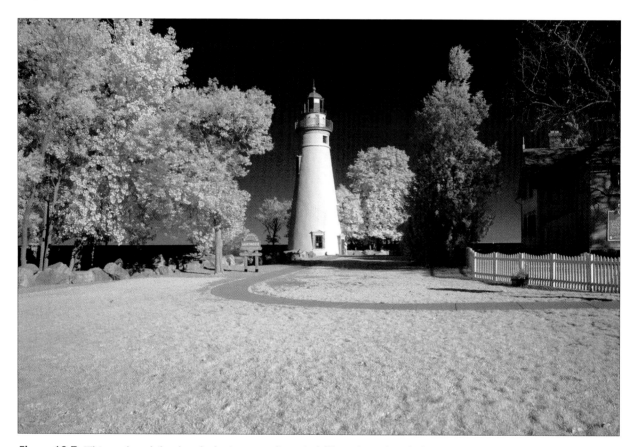

Figure 12.7 This unaltered shot has the basic tones of a typical false-color infrared photograph.

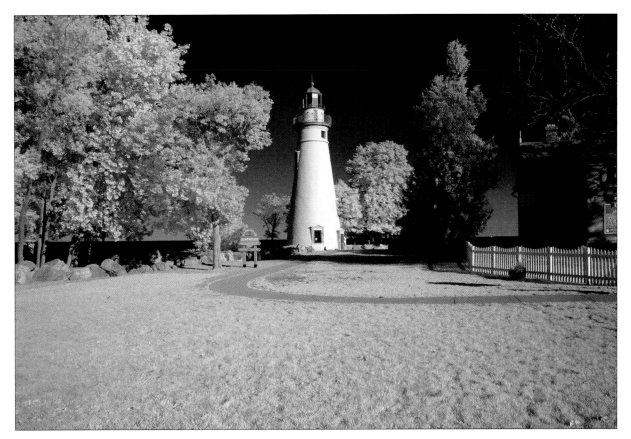

Figure 12.8 Photoshop's Hue/Saturation controls have altered the colors of the image and boosted the richness of the color.

Bending Curves

The Curves command found in Photoshop and many other image editors can be a godsend when you need to adjust the tones of an infrared image (as described in Chapter 11). However, you can also use Curves to create unique color effects. The secret is to bend the curve in unusual ways, as shown in Figure 12.9, so that some tones are reversed, while others retain their normal relationships.

That happens to be exactly what happens when a film image is subjected to the Sabattier effect (sometimes inaccurately called solarization, which is a different phenomenon). Film images that are exposed to light after they have been partially developed also suffer from a reversal of some tones—but not all—creating the odd semi-negative effect that was used extensively on record album covers in the 1960s. You can do much the same thing in your image editor (without the risk of fogging film) by manipulating the curves of a digital IR image. As with most radical

Figure 12.9 Curves can be manipulated in imaginative ways to produce strange looks.

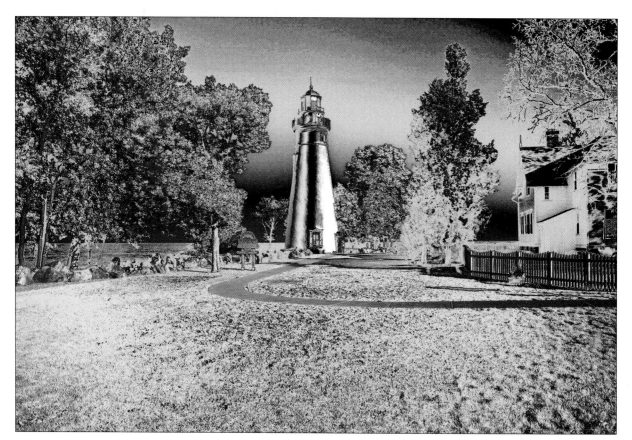

Figure 12.10 A partially reversed negative results from manipulating curves.

effects of this sort, you're better off working with a Curves Adjustment Layer. If you later decide you don't like the look, you can always go back and remanipulate the Adjustment Layer, or even delete it to return to your original image.

Figure 12.10 shows the lighthouse image processed by manipulating its curves.

Applying Filters

There are more than 100 filter effects built into Photoshop, and hundreds more are available from third-party software developers. Many of them can be applied to digital infrared images, turning even a basic image (like the channel-swapped scenic photo shown in Figure 12.11) into a more artistic or painterly image.

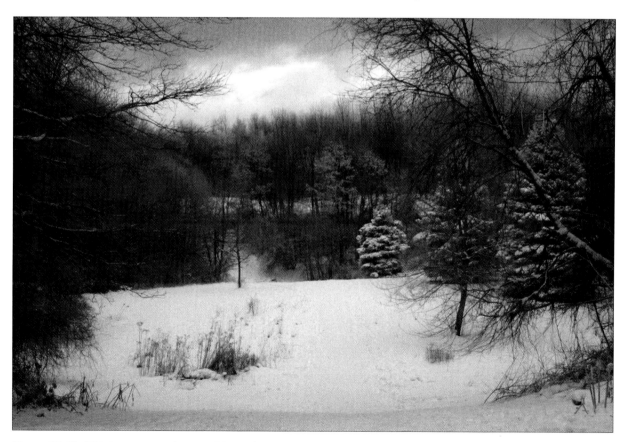

Figure 12.11 This basic scenic photo could use a little spice.

For Figure 12.12, I used the Diffuse Glow filter, found, oddly enough, in Photoshop's Filter > Distort menu to create a dreamy look. An entirely different appearance was developed for Figure 12.13 using the Filter > Brush Strokes > Accented Edges filter. You can fade any of the filter effects to add more or less of a look, as you prefer.

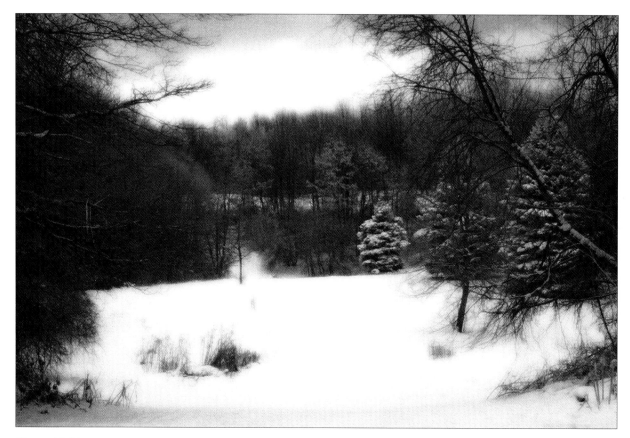

Figure 12.12 Photoshop's Diffuse Glow filter created this look.

Figure 12.13 The Accented Edges filter applied "brush strokes" to this version.

Psychedelic Colors

You don't need a special effects filter to produce some types of strange color combinations. For the next two images, which originally appeared in Chapter 6, I've applied Photoshop's Gradient Map (found in the Image > Adjustments submenu).

When the Gradient palette pops up (using a default grayscale gradient), click on the flyout menu (the little triangle at the right) and choose one of the preset gradients to apply (or you can create your own gradient using your own combination of colors). For Figure 12.14, I selected the blue, red, yellow gradient to provide a vivid new take on "fall colors." I applied the Chrome gradient preset to the image in Figure 12.15, but just to the upper two-thirds of the image (select the portion you want to include in the gradient before activating the Gradient Map). The result produced both a blue sky as well as the proverbial amber waves of grain.

Figure 12.14 A red, yellow, and blue gradient applied to this image produced much more vivid "fall" colors.

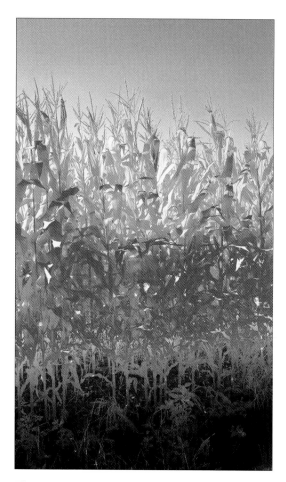

Figure 12.15 Photoshop's Chrome gradient produced this effect on an infrared photo that was originally black and white.

Next Up

The final chapter of this book will provide a few tips on printing your infrared photos. These days, that almost always means some type of inkjet printer, or a photographic printer located at your local retailer's digital photo lab, so your options range from not-so-cheap, but fast (using your own printer) to cheap and almost-as-fast (at your retailer).

13

Hard Copies Made Easy

For a long time, a hard copy print was the expected destination for any photograph—film or digital—good enough to be preserved for posterity. Certainly, we kept our negatives and slides filed away for future use, and archived our digital originals to CD or DVD, but a print, available to pass around among friends, mail to relatives across the country, or hang on the wall for display, was how many photographs ended up.

But, as digital photography has become firmly entrenched, there have been some dramatic changes in the way we use our images. Thanks to the Delete button on digital cameras, some pictures are deleted from your solid-state "film" before they even make it out of the camera. Only the most photographically fit images survive. Anyone who has shot an entire roll of film just to get a shot or two that was worth printing will appreciate the film-saving economy of a digital camera.

We're doing less printing of images for distribution to family and friends, too. It's more common to e-mail photos to those who want them. Many images never see hard copy form at all. They are displayed on web pages, used in PowerPoint presentations, become computer wallpaper or images stored in iPods, and live as slide shows that are only viewed on computer screens.

Even so, we'll always need prints, especially for infrared photographs, with their additional "arty" factor, which makes IR shots often especially suitable for hardcopy display. The continued viability of hardcopies comes from the availability of inexpensive photo quality printers and super-cheap retail digital photo labs, which both encourage digital photographers to make bigger and better prints of their efforts. Photoshop and rampant output technology not only lets you limit your hard copies to the prints you really want, but also makes the prints you do create better looking, with better colors, in larger sizes, and available faster than ever before.

How IR Printing Differs

In most senses, making prints from infrared images is virtually identical to producing hardcopies from ordinary visual light photos. In both types of images you want to see pure, creamy whites in areas that should be without detail (including the whitest whites and the borders of the print); subtle detail in the lightest highlights; nicely gradated midtones; and deep, inky blacks that have detail in the shadows.

IR photos are, in many ways, similar to black-and-white prints—especially if you've converted a false-color infrared shot to straight monochrome. You might want to choose to print your IR photos using your printer's black-and-white mode (if it has one), either to ensure pure monochrome tones or to save money by not expending color inks needlessly.

Infrared photos also share some characteristics with color pictures, except that the colors are likely to be exceptionally subtle, and usually are not fully saturated. If you treat an IR photo as a delicate color photo, you won't be far wrong. Remove the unwanted color casts and leave the colors you do want to see, and you'll be all set. Even if there isn't much color in an infrared photo, you might still want to print it using your printer's full color mode, to take advantage of those subtle hues.

IR photos may tend to have more noise and use softer focus than visible light photos, either as part of their inherent nature or because you used higher ISO settings to reduce the required shutter speeds and neglected to compensate completely for the different focus point found in IR photography. You may end up making prints in smaller sizes to reduce the effects of this different kind of image quality.

Your Output Options

Until a few years ago, your output options at home were broad and versatile, but tended to be costly in terms of per-print prices. There were three or four different print-making technologies to choose from in a home printer. If you ventured outside the home to have your prints made professionally, the cost was a little lower, the service not especially speedy (unless you chose one of the early make-it-yourself print kiosks), and it was sometimes even tricky to find a retailer who could accept particular memory cards or CD-ROM discs.

Today, the options have been turned topsy-turvy. Instead of inkjet, color laser, dye sublimation, and thermal wax printing technologies for making photos at home, your choices are basically among various types of inkjet printers. There are still a couple dye sublimation models available as snapshot printers. The changes have been even more dramatic at the retail level.

Today, you'll find printing kiosks virtually everywhere, and all of them can accept any memory card made (including obsolete types like SmartMedia), as well as CDs and DVDs you've burned yourself. You can usually find a kiosk with a scanner, too, for making copies of existing prints. If you'd rather not make your own prints, in-store minilabs, which used to count processing and printing your film rolls as their bread-and-butter, today spend more time making prints from digital images. You can drop your memory card off at the counter, wait a few minutes, and walk away with a stack of prints priced at only a fraction of what it would cost you to print them at home. Some services allow uploading images over the Internet for return by mail or for pickup at your local store.

Inkjet Printers

Inkjet printers have become ubiquitous. You can buy them in your supermarket for $50, trot down to your electronics or computer store and purchase a photo-quality model for around $100, or spend as little as $300 to $400 for an inkjet specifically designed to print eye-popping color photos on larger-format (bigger than 8.5 × 11 inches) glossy or matte paper. These printers are cheap enough to buy that virtually any amateur photographer can afford one, and serious amateurs and pros can easily justify the best models available.

Whether you can afford to *operate* an inkjet printer is something else again. One of the reasons inkjets are priced so low is that the vendors tend to make lots of money on the consumables. One inkjet printer I purchased last year cost $75 on sale. One month and two ink cartridges later, I'd spent more than my original investment on ink alone. I ended up giving the printer away and purchasing a more economical model.

Why do inkjet printers cost so much to operate? Start with the paper. Most inkjet printers can make acceptable prints on ordinary copier paper that costs a cent or two per sheet. However, the paper is thin and flimsy, has a dull paper-like finish, and neither looks nor feels like a real photograph. Plain paper inkjet prints have a look and quality that resemble a picture you might clip out of the newspaper rather than an actual photo.

For best results, you must use special "photo" papers that cost 50 cents to $1 a sheet or more. These sheets have a water-resistant plastic substrate that doesn't absorb ink, coated with glossy and matte surfaces (on alternate sides, so you can print on whichever side of the sheet you need). Because the ink doesn't spread, the printer is able to apply smaller, more distinct dots of color, producing sharper photographic-quality prints. While the improved quality is important, a buck per print isn't cheap, especially if you like to experiment or if you make many mistakes.

Special paper is only part of the cost. Color ink cartridges can cost $15–$35 each, and generally must be used in conjunction with a black-and-white ink cartridge at $20 and up. Some printers use multiple color cartridges ("strong" color carts for cyan, magenta, and yellow; and "weak" color carts for cyan and magenta) to provide additional tones. A single ink tank may output hundreds of pages if you're outputting text that covers roughly 5 to 15 percent of the page. A full-color image, on the other hand, typically covers 100 percent of the area printed (whether it's a 4 × 6 print or a full 8 × 10), so you may get as few as 20 to 30 full-page prints per ink cartridge. Plan on allocating another $1 per page just for ink.

It gets worse. If your particular printer's ink cartridge is an older model that includes all three colors in a single module, you may find that one color runs out even more quickly (because, say, you're printing images that contain lots of yellow) and you must throw away a cartridge even when there are plenty of the other hues in the remaining tanks. Fortunately, today, with few exceptions, almost all inkjet printers use separate ink tanks for each color. But, at the same time, the number of tanks has proliferated, with some printers using eight or more different colors (cyan, magenta, yellow, black, plus photo cyan, photo magenta, red, and green).

Of course, you may want to try out one of those inkjet refill kits, which come with bottles of ink and one or more syringes. They can provide two or three fillings at less than the cost of a single new color cartridge. Some people swear by them, although I, personally, swear at them. The process takes a lot of time, which can be better spent taking pictures or working with Photoshop. If you have only one syringe, you must clean it with distilled water to remove all the ink before refilling another tank with a different color. If you use three syringes, you have to clean all three when you're done. The ink tends to spill and get all over your fingers and everything else in the vicinity. If you don't refill at exactly the right time, the innards of the cartridge may dry out, leaving you with a freshly refilled, non-working ink cartridge. Nor can cartridges be refilled indefinitely. If your printer uses nozzles built into the cartridge itself, these nozzles may wear out after a few refills. You'll have to buy a new one at full price and start over.

Many inkjet printers accept third-party ink cartridges that cost half or a third of what the vendor sells them for. Of course, you must take your chances that the cartridges are as good and that the ink is of the same quality and permanence as that in the vendor's own cartridges.

Saving Money with Inkjets

Paper costs are easy to trim. Try these cost-savers:

■ **Buy photo paper in larger quantities.** You'll find that a 50-sheet or 100-sheet pack can be 50 percent cheaper per sheet than the 10-sheet or 25-sheet packages. Buy smaller quantities only to test the quality of a particular kind of paper. Once you're certain you like it, stock up on the larger packages.

■ **Don't lock yourself into the vendor's product line.** Vendors guarantee that their papers will be compatible with their inks. In practice, there have been some combinations of paper stocks and inks that perform poorly, particularly when it comes to archival permanence. Use the wrong paper with the wrong ink and you may find yourself with faded photos in a few months. However, you should test a variety of papers, including generic store-brand stocks to see which provides the best combination of performance and longevity. For example, many of the color prints I make are submitted to newspapers. I don't care what they look like three months later; I never see them again.

■ **Experiment with premium-quality plain paper.** I've used various brands with Bright White, Heavy Weight, or Premium Weight designations, including some that have a fairly glossy finish. I've even used old thermal printer paper stocks with inkjet printers. Paying $5 and up for a ream of "ordinary" paper can pay off if it gives you superior results when printing photos. You may have to test to see which of your printer's paper settings work best. For example, when I use glossy plain paper with my inkjet, I must use a High Resolution paper setting (but not any of the glossy photo paper settings) to get the best results.

■ **Choose appropriate print sizes.** If a 5 × 7 will do the job (which is the case with the prints I submit for publication), don't make an 8 × 10. You can fit two 5 × 7s on a single 8.5 × 11-inch sheet, which cuts your cost for paper in half.

■ **Use plain paper instead of photo paper when plain paper will do the job.** You don't always need a glossy or matte photo-quality print. You'd be surprised at how good a picture can look on $2-a-ream paper that costs less than half a cent a sheet.

The cost of ink is the consumable expense that offers the most options for control. Try these:

- **Choose an ink-frugal printer.** When I chucked my old ink-hog inkjet, I invested a whopping $149 in a Canon model that uses individual ink tanks for each color, plus black. I no longer worry about what mix of colors my prints have, or whether I'm about to deplete my yellow, cyan, or magenta inks. When one color runs out, instead of dropping a new $35 cartridge in the printer, I replace only one color tank, for $10 or less. As a bonus, my new printer's larger tanks get many more prints per color than my old clunker.

- **Investigate less expensive ink sources.** Actually, I don't pay anywhere near $10 for an ink tank. I found a source that sells Canon-brand ink tanks, still factory sealed, for half the regular price. If you can't find discounted ink cartridges or tanks for your printer, check out third-party cartridges, which are available for the most common Epson and Hewlett-Packard models.

- **Give an ink refilling kit a try.** If you like to tinker and aren't as clumsy as I am, these could work for you. Shop carefully so you purchase kits with good quality ink. And don't forget to buy some extra syringes.

- **Watch those print sizes.** An 8 × 10 uses a lot of ink. Save the larger sizes for your portfolio, or for display on a mantel.

Tips for Getting the Best Digital Prints at Home

If you make prints from your digital images yourself, you'll want to keep these tips in mind to get the best quality and best economy.

- Use Photoshop's provision for calibrating your monitor, using the Adobe Gamma Control Panel (Windows and Mac OS 9.x and earlier) or the Apple Calibration Utility (Mac OS). You'll find instructions for using the Adobe tool in Chapter 6. Your scanner also may have calibration procedures to help match your scanner's output to your printer. This will help ensure that what you see (on your monitor) is what you get (in your prints). If you're an advanced worker, learn to use the color matching software provided with your particular printer. Every device comes with different software, so we can't cover them here, but most have wizards and other tools to let you calibrate or characterize your equipment quickly. There are also cheap hardware calibration tools that can make life easier.

- As mentioned earlier, if image quality is important to you, get the best glossy photographic paper for printing out your images. Experiment with several different stocks to see which you like best. You'll probably find that the paper offered by your printer manufacturer will be fine-tuned for your particular printer, but you needn't limit yourself to those products.

- Don't ruin one of those expensive sheets to a paper jam. If you're making prints one at a time, load your printer with one sheet of photo paper each time. Load multiple sheets only if you want to print many pages unattended, and even then make sure that only photo paper is loaded.

- Remember to clean your inkjet's print heads periodically and keep the printer's rollers and paper path clean. You'll avoid blurry or spotted prints and unwanted artifacts like visible lines.

- Don't touch your prints after they've emerged from the printer. Give them a chance to dry before you handle them. If you can't spread them out individually and must place them in stacks, put a sheet of plain paper between your prints so that any ink won't transfer to the print above.

- Experiment with special paper stocks that let you get even more use from your digital prints. You'll find paper designed especially for making t-shirt transfers, fabric printing, making greeting cards, or creating overhead transparencies.

The Digital Lab Option

The fastest, most convenient, and least expensive option these days may be to allow your retailer's digital photo lab to make the prints. They can do it while you wait, and they are adept at correcting photos. You may throw the digital lab's technicians for a loop the first time you present them with some infrared photos however, so plan to hang around while your initial prints are made to provide "consulting" input about what you want to see in your finished prints. There are hundreds of eager picture services ready to create prints for you. They'll output your images directly from your camera's film card or allow you to upload them over the Internet from your home for printing at your local retailer's lab.

You can also make your prints yourself at the retailer. The easiest way is to stop in at your local department store and look for one of those standalone kiosks. I've used these when I was on the run, going directly from a photo opportunity to a nearby discount store, making a print, and dropping it off at a newspaper with handwritten cutline. Total elapsed time, 30 minutes, and at a cost of a few dollars for two 5 × 7 prints made from my camera's memory card.

Photo kiosks accept images in many formats, including CompactFlash, Secure Digital, Sony Memory Sticks, xD Cards, plus CDs, floppy diskettes (sometimes), or original prints, slides, or negatives. The latter are captured with a built-in scanner. It's worthwhile to check out your local kiosk *before* you need pictures in a crunch. Determine whether the kiosk will accept the file types you want to work with, such as TIF. If not, you may have to present the device with a JPG file when

using a memory card, for example. (Save your JPG in its highest resolution, and you may not notice any loss of quality.)

This option is quick and dirty, but you don't lose all control. The kiosk's software has tools for fixing bad color, removing red-eye, and adding borders or text. You can crop, enlarge, or reduce your photos, but not with complete freedom. You may have to crop using the aspect ratio of your selected picture size (for example, 5 × 7 or 8 × 10) and you may be unable to produce an odd-size image (say, a 3 × 7) using the kiosk's controls alone. (You can add white space yourself using Photoshop's tools, then print a 5 × 7 with very, very wide borders along the long dimension, for example.)

The kiosk will let you print various combinations of pictures that will fill an 8.5 × 11-inch sheet, such as a single 8 × 10, two 5 × 7s, four 4 × 5s, and so forth, but only with duplicates of a single image. You can't print two different 5 × 7s on one sheet, for example, without creating a special image in Photoshop. I've done this on occasion, ganging several images in one file, and then printing it on the kiosk as an 8 × 10. The latest kiosks will let you input your images to a connected digital minilab and output prints on regular photo paper at very attractive prices.

You can also find printing services online. These companies let you upload your images, display them on web pages, or order prints. For your non-infrared, film-based photography there also are firms that accept unprocessed or processed film and convert them to both hard copies and digital images that you can share, download over the Internet, or choose to receive on Photo CD. These are a good choice for those using conventional film and prints, but who don't have a scanner to make digital copies.

Next Up

The next step is up to you. I've introduced you to the mysteries of digital infrared photography, showed you how to use your current camera to take IR pictures, led you step-by-step through the process of converting an existing camera, and offered examples of the kind of results you can expect to get under a variety of conditions. I hope this book has inspired you to go out and explore this exciting arena on your own.

A

Glossary of Photographic, Digital, and Infrared Terminology

This glossary includes most of the jargon included in this book, relating to infrared photography, film photography, and digital photography, as well as words that are not within these pages, but which you'll frequently come across as you take photos.

accessory viewfinder An external device that displays the approximate frame captured by the lens when peered through. Digital SLR photographers using infrared filters that cut off all or most visible light can use an accessory finder as an aid to pointing the camera and roughly composing an image. These external viewfinders, originally created for rangefinder-type non-SLR cameras, generally clip onto the flash accessory shoe on top of the camera, and are available in fixed view type for a single focal length lens, or for multiple focal lengths using several brightline frames.

acutance A way of describing sharpness by measuring the transitions between edge details in an image.

additive primary colors The red, green, and blue hues that are used alone or in combinations to create all other visible colors you capture with a digital camera, view on a computer monitor, or work with in an image-editing program like Photoshop.

ambient lighting Diffuse nondirectional lighting already present in a scene that doesn't appear to come from a specific source but, rather, bounces off walls, ceilings, and other objects in the scene when a picture is taken.

analog/digital converter In digital imaging, the electronics built into a camera or scanner that convert the analog information captured by the sensor into digital bits that can be stored as an image.

angle of view The area of a scene that a lens can capture, determined by the focal length of the lens. Lenses with a shorter focal length have a wider angle of view than lenses with a longer focal length.

antialias A process in image editing that smooths the rough edges in images (called jaggies or staircasing) by creating partially transparent pixels along the boundaries that are merged into a smoother line by our eyes.

antialiasing filter A layer placed in front of a digital camera sensor to eliminate moiré effects that can occur when fine detail or patterns in a subject react with the sensor's inherent photosite pattern to create interference. See also *moiré.*

antihalation backing A dye used on the back surface of most films that absorbs any remaining light that has already passed through the emulsion, preventing it from reflecting back into the emulsion from the camera surface that holds the film flat.

aperture-preferred A camera setting that allows you to specify the lens opening or f/stop that you want to use, with the camera selecting the required shutter speed automatically based on its light-meter reading. See also *shutter-preferred.*

aperture ring A control on the barrel of many SLR lenses that allows setting the f/stop manually. Some lenses have the aperture set by the camera only, and lack this ring.

artifact A type of noise in an image, or an unintentional image component produced in error by a digital camera or scanner during processing or during compression by file formats such as JPEG.

aspect ratio The proportions of an image as printed, displayed on a monitor, or captured by a digital camera. An 8 × 10-inch or 16 × 20-inch photo both have a 4:5 aspect ratio. Your monitor set to 800 × 600, 1024 × 768, or 1600 × 1200 pixels has a 4:3 aspect ratio. When you change the aspect ratio of an image, you must crop out part of the image area or create some blank space at top or sides.

aspherical element A component of a ground glass or molded glass or plastic lens that is not a cross-section of a sphere, but rather formed from a non-spherical surface to provide better correction characteristics.

autofocus A camera setting that allows the camera to choose the correct focus distance for you, usually based on the contrast of an image (the image will be at maximum contrast when in sharp focus) or a mechanism such as an infrared sensor that measures the actual distance to the subject. Cameras can be set for single autofocus (the lens is not focused until the shutter release is partially depressed) or continuous autofocus (the lens refocuses constantly as you frame and reframe the image).

averaging meter A light-measuring device that calculates exposure based on the overall brightness of the entire image area. Averaging tends to produce the best exposure when a scene is evenly lit or contains equal amounts of bright and dark areas that contain detail. Most digital cameras use much more sophisticated exposure measuring systems based in center-weighting, spot-reading, or calculating exposure from a matrix of many different picture areas. See also *spot meter.*

B (bulb) A camera setting for making long exposures. Press down the shutter button and the shutter remains open until the shutter button is released. Bulb exposures can also be made using a camera's electronic remote control, or a cable release cord that fits to the camera. See also *T (Time).*

back focus The tendency of an autofocus system to apply focus *behind* the point of true focus.

back lighting A lighting effect produced when the main light source is located behind the subject. Back lighting can be used to create a silhouette effect or to illuminate translucent objects. See also *front lighting, fill lighting,* and *ambient lighting.* Back lighting is also a technology for illuminating an LCD display from the rear, making it easier to view under high ambient lighting conditions.

balance An image that has equal elements on all sides.

ball head A type of tripod camera mount with a ball-and-socket mechanism that allows greater freedom of movement than simple pan and tilt heads.

barrel distortion A defect found in some wide-angle prime and zoom lenses that causes straight lines at the top or side edges of an image to bow outward into a barrel shape. See also *pincushion distortion.*

Bayer filter array A matrix of alternating red, green, and blue color filters overlaid on a digital camera sensor to enable the sensor to detect the primary colors of light.

beam splitter A partially silvered mirror or prism that divides incoming light into two portions, usually to send most of the illumination to the viewfinder and part of it to an exposure meter, focusing mechanism, or image capture system.

black The color formed by the absence of reflected or transmitted light.

black point The tonal level of an image where blacks begin to provide important image information, usually measured by using a histogram. When correcting an image with a digital camera that has an on-screen histogram, or within an image editor, you'll usually want to set the histogram's black point at the place where these tones exist.

blooming An image distortion caused when a photosite in an image sensor has absorbed all the photons it can handle, so that additional photons reaching that pixel overflow to affect surrounding pixels producing unwanted brightness and overexposure around the edges of objects.

blur In photography, to soften an image or part of an image by throwing it out of focus, or by allowing it to become soft due to subject or camera motion. In image editing, blurring is the softening of an area by reducing the contrast between pixels that form the edges.

bokeh A buzzword used to describe the aesthetic qualities of the out-of-focus parts of an image, with some lenses producing "good" bokeh and others offering "bad" bokeh. *Boke* is a Japanese word for "blur," and the h was added to keep English speakers from rhyming it with *broke.*

Out-of-focus points of light become discs, called the *circle of confusion.* Some lenses produce a uniformly illuminated disc. Others, most notably *mirror* or *catadioptic* lenses, produce a disk that has a bright edge and a dark center, producing a "doughnut" effect, which is the worst from a bokeh standpoint. Lenses that generate a bright center that fades to a darker edge are favored, because their bokeh allows the circle of confusion to blend more smoothly with the surroundings. The bokeh characteristics of a lens are most important when you are using selective focus (say, when shooting a portrait) to deemphasize the background, or when shallow depth-of-field is a given because you're working with a macro lens, long telephoto, or with a wide open aperture. See also *mirror lens* and *circle of confusion.*

bounce lighting Light bounced off a reflector, including ceiling and walls, to provide a soft, natural-looking light.

bracketing Taking a series of photographs of the same subject at different settings to help ensure that one setting will be the correct one. Many digital cameras will automatically snap off a series of bracketed exposures for you. Other settings, such as color and white balance, can also be "bracketed" with some models. Digital SLRs may even allow you to choose the order in which bracketed settings are applied.

brightness The amount of light and dark shades in an image, usually represented as a percentage from 0 percent (black) to 100 percent (white).

broad lighting A portrait lighting arrangement in which the main light source illuminates the side of the face closest to the camera.

buffer A digital camera's internal memory which stores an image immediately after it is taken until the image can be written to the camera's non-volatile (semi-permanent) memory or a memory card.

burn A darkroom technique, mimicked in image editing, which involves exposing part of a print for a longer period, making it darker than it would be with a straight exposure.

burst mode The digital camera's equivalent of the film camera's "motor drive," used to take multiple shots within a short period of time.

calibration A process used to correct for the differences in the output of a printer or monitor when compared to the original image. Once you've calibrated your scanner, monitor, and/or your image editor, the images you see on the screen more closely represent what you'll get from your printer, even though calibration is never perfect.

Camera Raw A plug-in included with Adobe Photoshop and Adobe Photoshop Elements that can manipulate the unprocessed RAW images captured by digital cameras.

camera shake Movement of the camera, aggravated by slower shutter speeds, which produces a blurred image. Some of the latest digital cameras have *image stabilization* features that correct for camera shake, while a few high-end interchangeable lenses have a similar vibration correction or reduction feature. See also *image stabilization*.

cast An undesirable tinge of color in an image.

CCD Charge-Coupled Device. A type of solid-state sensor that captures the image—used in scanners and digital cameras. See also *CMOS*.

center-weighted meter A light-measuring device that emphasizes the area in the middle of the frame when calculating the correct exposure for an image. See also *averaging meter* and *spot meter*.

channel swapping A method for creating false color infrared photos. Channel swapping is accomplished in an image editor, using tools like Photoshop's Channel Mixer, to exchange the red and blue channels.

chlorophyll The substance in plants that gives them their green color and enables them to convert sunlight into energy. Chlorophyll absorbs blue and red light most strongly, and reflects green and infrared light. Its infrared reflectance accounts for

most of the dramatic white appearance of foliage in infrared photography, although a small amount of additional light is provided from fluorescence of the pigment under exposure to IR.

chroma Color or hue.

chromatic aberration An image defect, often seen as green or purple fringing around the edges of an object, caused by a lens failing to focus all colors of a light source at the same point. See also *fringing*.

chromatic color A color with at least one hue and a visible level of color saturation.

chrome An informal photographic term used as a generic for any kind of color transparency, including Kodachrome, Ektachrome, or Fujichrome.

CIE (Commission Internationale de l'Eclairage) An international organization of scientists who work with matters relating to color and lighting. The organization is also called the International Commission on Illumination.

circle of confusion A term applied to the fuzzy discs produced when a point of light is out of focus. The circle of confusion is not a fixed size. The viewing distance and amount of enlargement of the image determine whether we see a particular spot on the image as a point or as a disc. See also *bokeh*.

close-up lens A lens add-on that allows you to take pictures at a distance that is less than the closest-focusing distance of the lens alone.

CMOS Complementary Metal-Oxide Semiconductor. A method for manufacturing a type of solid-state sensor that captures the image, used in scanners and digital cameras. See also *CCD*.

cold mirror A specialized type of optical component that reflects the entire visible light spectrum while allowing infrared wavelengths to pass through. See also *dichroic filter* and *hot mirror*.

color correction Changing the relative amounts of color in an image to produce a desired effect, typically a more accurate representation of those colors. Color correction can fix faulty color balance in the original image, or compensate for the deficiencies of the inks used to reproduce the image.

Compact Flash A type of memory card used in most digital single lens reflexes.

compression Reducing the size of a file by encoding using fewer bits of information to represent the original. Some compression schemes, such as JPEG, operate by discarding some image information, while others, such as TIF, preserve all the detail in the original, discarding only redundant data. See also *GIF, JPEG*, and *TIF*.

continuous autofocus An automatic focusing setting in which the camera constantly refocuses the image as you frame the picture. This setting is often the best choice for moving subjects. See also *autofocus.*

cones Any of three different varieties of cells in the eye (S-cones, M-cones, and L-cones) that detect short, medium, and long wavelengths of visible light, respectively, making color vision possible. See also *rods.*

contrast The range between the lightest and darkest tones in an image. A high-contrast image is one in which the shades fall at the extremes of the range between white and black. In a low-contrast image, the tones are closer together.

contrasty Having higher than optimal contrast.

crop To trim an image or page by adjusting its boundaries.

cutoff point In infrared photography, the wavelength at which a given filter passes no more than 50 percent of the available illumination. For example, an IR filter with a cutoff point of 700 nm would block at least 50 percent of the light with wavelengths shorter than 700 nm, while allowing the light above that focal length to pass through.

dedicated flash An electronic flash unit designed to work with the automatic exposure features of a specific camera.

demosaicing The process of interpreting the red, green, and blue pixels of a Bayer filter array to create an interpolated image that corresponds to what the photo would look like if red, green, or blue pixels were available at every photosite in a sensor.

densitometer An electronic device used to measure the amount of light reflected by or transmitted through a piece of artwork—used to determine accurate exposure when making copies or color separations.

density The ability of an object to stop or absorb light. The less light reflected or transmitted by an object, the higher its density.

depth-of-field A distance range in a photograph in which all included portions of an image are at least acceptably sharp. With many dSLRs, you can see the available depth-of-field at the taking aperture by pressing the depth-of-field preview button, or estimate the range by viewing the depth-of-field scale found on many lenses.

depth-of-field scale A set of markings on a lens that show the approximate depth-of-field at a given f/stop. On some lenses, this scale also includes a red dot or other marking to indicate the amount of offset needed to focus at an indicated distance using infrared light instead of visible light.

depth of focus The range that the image-capturing surface (such as a sensor or film) could be moved while maintaining acceptable focus.

desaturate To reduce the purity or vividness of a color, making a color appear to be washed out or diluted.

diaphragm An adjustable component, similar to the iris in the human eye, that can open and close to provide specific sized lens openings, or f/stops. See also *f/stop* and *iris*.

dichroic filter A filter with multiple thin layers that selectively block certain wavelengths of light while passing others with great accuracy. See also *hot mirror* and *cold mirror.*

diffraction In photography, the loss of sharpness due to light scattering as an image passes through smaller and smaller f/stop openings. Diffraction is dependent only on the actual f/stop used and the wavelength of the light.

diffuse lighting Soft, low-contrast lighting.

diffusion Softening of detail in an image by randomly distributing gray tones in an area of an image to produce a fuzzy effect. Diffusion can be added when the picture is taken, often through the use of diffusion filters, or in post-processing with an image editor. Diffusion can be beneficial to disguise defects in an image and is particularly useful for portraits of women.

digital processing chip A solid-state device found in digital cameras that's in charge of applying the image algorithms to the raw picture data prior to storage on the memory card.

diopter A value used to represent the magnification power of a lens, calculated as the reciprocal of a lens' focal length (in meters). Diopters are most often used to represent the optical correction used in a viewfinder to adjust for limitations of the photographer's eyesight, and to describe the magnification of a close-up lens attachment.

dodging A darkroom term for blocking part of an image as it is exposed, lightening its tones. Image editors can mimic this effect by lightening portions of an image using a brush-like tool. See also *burn.*

dots per inch (dpi) The resolution of a printed image, expressed in the number of printer dots in an inch. You'll often see dpi used to refer to monitor screen resolution or the resolution of scanners. However, neither of these uses dots; the correct term for a monitor is pixels per inch (ppi), whereas a scanner captures a particular number of samples per inch (spi).

electronic viewfinder (EVF) An LCD located inside a digital camera and used to provide a view of the subject based on the image generated by the camera's sensor. Sometimes, the term EVF is used to describe the class of camera using this type of viewfinder.

emulsion The light-sensitive coating on a piece of film, paper, or printing plate. When making prints or copies, it's important to know which side is the emulsion side so the image can be exposed in the correct orientation (not reversed). Image editors such as Photoshop include "emulsion side up" and "emulsion side down" options in their print preview feature.

equivalent focal length A digital camera's focal length translated into the corresponding values for a 35mm film camera. For example, a 5.8mm to 17.4mm lens on a digital camera might provide the same view as a 38mm to 114mm zoom with a film camera. Equivalents are needed because sensor size and lens focal lengths are not standardized for digital cameras, and translating the values provides a basis for comparison.

Exif Exchangeable Image File Format. Developed to standardize the exchange of image data between hardware devices and software. A variation on JPEG, Exif is used by most digital cameras, and it includes information such as the date and time a photo was taken, the camera settings, resolution, amount of compression, and other data.

existing light In photography, the illumination that is already present in a scene. Existing light can include daylight or the artificial lighting currently being used, but it is not considered to be electronic flash or additional lamps set up by the photographer.

export To transfer text or images from a document to another format.

exposure The amount of light allowed to reach the film or sensor, determined by the intensity of the light, the amount admitted by the iris of the lens, and the length of time determined by the shutter speed.

exposure program An automatic setting in a digital camera that provides the optimum combination of shutter speed and f/stop at a given level of illumination. For example a "sports" exposure program would use a faster, action-stopping shutter speed and larger lens opening instead of the smaller, depth-of-field-enhancing lens opening and slower shutter speed that might be favored by a "close-up" program at exactly the same light level.

exposure values (EV) EV settings are a way of adding or decreasing exposure without the need to reference f/stops or shutter speeds. For example, if you tell your camera to add +1EV, it will provide twice as much exposure, either by using a larger f/stop, slower shutter speed, or both.

eyedropper An image-editing tool used to sample color from one part of an image so it can be used to paint, draw, or fill elsewhere in the image. Within some features, the eyedropper can be used to define the actual black points and white points in an image.

false color infrared A color infrared image in which various levels of IR reflectance are assigned to specific colors, making it easier to interpret those levels, but resulting in a color image that has no relation to the colors of the subject in real life. False color infrared is often used with satellite imaging and aerial photography.

feather To fade out the borders of an image element, so it will blend in more smoothly with another layer.

fill lighting In photography, lighting used to illuminate shadows. Reflectors or additional incandescent lighting or electronic flash can be used to brighten shadows. One common technique outdoors is to use the camera's flash as a fill.

filter In photography, a device that fits over the lens, changing the light in some way. In image editing, a feature that changes the pixels in an image to produce blurring, sharpening, and other special effects. Photoshop CS3 and Elements 5.0 include several filter effects, including Lens Blur and Photo Filters.

FireWire (IEEE-1394) A fast serial interface used by scanners, digital cameras, printers, and other devices.

flash sync The timing mechanism that ensures that an internal or external electronic flash fires at the correct time during the exposure cycle. A dSLR's flash sync speed is the highest shutter speed that can be used with flash. See also *front curtain sync* and *rear curtain sync.*

flat An image with low contrast.

flatbed scanner A type of scanner that reads one line of an image at a time, recording it as a series of samples, or pixels.

focal length The distance between the film and the optical center of the lens when the lens is focused on infinity, usually measured in millimeters.

focal plane An imaginary line (often marked on the body of some cameras), perpendicular to the optical access, that passes through the focal point forming a plane of sharp focus when the lens is set at infinity.

focus To adjust the lens to produce a sharp image.

focus lock A camera feature that lets you freeze the automatic focus of the lens at a certain point, when the subject you want to capture is in sharp focus.

focus range The minimum and maximum distances within which a camera is able to produce a sharp image, such as two inches to infinity.

focus servo A dSLR's mechanism that adjusts the focus distance automatically. The focus servo can be set to single autofocus, which focuses the lens only when the shutter release is partially depressed, and continuous autofocus, which adjusts focus constantly as the camera is used.

focus tracking The ability of the automatic focus feature of a camera to change focus as the distance between the subject and the camera changes. One type of focus tracking is *predictive*, in which the mechanism anticipates the motion of the object being focused on, and adjusts the focus to suit.

Foveon sensor A special type of CMOS digital camera sensor that uses three layers sensitive to red, green, and blue light to capture images, rather than a single layer with a Bayer filter array.

framing In photography, composing your image in the viewfinder. In composition, using elements of an image to form a sort of picture frame around an important subject.

frequency The number of lines per inch in a halftone screen.

fringing A chromatic aberration that produces fringes of color around the edges of subjects, caused by a lens' inability to focus the various wavelengths of light onto the same spot. *Purple fringing* is especially troublesome with backlit images.

front-curtain sync The default kind of electronic flash synchronization technique, originally associated with focal plane shutters, that consists of a traveling set of curtains, including a front curtain (which opens to reveal the film or sensor) and a rear curtain (which follows at a distance determined by shutter speed to conceal the film or sensor at the conclusion of the exposure).

For a flash picture to be taken, the entire sensor must be exposed at one time to the brief flash exposure, so the image is exposed after the front curtain has reached the other side of the focal plane, but before the rear curtain begins to move.

Front-curtain sync causes the flash to fire at the *beginning* of this period when the shutter is completely open, in the instant that the first curtain of the focal plane shutter finishes its movement across the film or sensor plane. With slow shutter speeds, this feature can create a blur effect from the ambient light, showing as patterns that follow a moving subject, with the subject shown sharply frozen at the beginning of the blur trail (think of an image of The Flash running backwards). See also *rear-curtain sync*.

front focus The tendency of an autofocus system to apply focus in front of the point of true focus.

front lighting Lighting falling on the subject that originates in the general direction of the camera rather than from behind or to either side of the subject.

f/stop The relative size of the lens aperture, which helps determine both exposure and depth-of-field. The larger the f/stop number, the smaller the f/stop itself. It helps to think of f/stops as denominators of fractions, so that f/2 is larger than f/4, which is larger than f/8, just as 1/2, 1/4, and 1/8 represent ever smaller fractions. In photography, a given f/stop number is multiplied by 1.4 to arrive at the next number that admits exactly half as much light. So, f/1.4 is twice as large as f/2.0 (1.4 × 1.4), which is twice as large as f/2.8 (2 × 1.4), which is twice as large as f/4 (2.8 × 1.4). The f/stops that follow are f/5.6, f/8, f/11, f/16, f/22, f/32, and so on. See also *diaphragm.*

full-color image A visible light image that uses 16.8 million possible hues. Images are sometimes captured in a scanner with more colors, but the colors are reduced to the best 16.8 million shades for manipulation in image editing.

gamma A numerical way of representing the contrast of an image. Devices such as monitors typically don't reproduce the tones in an image in straight-line fashion (all colors represented in exactly the same way as they appear in the original). Instead, some tones may be favored over others, and gamma provides a method of tonal correction that takes the human eye's perception of neighboring values into account. Gamma values range from 1.0 to about 2.5. The Macintosh has traditionally used a gamma of 1.8, which is relatively flat compared to television. Windows PCs use a 2.2 gamma value, which has more contrast and is more saturated.

gamma correction A method for changing the brightness, contrast, or color balance of an image by assigning new values to the gray or color tones of an image to more closely represent the original shades. Gamma correction can be either linear or nonlinear. Linear correction applies the same amount of change to all the tones. Nonlinear correction varies the changes tone-by-tone, or in highlight, midtone, and shadow areas separately to produce a more accurate or improved appearance.

gamut The range of viewable and printable colors for a particular color model, such as RGB (used for monitors) or CMYK (used for printing).

Gaussian blur A method of diffusing an image using a bell-shaped curve to calculate the pixels that will be blurred, rather than blurring all pixels, producing a more random, less "processed" look.

GIF (Graphics Interchange Format) An image file format limited to 256 different colors that compresses the information by combining similar colors and discarding the rest. Condensing a 16.8-million-color photographic image to only 256 different hues often produces a poor-quality image, but GIF is useful for images that don't have a great many colors, such as charts or graphs. The GIF format also includes transparency options, and can include multiple images to produce animations that may be viewed on a web page or other application. See also *JPEG* and *TIF.*

graduated filter A lens attachment with variable density or color from one edge to another. A graduated neutral density filter, for example, can be oriented so the neutral density portion is concentrated at the top of the lens' view with the less dense or clear portion at the bottom, thus reducing the amount of light from a very bright sky while not interfering with the exposure of the landscape in the foreground. Graduated filters can also be split into several color sections to provide a color gradient between portions of the image.

grain The metallic silver in film which forms the photographic image. The term is often applied to the seemingly random noise in an image (both conventional and digital) that provides an overall texture.

gray card A piece of cardboard or other material with a standardized 18-percent reflectance. Gray cards can be used as a reference for determining correct exposure.

grayscale image An image represented using 256 shades of gray. Scanners often capture grayscale images with 1024 or more tones, but reduce them to 256 grays for manipulation by Photoshop.

halftone A method used to reproduce continuous-tone images, as in newspapers, magazines, and books, representing the image as a series of dots.

high contrast A wide range of density in a print, negative, or other image.

highlights The brightest parts of an image containing detail.

histogram A kind of chart showing the relationship of tones in an image using a series of 256 vertical "bars," one for each brightness level. A histogram chart typically looks like a curve with one or more slopes and peaks, depending on how many highlight, midtone, and shadow tones are present in the image.

hot mirror A specialized type of optics that allows visible light to pass, while blocking infrared illumination.

hot shoe A mount on top of a camera used to hold an electronic flash, while providing an electrical connection between the flash and the camera.

hot spots Flare or glare in an image. In infrared photography, hot spots can be caused by lenses that don't trap extraneous internal reflections efficiently in the IR range, or from sensors that react unevenly to infrared light.

hue The color of light that is reflected from an opaque object or transmitted through a transparent one.

hyperfocal distance A point of focus where everything from half that distance to infinity appears to be acceptably sharp. For example, if your lens has a hyperfocal distance of 4 feet, everything from 2 feet to infinity would be sharp. The hyperfocal distance varies by the lens and the aperture in use. If you know you'll

be making a "grab" shot without warning, sometimes it is useful to turn off your camera's automatic focus and set the lens to infinity, or, better yet, the hyperfocal distance. Then, you can snap off a quick picture without having to wait for the lag that occurs with most digital cameras as their autofocus locks in.

image stabilization A technology, also called vibration reduction and anti-shake, that compensates for camera shake, usually by adjusting the position of the camera sensor or lens elements in response to movements of the camera.

incident light Light falling on a surface.

indexed color image An image with 256 different colors, as opposed to a grayscale image, that has 256 different shades of the tones between black and white.

infinity A distance so great that any object at that distance will be reproduced sharply if the lens is focused at the infinity position.

infrared illumination The non-visible part of the electromagnetic spectrum with wavelengths between 700 and 1200 nanometers, which can be used for infrared photography when the lens is filtered to remove visible light.

infrared (IR) blocking filter A filter that cuts off infrared light and keeps it from reaching the sensor or film. See also *infrared (IR) filter*.

infrared (IR) contamination Incorrect colors in conventional full-color images caused by interference from infrared illumination.

infrared (IR) conversion The process of converting a digital camera to full-time infrared use by removing its IR blocking filter.

infrared (IR) cutoff The point at which at least 50 percent of shorter wavelengths are blocked.

infrared (IR) filter A filter that removes visible light and allows only infrared light to pass to the sensor. See also *infrared (IR) blocking filter*.

interchangeable lens Lens designed to be readily attached to and detached from a camera; a feature found in more sophisticated digital cameras.

International Organization for Standardization (ISO) A governing body that provides standards used to represent film speed, or the equivalent sensitivity of a digital camera's sensor. Digital camera sensitivity is expressed in ISO settings.

interpolation A technique digital cameras, scanners, and image editors use to create new pixels required whenever you resize or change the resolution of an image based on the values of surrounding pixels. Devices such as scanners and digital cameras can also use interpolation to create pixels in addition to those actually captured, thereby increasing the apparent resolution or color information in an image.

invert In image editing, to change an image into its negative; black becomes white, white becomes black, dark gray becomes light gray, and so forth. Colors are also changed to the complementary color; green becomes magenta, blue turns to yellow, and red is changed to cyan.

iris A set of thin overlapping metal leaves in a camera lens, also called a diaphragm, that pivot outwards to form a circular opening of variable size to control the amount of light that can pass through a lens.

jaggies Staircasing effect of lines that are not perfectly horizontal or vertical, caused by pixels that are too large to represent the line accurately. See also *antialias*.

JPEG (Joint Photographic Experts Group) A file format that supports 24-bit color and reduces file sizes by selectively discarding image data. Digital cameras generally use JPEG compression to pack more images onto memory cards. You can select how much compression is used (and therefore how much information is thrown away) by selecting from among the Standard, Fine, Super Fine, or other quality settings offered by your camera. See also *GIF* and *TIF*.

Kelvin (K) A unit of measurement based on the absolute temperature scale in which absolute zero is zero; used to describe the color of continuous spectrum light sources, such as tungsten illumination (3200 to 3400K) and daylight (5500 to 6000K).

lag time The interval between when the shutter is pressed and when the picture is actually taken. During that span, the camera may be automatically focusing and calculating exposure. With digital SLRs, lag time is generally very short; with non-dSLRs, the elapsed time easily can be one second or more.

landscape The orientation of a page in which the longest dimension is horizontal, also called wide orientation.

latitude The range of camera exposures that produces acceptable images with a particular digital sensor or film.

layer A way of managing elements of an image in stackable overlays that can be manipulated separately, moved to a different stacking order, or made partially or fully transparent. Photoshop allows collecting layers into layer sets.

lens One or more elements of optical glass or similar material designed to collect and focus rays of light to form a sharp image on the film, paper, sensor, or a screen.

lens aperture The lens opening, or iris, that admits light to the film or sensor. The size of the lens aperture is usually measured in f/stops. See also *f/stop* and *iris*.

lens flare A feature of conventional photography that is both a bane and creative outlet. It is an effect produced by the reflection of light internally among elements of an optical lens. Bright light sources within or just outside the field of view cause

lens flare. Flare can be reduced by the use of coatings on the lens elements or with the use of lens hoods. Lenses sometimes respond to flare in the infrared wavelengths differently, so a lens that has no flare problems with visible light will produce hot spots under IR illumination.

lens hood A device that shades the lens, protecting it from extraneous light outside the actual picture area which can reduce the contrast of the image, or allow lens flare.

lens speed The largest lens opening (smallest f/number) at which a lens can be set. A fast lens transmits more light and has a larger opening than a slow lens. Determined by the maximum aperture of the lens in relation to its focal length; the "speed" of a lens is relative: A 400mm lens with a maximum aperture of f/3.5 is considered extremely fast, while a 28mm f/3.5 lens is thought to be relatively slow.

lighting ratio The proportional relationship between the amount of light falling on the subject from the main light and other lights, expressed in a ratio, such as 3:1.

lossless compression An image-compression scheme, such as TIFF, that preserves all image detail. When the image is decompressed, it is identical to the original version.

lossy compression An image-compression scheme, such as JPEG, that creates smaller files by discarding image information, which can affect image quality.

luminance The brightness or intensity of an image, determined by the amount of gray in a hue.

LZW compression A method of compacting TIFF files using the Lempel-Ziv Welch compression algorithm, an optional compression scheme offered by some digital cameras and software applications.

macro lens A lens that provides continuous focusing from infinity to extreme close-ups, often to a reproduction ratio of 1:2 (half life-size) or 1:1 (life-size).

macro photography The process of taking photographs of small objects at magnifications of 1X or more.

magnification ratio A relationship that represents the amount of enlargement provided by the macro setting of the zoom lens, macro lens, or with other close-up devices.

matrix metering A system of exposure calculation that looks at many different segments of an image to determine the brightest and darkest portions.

maximum aperture The largest lens opening or f/stop available with a particular lens, or with a zoom lens at a particular magnification.

microdrive A tiny hard disk drive in the Compact Flash form factor that can be used in most digital cameras that take Compact Flash memory.

microlens A tiny optical element placed over each pixel in a digital camera sensor to direct incoming photons into the photosensitive area of the photosite.

midtones Parts of an image with tones of an intermediate value, usually in the 25 to 75 percent range. Many image-editing features allow you to manipulate midtones independently from the highlights and shadows.

mirror lens A type of lens, more accurately called a *catadioptric lens*, that contains both lens elements and mirrors to "fold" the optical path to produce a shorter, lighter telephoto lens. Because of their compact size and relatively low price, these lenses are popular, even though they have several drawbacks, including reduced contrast, fixed apertures, and they produce doughnut-shaped out-of-focus points of light (because one of the mirrors is mounted on the front of the lens).

mirror lock-up The ability to retract the SLR's mirror to reduce vibration prior to taking the photo, or to allow access to the sensor for cleaning.

moiré An objectionable effect caused by the interference of patterns, such as patterns found in subjects that happen to be close to the resolution of a digital camera sensor. Moiré can also be produced by scanning or photographing images that already have a halftone screen. See also *antialiasing filter*.

monochrome Having a single color, plus white. Grayscale images are monochrome (shades of gray and white only).

nanometer One billionth of a meter.

negative A representation of an image in which the tones and colors are reversed: blacks as white, and vice versa.

neutral color In image-editing's RGB mode, a color in which red, green, and blue are present in equal amounts, producing a gray.

neutral density filter A gray camera filter reduces the amount of light entering the camera without affecting the colors.

noise In an image, pixels with randomly distributed color values. Noise in digital photographs tends to be the product of low-light conditions and long exposures, particularly when you have set your camera to a higher ISO rating than normal.

noise reduction A technology used to cut down on the amount of random information in a digital picture, usually caused by long exposures at increased sensitivity ratings. Noise reduction involves the camera automatically taking a second blank/dark exposure at the same settings that contain only noise, and then using

the blank photo's information to cancel out the noise in the original picture. With most cameras, the process is very quick, but does double the amount of time required to take the photo. Noise reduction can also be performed within image editors and stand alone noise reduction applications.

normal lens A lens that makes the image in a photograph appear in a perspective that is like that of the original scene, typically with a field of view of roughly 45 degrees. A quick way to calculate the focal length of a normal lens is to measure the diagonal of the sensor or film frame used to capture the image, usually ranging from around 7mm to 45mm.

open flash A technique used for "painting with light" or other procedures, where the tripod-mounted camera's shutter is opened, the flash is triggered manually (sometimes several times), and then the shutter is closed.

overexposure A condition in which too much light reaches the film or sensor, producing a dense negative or a very bright/light print, slide, or digital image.

pan-and-tilt head A tripod head allowing the camera to be tilted up or down or rotated 360 degrees.

panning Moving the camera so that the image of a moving object remains in the same relative position in the viewfinder as you take a picture. The eventual effect creates a strong sense of movement when used with a relatively slow shutter speed.

panorama A broad view, usually scenic. Photoshop and Elements' Photomerge feature helps you create panoramas from several photos. Many digital cameras have a panorama assist mode that makes it easier to shoot several photos that can be stitched together later.

parallax compensation An adjustment made by the non-SLR camera or photographer to account for the difference in views between the taking lens and the external viewfinder.

PC terminal A connector for attaching standard electronic flash cords, named after the Prontor-Compur shutter companies that developed this connection.

peak response The wavelengths that are most strongly seen by a sensing system, such as the human eye or a digital sensor.

perspective The rendition of apparent space in a photograph, such as how far the foreground and background appear to be separated from each other. Perspective is determined by the distance of the camera to the subject. Objects that are close appear large, while distant objects appear to be far away.

perspective control lens A special lens, most often used for architectural photography, that allows correcting distortion resulting from a high or low camera angle.

pincushion distortion A type of distortion, most often seen in telephoto prime lenses and zooms, in which lines at the top and side edges of an image are bent inward, producing an effect that looks like a pincushion. See also *barrel distortion.*

pixel The smallest element of a screen display that can be assigned a color. The term is a contraction of "picture element."

pixels per inch (ppi) The number of pixels that can be displayed per inch, usually used to refer to pixel resolution from a scanned image or on a monitor.

plug-in A module such as a filter that can be accessed from within an image editor to provide special functions.

point Approximately 1/72 of an inch outside the Macintosh world, exactly 1/72 of an inch within it.

polarizing filter A filter that forces light, which normally vibrates in all directions, to vibrate only in a single plane, reducing or removing the specular reflections from the surface of objects and emphasizing the blue of skies in color images.

portrait The orientation of a page in which the longest dimension is vertical, also called tall orientation. In photography, a formal picture of an individual or, sometimes, a group.

positive The opposite of a negative, an image with the same tonal relationships as those in the original scenes—for example, a finished print or a slide.

prime A camera lens with a single fixed focal length, as opposed to a zoom lens.

process color The four color pigments used in color printing: cyan, magenta, yellow, and black (CMYK).

RAW An image file format offered by many digital cameras that includes all the unprocessed information captured by the camera. RAW files are very large, and must be processed by a special program supplied by camera makers, image editors, or third parties, after being downloaded from the camera.

rear-curtain sync An optional kind of electronic flash synchronization technique, originally associated with focal plane shutters, which consists of a traveling set of curtains, including a front curtain (which opens to reveal the film or sensor) and a rear curtain (which follows at a distance determined by shutter speed to conceal the film or sensor at the conclusion of the exposure).

For a flash picture to be taken, the entire sensor must be exposed at one time to the brief flash exposure, so the image is exposed after the front curtain has reached the other side of the focal plane, but before the rear curtain begins to move.

Rear-curtain sync causes the flash to fire at the *end* of the exposure, an instant before the second or rear curtain of the focal plane shutter begins to move. With

slow shutter speeds, this feature can create a blur effect from the ambient light, showing as patterns that follow a moving subject with the subject shown sharply frozen at the end of the blur trail. If you were shooting a photo of The Flash, the superhero would appear sharp, with a ghostly trail behind him. See also *front-curtain sync*.

red eye An effect from flash photography that appears to make a person's eyes glow red, or an animal's yellow or green. It's caused by light bouncing from the retina of the eye, and is most pronounced in dim illumination (when the irises are wide open) and when the electronic flash is close to the lens and therefore prone to reflect directly back. Image editors can fix red eye through cloning other pixels over the offending red or orange ones.

red-eye reduction A way of reducing or eliminating the red-eye phenomenon. Some cameras offer a red-eye reduction mode that uses a preflash that causes the irises of the subjects' eyes to close down just prior to a second, stronger flash used to take the picture.

reflector Any device used to reflect light onto a subject to improve balance of exposure (contrast). Another way is to use fill-in flash.

registration mark A mark that appears on a printed image, generally for color separations, to help in aligning the printing plates. Photoshop can add registration marks to your images when they are printed.

reproduction ratio Used in macrophotography to indicate the magnification of a subject.

resample To change the size or resolution of an image. Resampling down discards pixel information in an image; resampling up adds pixel information through interpolation.

resolution In image editing, the number of pixels per inch used to determine the size of the image when printed. That is, an 8 × 10-inch image that is saved with 300 pixels per inch resolution will print in an 8 × 10-inch size on a 300 dpi printer, or 4 × 5-inches on a 600 dpi printer. In digital photography, resolution is the number of pixels a camera or scanner can capture.

retouch To edit an image, most often to remove flaws or to create a new effect.

RGB color mode A color mode that represents the three colors—red, green, and blue—used by devices such as scanners or monitors to reproduce color. Photoshop works in RGB mode by default, and even displays CMYK images by converting them to RGB.

rods The "color-blind" cells in the human eye that perceive fine details under low light.

saturation The purity of color; the amount by which a pure color is diluted with white or gray.

scale To change the size of all or part of an image.

scanner A device that captures an image of a piece of artwork and converts it to a digitized image or bitmap that the computer can handle.

Secure Digital memory card A postage-stamp-sized flash memory card format that is gaining acceptance for use in digital cameras and other applications.

selection In image editing, an area of an image chosen for manipulation, usually surrounded by a moving series of dots called a selection border.

selective focus Choosing a lens opening that produces a shallow depth-of-field. Usually this is used to isolate a subject by causing most other elements in the scene to be blurred.

self-timer Mechanism delaying the opening of the shutter for some seconds after the release has been operated. Also known as delayed action.

sensitivity A measure of the degree of response of a film or sensor to light.

sensor array The grid-like arrangement of the red, green, and blue-sensitive elements of a digital camera's solid-state capture device. Sony offers a sensor array that captures a fourth color, termed *emerald*.

shadow The darkest part of an image, represented on a digital image by pixels with low numeric values or on a halftone by the smallest or absence of dots.

sharpening Increasing the apparent sharpness of an image by boosting the contrast between adjacent pixels that form an edge.

shutter In a conventional film camera, the shutter is a mechanism consisting of blades, a curtain, plate, or some other movable cover that controls the time during which light reaches the film. Digital cameras can use actual shutters, or simulate the action of a shutter electronically. Quite a few use a combination, employing a mechanical shutter for slow speeds and an electronic version for higher speeds.

shutter lag The tendency of a camera to hesitate after the shutter release is depressed prior to making the actual exposure. Point-and-shoot digital cameras often have shutter lag times of up to 2 seconds, primarily because of slow autofocus systems. Digital SLRs typically have much less shutter lag, typically 0.2 seconds or less.

shutter-preferred An exposure mode in which you set the shutter speed and the camera determines the appropriate f/stop. See also *aperture-preferred*.

side lighting Light striking the subject from the side relative to the position of the camera; produces shadows and highlights to create modeling on the subject.

single lens reflex (SLR) camera A type of camera that allows you to see through the camera's lens as you look in the camera's viewfinder. Other camera functions, such as light metering and flash control, also operate through the camera's lens.

slave unit An accessory flash unit that supplements the main flash, usually triggered electronically when the slave senses the light output by the main unit, or through radio waves.

slide A photographic transparency mounted for projection.

slow sync An electronic flash synchronizing method that uses a slow shutter speed so that ambient light is recorded by the camera in addition to the electronic flash illumination, so that the background receives more exposure for a more realistic effect.

SLR (single lens reflex) A camera in which the viewfinder sees the same image as the film or sensor.

SmartMedia An obsolete type of memory card storage, generally outmoded today because its capacity is limited to 128MB, for digital cameras and other computer devices.

smoothing To blur the boundaries between edges of an image, often to reduce a rough or jagged appearance.

soft focus An effect produced by use of a special lens or filter that creates soft outlines.

soft lighting Lighting that is low or moderate in contrast, such as on an overcast day.

solarization In photography, an effect produced by exposing film to light partially through the developing process. Some of the tones are reversed, generating an interesting effect. In image editing, the same effect is produced by combining some positive areas of the image with some negative areas. Also called the Sabattier effect, to distinguish it from a different phenomenon called overexposure solarization, which is produced by exposing film to many, many times more light than is required to produce the image. With overexposure solarization, some of the very brightest tones, such as the sun, are reversed.

specular highlight Bright spots in an image caused by reflection of light sources.

spot meter An exposure system that concentrates on a small area in the image. See also *averaging meter*.

subtractive primary colors Cyan, magenta, and yellow, which are the printing inks that theoretically absorb all color and produce black. In practice, however,

they generate a muddy brown, so black is added to preserve detail (especially in shadows). The combination of the three colors and black is referred to as CMYK. (K represents black, to differentiate it from blue in the RGB model.)

T (time) A shutter setting in which the shutter opens when the shutter button is pressed, and remains open until the button is pressed a second time. See also *B (bulb)*.

telephoto A lens or lens setting that magnifies an image.

thermal infrared Very long wavelengths, from 3000nm to 1mm, that represent heat.

threshold A predefined level used by a device to determine whether a pixel will be represented as black or white.

TIFF (Tagged Image File Format) A standard graphics file format that can be used to store grayscale and color images plus selection masks. See also *GIF* and *JPEG*.

time exposure A picture taken by leaving the shutter open for a long period, usually more than one second. The camera is generally locked down with a tripod to prevent blur during the long exposure. See also *B (bulb)*.

time lapse A process by which a tripod-mounted camera takes sequential pictures at intervals, allowing the viewing of events that take place over a long period of time, such as a sunrise or flower opening. Many digital cameras have time-lapse capability built in. Others require you to attach the camera to your computer through a USB cable and let software in the computer trigger the individual photos.

tint A color with white added to it. In graphic arts, often refers to the percentage of one color added to another.

transparency A positive photographic image on film, viewed or projected by light shining through film.

transparency scanner A type of scanner that captures color slides or negatives.

tripod A three-legged supporting stand used to hold the camera steady. Useful when using slow shutter speeds and/or telephoto lenses, especially when taking IR photos requiring long exposures.

TTL Through the lens. A system of providing viewing through the actual lens taking the picture (as with a camera with an electronic viewfinder, LCD display, or single lens reflex viewing), or calculation of exposure, flash exposure, or focus based on the view through the lens.

tungsten light Usually warm light from ordinary room lamps and ceiling fixtures, as opposed to fluorescent illumination.

underexposure A condition in which too little light reaches the film or sensor, producing a thin negative, dark slide, muddy-looking print, or dark digital image.

unipod A one-legged support, or monopod, used to steady the camera. See also *tripod.*

unsharp masking The process for increasing the contrast between adjacent pixels in an image, increasing sharpness, especially around edges.

USB A high-speed serial communication method commonly used to connect digital cameras and other devices to a computer.

viewfinder The device in a camera used to frame the image. With an SLR camera, the viewfinder is also used to focus the image if focusing manually. You can also focus an image with the LCD display of a digital camera, which is a type of viewfinder.

vignetting Dark corners of an image, often produced by using a lens hood that is too small for the field of view, or generated artificially using image-editing techniques.

white The color formed by combining all the colors of light (in the additive color model) or by removing all colors (in the subtractive model).

white balance The adjustment of a digital camera to the color temperature of the light source. Interior illumination is relatively red; outdoor light is relatively blue. Digital cameras often set correct white balance automatically, or let you do it through menus. Image editors can often do some color correction of images that were exposed using the wrong white-balance setting. For infrared photography outdoors, white balance should be set to that of foliage or grass, using a digital camera's custom white balance facility.

white point In image editing, the lightest pixel in the highlight area of an image.

wide-angle lens A lens that has a shorter focal length and a wider field of view than a normal lens for a particular film or digital image format.

xD card A very small type of memory card, used chiefly in Olympus and Fuji digital cameras.

zoom In image editing, to enlarge or reduce the size of an image on your monitor. In photography, to enlarge or reduce the size of an image using the magnification settings of a lens.

zoom ring A control on the barrel of a lens that allows changing the magnification, or zoom, of the lens by rotating it.

Index